KU-506-014

3D for the Web

Interactive 3D animation using 3ds max, Flash and Director

Carol MacGillivray and Anthony Head

Illustrations
Carol MacGillivray and Anthony Head

ELSEVIER

AMSTERDAM • BOSTON • HEIDELBERG • LONDON • NEW YORK • OXFORD •
PARIS • SAN DIEGO • SAN FRANCISCO • SINGAPORE • SYDNEY • TOKYO

Focal Press is an imprint of Elsevier

Focal
Press

Focal Press
An imprint of Elsevier
Linacre House, Jordan Hill, Oxford OX2 8DP
30 Corporate Drive, Burlington, MA 01803

First published 2005

Copyright © 2005, Carol MacGillivray and Anthony Head. All rights reserved

The right of Carol MacGillivray and Anthony Head to be identified
as the authors of this work have been asserted in accordance with
the Copyright, Designs and Patents Act 1988

No part of this publication may be reproduced in any material form (including
photocopying or storing in any medium by electronic means and whether
or not transiently or incidentally to some other use of this publication) without
the written permission of the copyright holder except in accordance with the
provisions of the Copyright, Designs and Patents Act 1988 or under the terms of
a licence issued by the Copyright Licensing Agency Ltd, 90 Tottenham Court Road
London, England W1T 4LP. Applications for the copyright holder's written
permission to reproduce any part of this publication should be
addressed to the publisher

Permissions may be sought directly from Elsevier's Science and Technology Rights
Department in Oxford, UK: phone: (+44) 1865 843830, fax: (+44) 1865 85333,
e-mail: permissions@elsevier.co.uk. You may also complete your request on-line via the
Elsevier homepage (http://www.elsevier.com), by selecting 'Customer Support'
and then 'Obtaining Permissions'

British Library Cataloguing in Publication Data
A catalogue record for this book is available from the British Library

Library of Congress Cataloguing in Publication Data
A catalogue record for this book is available from the Library of Congress

ISBN 0 240 51910 8

For information on all Focal Press publications visit our website
at www.focalpress.com

Typeset by Charon Tec Pvt. Ltd, Chennai, India
www.charontec.com
Printed and bound in Italy

Working together to grow
libraries in developing countries

www.elsevier.com | www.bookaid.org | www.sabre.org

ELSEVIER BOOK AID International Sabre Foundation

Contents

Introduction

This is a book about bringing high quality 3D animations to the Web. It is a much needed book in a market that is shifting rapidly. The advent of broadband has increased the viability of using 3D to seduce, entertain and inform on the Web. This is a unique book that deals with making 3D artifacts, specifically designed for Web delivery. You will be shown how to make stunning interactive 3D animations that will elevate your website to cutting-edge status.

The book is aimed at Web designers new to 3D, students, 3D modelers and animators and all Digital Artists. Whatever your current skill level, from beginner to advanced user, there will be something for you in this book. If you are a novice to the world of 3D then this book will teach you the basics and guide you through to an advanced level. If you are already knowledgeable in 3D then there are plenty of tips and tricks to further hone your skills and create complex and believable animations, games and environments.

To those of you who have picked up this book and are new to 3D, you probably have one big question: 'What's so special about 3D?'

My reply would be that 3D has immediate appeal far beyond that of a 2D graphic representation.

To see how attractive 3D is, try this simple test. If you were visiting a website and wanted to search for a book. Which icon would you rather click on? My guess is the one on the right.

Even though the actual information on the 3D object is smaller and less legible, it is somehow friendlier and more accessible. You are also able to see much more visual information about the shape of the object, by seeing more than one dimension.

3D has an immediate appeal. It can reflect the world we know and live in. Clicking on the 3D icon feels more like browsing through a bookshop.

Now let us think about 3D that moves. How about a button, which one do you want to push?

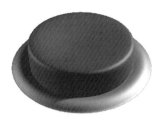

I think you will agree that the 3D button is more likely to get hit. It is also likely to respond in a typical way. We would expect the middle part to depress and the collar to stay where it is. It also looks like it might produce a satisfying clunk when hit. The other button might do that too, but we have no expectation. How great is it to see the button move, have an idea of its texture and hear its re-assuring sound? 3D delivers the world as we know it, enabling us to understand what we see faster and more easily.

So if you wanted to sell something on a website 3D is clearly a better way of showing the goods, but it is also the best way of entertaining and seducing a visitor to your site. This is why games have graduated to 3D. Why play Asteroids in 2D when you can add a whole new dimension? 2D is the silent black and white movie to 3D's Technicolor Surround sound.

Okay, I hope I have convinced you, now let's get to the inevitable next question; how do I learn it? This book is going to give you all the knowledge you need. You will acquire the techniques and skills to produce high quality 3D for the Web. But it is more than a manual; each chapter is divided into two parts. The first part is tutorial based, and is meant to be used alongside your computer. You will get step-by-step instructions on how to create everything from simple 3D buttons, to fully fledged interactive character animations. The second part consists of interviews with award winning, internationally acclaimed companies and individuals who use 3D as a major component in their websites. You will get hands-on technical instruction and an understanding of how it fits into real projects. There is also a CD full of examples and tutorial files.

'High quality' – what is it and how do you achieve it?

Defining high quality is a subjective topic – how do you quantify good design and good taste. Surely quality is in the eye of the beholder. A high quality website for me is a link I want to send to friends saying, 'Have a look at this', not for the information the site holds, but for the idea behind it and the visual 'wow' factor. Now admittedly, I work in Animation and Design, and so do a lot of my friends, but you would be amazed by the buzz a good website makes – news travels the way it does for a sleeper hit movie or a new electronic game. You have experienced something good and you want to share that enjoyment with others. Before you know it, chat rooms are buzzing with people discussing your site. Away from the Internet, this sort of buzz is called 'word-of-mouth', on the Internet it has the rather unfortunate name of 'Viral Marketing', but do not be put off by the name, achieving the sort of publicity where your site is recommended by individuals can lead to an exponential growth in the number of visitors you get. Creating a high quality and entertaining website that stands out from the others is going to get you noticed. Whether you use 3D for the interface design or in the creation of computer games, this book will show how to get that competitive edge.

The people we have chosen to interview are successful and have that competitive edge, their websites are a joy to behold. There is a lot to learn from the interviews. Factors such as character design, lighting, sound, timing, economy and good ideas have played a lot in their success. We cannot give you good ideas on a plate, but we can show you the path to recognizing the good ideas you have and realizing these ideas in 3D on the Web.

Using the software

To anyone new to 3D, there may well seem a bewildering array of software. You will need to use different pieces of software to achieve great 3D results, from modeling and animation to interactivity, game creation and Web publishing. Although some pieces of software do cover most of these areas, in this book we are using the most popular packages in the Web and Game industry. The modeling and animation tutorials in this book were written in Discreet's 3D Studio Max 5.1 with Character Studio, but should work equally well on earlier and later versions. Macromedia's Flash (MX 2004) and Director (MX) are the most widely used packages for delivering interactive content on the Web and the tutorials take you through the essential skills needed for 3D interactivity. 96% of Internet computers have the Flash player on and 85% have the Director Shockwave player, making them industry standards. Macromedia Dreamweaver (MX 2004) is the most popular

web page authoring package and using this in combination with the other programs will give you the depth of knowledge you need. All of these programs are available as demos from their respective websites (www.discreet.com and www.macromedia.com). The chances are that you will already have access to one or more of these packages and by using this multi-stage approach, you will gain the flexibility you need to be a successful 3D Web designer.

This book is written in user-friendly and accessible language. It is intended to inspire you, and help you unleash your ambitions in the wonderful world of 3D.

Chapter 1

3D for beginners: basic buttons

Why we all love buttons

As anyone who has been to the Science Museum with a kid knows, seeing a button creates an irresistible urge to press it. Indeed, young kids often skip from one exhibit to another pressing buttons as they go and not even waiting to see the effect the button has. Adults do it too. Have you ever pressed the button at a pedestrian traffic light even though the wait light is showing, as if it will make the little red man turn green faster? Or pumped an elevator button to make the lift hurry up?

So how does this translate to a website? Websites consist of buttons, graphics and text. The idea of a button or hyperlink is crucial to all website navigation. This button could be a text or a graphic. It is important that all visitors to your site can first identify what a button is, and that having found it, they are motivated to click on that button to get through to further information on your site.

As we have already indicated, a 3D button oozes appeal. There is no trouble recognizing it, as it looks like a button from the real world, and on a website we have an added advantage in helping the visitor hit that button. Website buttons inherently have three states. First, the dormant state of the button waiting to be noticed. Secondly, the 'rollover' state as the mouse hovers over it, will the visitor succumb to the urge? Thirdly, the mouse 'click' on the button. Hurrah, your audience is snared; they are traveling deeper into your website.

So let us start by building a simple button in 3D. This is an easy exercise to get you going, but it provides the stepping stone to so much more.

Open your 3D package and you will see a shocking amount of interface – even the simplest 3D software program is 'deep'. It has to be; this is in essence the same sort of software that brought you Toy Story and the effects in The Matrix. Do not panic, you have to start somewhere, once we have guided you through the tutorials in this book; you will have accumulated a lot of knowledge.

Whatever 3D software you have, you are likely to have the default four windows. Three of these windows give the orthographic (non-perspective) view of anything you build in them. Typically your interface will have a front elevation, side elevation and top view. The fourth window will allow you to move your view of on object in an isometric or Perspective view.

If you are a beginner, when you create an object and manipulate it, it is best to use the orthographic views, as the Perspective view is more for looking around your object and checking you like it from all angles.

Working in a 3D environment, every point in space can be mapped using coordinates on three axes: x, y and z. A virtual object is created by joining points or vertices in this space.

It takes a while to get used to moving around between these windows, so if you are completely new to the software, try this simple exercise to get warmed up.

Introduction to modeling in 3D: building blocks

Create two separate standard primitive boxes in the top viewport, any size, and stack one on top of the other.

What to do

Click Create > Standard Primitives > Box. Click and drag in the top viewport to create a rectangle, then drag again (three dimensions, remember).

You will not see anything happen in the top viewport, but if you look at the others, you will see a new height dimension being added. Make another box. Put one box on top of the other by using the Select and Move icon in the Tool Bar. Try this first of all in the perspective viewport, and you will discover how hard it can be to manipulate in freeform 3D space, but if you use the three orthographic views, it is a simple matter to arrange a stack of boxes by sticking to two axes at a time (Figure 1.1). Try and develop an ease with looking and moving from one window to another, and check the result in your perspective viewport. (Incidentally, it is always good practice to start creating any object in the top viewport.)

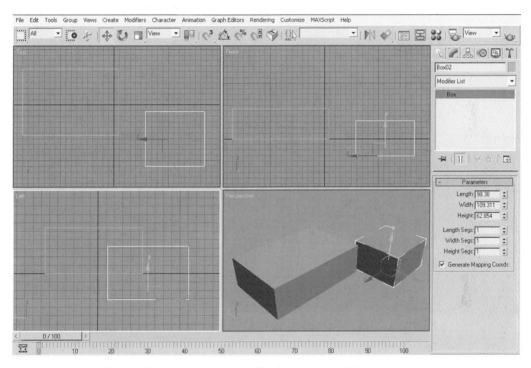

Figure 1.1 Stacking Boxes. The four views in 3D Studio Max

How to make a simple 3D button

Use simple primitive objects to make a realistic button.

What to do

This button is made from two standard primitives. First the button itself is made from a cylinder. Create a cylinder that looks suitably proportioned in the top viewport. Notice that as you make your cylinder there are different

parameter counters on the screen. All cylinders are defined by their radius and height. If you are a precise person, you can type values in here to make sure the button is the correct proportion for you. The other options you are given are whether the cylinder is capped top and bottom, how many height segments it has, and how many sides make up the perimeter. You can see in this perspective view that this cylinder has 5 height segments and 18 sides. It also has two cap segments (Figure 1.2).

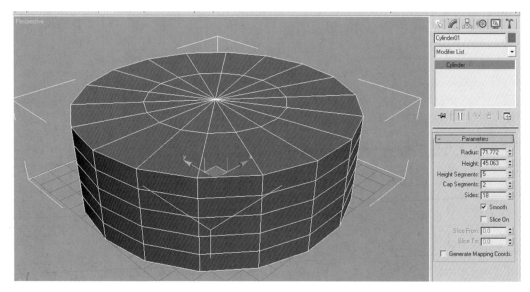

Figure 1.2 Standard Primitive > Cylinder (shown as Smooth + Highlights with Edged Faces on)

Note *Whenever you set out to build anything in 3D, it is a good idea to think about these extra parameters, as they are the key to the all important face count when transferring to Shockwave. More of this later. Because your button will end up as a still at this at this stage, we can be as generous as we like with our face count.*

Top Tip

It is usual to keep the three orthographic views as showing objects in Wireframe, and the perspective viewport showing Smooth + Highlights. It is often helpful to tick Edged Faces, so you can see the model and the structure together. You can change from one mode to another by R-clicking in the top-left of a viewport over the named view, and selecting what you wish from the drop down menu. (Alternatively F3 will toggle between Wireframe and Smooth + Highlights, and F4 toggles Edged Faces on and off.)

Now comes the fun bit. We want the cylinder to look more realistic and put a dimple in the middle. To do this we have to tweak it at Sub-Object level, and this means converting it to an Editable Mesh. In 3D Studio Max this is done by selecting the object and R-clicking in a viewport, a drop down menu appears and you choose Convert to > Editable Mesh. When you do this the modifier stack for your cylinder will have a new label: Editable Mesh.

Note	*The modifier stack allows you to travel up and down an object's history. Because the program reads the stack from the bottom to the top, you can change parameters from the beginning of an object's history. In 3D Studio Max, converting the object to an Editable Mesh collapses the stack; i.e. You can no longer change the cylinder's mesh parameters. In more complex modeling, it is a good idea to save versions of your work before you commit to this action.*

Editable Meshes have a drop down menu for Sub-Object manipulation. Open it out and have a look. This is the heart of all modeling in 3D (Figure 1.3).

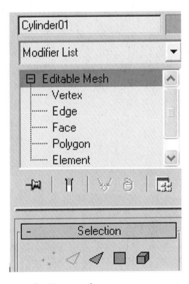

Figure 1.3 Sub-Object mode. Text and icons

- A vertex is a single point on your model.
- An edge is the line between two vertices.
- A face is a planar triangular surface.
- A polygon is made from two faces, and is the plane between four vertices.
- The element is the whole object.

Click on each and select some to see what you get. If you select vertex, then all the points show up in blue, selected points are red.

In Sub-Object mode we can manipulate each individual vertex, or groups of them. Pick the middle vertex at the top of your cylinder and move it up and down. If you have selected from the top viewport, you may find you have picked up the middle vertex at the bottom too. Turn on Ignore Backfacing, and select it again. Pulling the vertex down creates a dip, but rather a harsh one. Undo (Control + Z) and return the vertices to their original position. We are going to ease the harshness of the dimple in the button by using Soft Selection. With the center vertex still selected, open out Soft Selection and tick it on. Crank the Falloff slider up until the inner ring of vertices turn yellow. Now tweak the center vertex down to create a smooth dip in the top of your button (Figure 1.4).

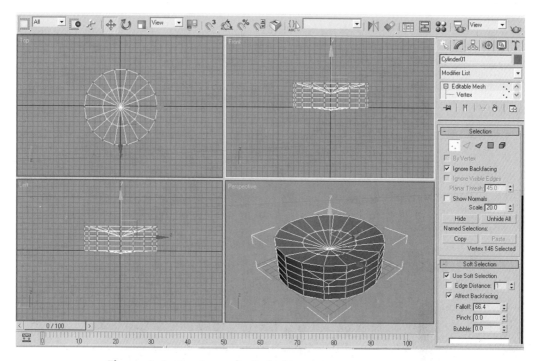

Figure 1.4 Creating a dip in the button

Top Tip

You can toggle on and off locking your selection by hitting the space bar. This can be very useful if you are moving from one viewport to another a lot.

Our button still looks a bit jagged, and so all that remains is to smooth it. We do this by sub-dividing the polygons. In 3D Studio Max this is done by adding a Meshsmooth modifier. (Other programs such as Maya call it Sub-Division.)

Leave Sub-Object mode, and with your cylinder selected, look down the Modifier List to find the Meshsmooth modifier. Add it to the cylinder's stack. You will see a box marked 'Iterations' make the value of this 1. The polygons on your button will increase by approximately fourfold. Your button will now look smooth and attractive.

Note *It is worth noting at this point that at the moment polygon count is not an issue for us – if it were we could achieve a smoother model with fewer polygons by slightly more complex methods. For now let us revel in the liberation of being able to use as many polygons as we want.*

Now to make the collar around the button. This is made from another standard primitive; the torus. Click on Create and select a Torus. Make this in the top viewport, if you start by centering it on the center of your cylinder, then you will end up with it in the correct position. You will notice that there are two separate radius parameters for your torus or donut, so you can decide on the width of the collar, you can also change the number of segments to make it smoother. As we are being generous, let us make it 48 segments to give an even, smooth look, as the finished object will be metallic. Now convert your torus to an Editable Mesh, just as you did the cylinder.

Choose polygons in Sub-Object mode, tick off Ignore Backfacing and select all the polygons in the lower half of your torus (Figure 1.5).

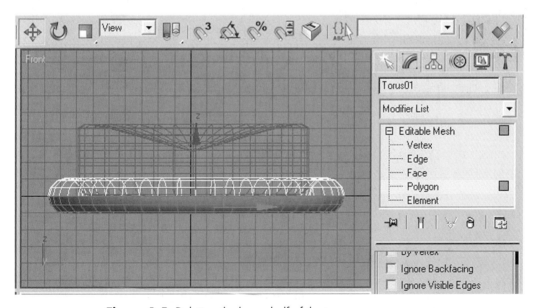

Figure 1.5 Deleting the lower half of the torus

Now press Delete. To make our button collar more realistic, it would be nice to flatten it a bit. To do this leave Sub-Object mode and select Melt from the Modifier List. Add it to the torus stack. Experiment with this modifier. There are different settings which make the Mesh of an object relax and mimic melting. I found an amount of 4 on the default Ice Melt to be about right.

Note *One of the confusing things to a beginner is how 3D programs give different modifiers widely varied parameters' scales; some slider settings are increments of 0.01 and others go up to tens of thousands. It is often worth moving the slider about a bit first so you can get a feel for the effect it is having.*

Make sure your collar and button fit together snugly. You can do this by examining it in the perspective viewport. When you are happy, hit Quick Render (the green teapot on the top tool bar. If you cannot see it, drag the tool bar to the left with the hand icon) and take a look at your button. Looking good, now let us give it some materials.

Select your button and open the Material Editor (Figure 1.6). You will see a number of sample gray slots containing spheres. Select one and click on the box next to Diffuse. A color chart pops up and you can select a red color for your button. We want the button to be a bit shiny, so increase the Specularity and Glossiness until the sample slot material looks suitable. Apply it to your button by either dragging and dropping or using the Assign Material to Selection button. Your button will go red as it takes on the assigned material.

Note *This is the most basic way materials can be used, simply assigning a color and light absorbency to an object. When we need to export materials using Shockwave, we can only use relatively simple materials like this, or enhance them by using materials created by us as bitmaps. Often this is enough to create great graphics, but the material options for ordinary export are manifold. No material can be treated in isolation, it is dependant on a huge number of influences like lighting, atmosphere and proximity of reflected objects. There are any number of ways of achieving the desired look and lighting and materials are an art in their own right.*

Now to give the collar a metallic look: select the collar and choose another material sample slot. The default gray can remain the same, but increase the Specular level to about 75 to make the ring shiny, and use your judgment on how glossy it should be (I opted for 20). Now scroll down to the Maps Rollout and open it. You will see a whole lot of extra parameters available.

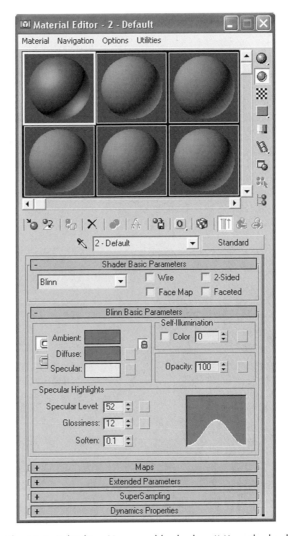

Figure 1.6 The Material Editor (Accessed by hotkey 'M' on the keyboard)

If you click in the box labeled 'None' next to Reflect, a Map Browser will pop up that offers you a lot of options for different maps to use with your material. The identifying symbol for a map is a green square. Choose Raytrace from the Browser by double-clicking it (Figure 1.7).

Set the amount to 25. The sample slot will not change, because Raytrace instructs the software to calculate reflections from the scene, any Raytracing will only be revealed when we render. Assign the metallic material to the collar in the scene and we will add some lights to make the object more realistic.

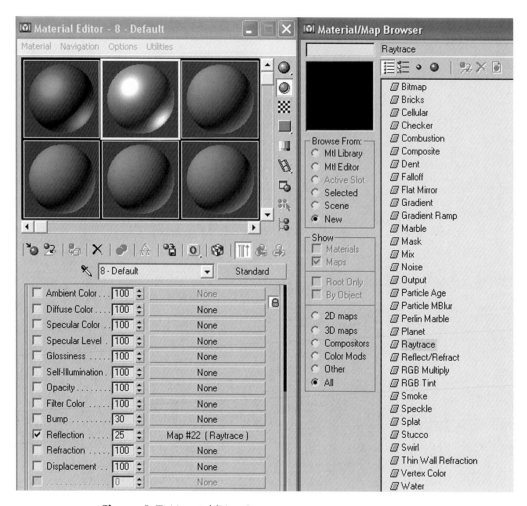

Figure 1.7 Material/Map Browser

Note *The default lighting in a 3D program is ambient. Ambient light means a flat uniform light emanating from each object, regardless of the light source. It is fine for general purposes, but fatal to bringing any quality of light in a scene. There are three basic lights in most 3D programs: spotlights, directional lights and omnis. Direct lights mimic distant spotlights like the sun, producing parallel shadows. Omnis are more likely to be fill lights, but can also be used as highlighters along with target spotlights. The look of a 3D scene is not as intuitive as live action is for a Lighting Photographer. We cannot see the light, as it is virtual, but have to check it by rendering previews. Lighting is 5% setting up and 95% revisions and adjustments.*

Click on Create > Lights (Figure 1.8).

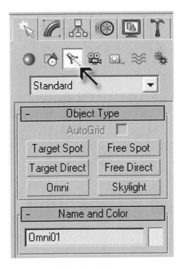

Figure 1.8 Creating lights in 3D Studio Max

Choose an Omni light; this is a light that shines all around equally, rather than directionally as a Target Spot. The default brightness is 1 (Called Multiplier in 3D Studio Max) and this will be our highlighter. Place the light above and to the right of your button, at an angle of approximately 45 degrees. Create another Omni and position it to the left of your button, and slightly lower, this will be our 'fill' light. Change the Multiplier to about 0.5 so it is half as bright. Now render from your perspective viewport. The collar should be reflecting the red of the button and you should have some pleasing highlights on the finished surfaces (Figure 1.9).

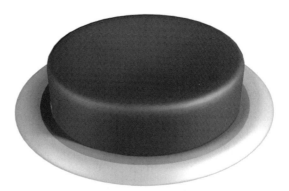

Figure 1.9 The rendered button

Now all that remains is to get your button ready for the Web.

Preparing a button for the Web

The language of the Web is HTML, and it has its limitations with regards to links. The effect of a button is to change the mouse pointer when you rollover it, thus indicating to the user that it is a button. However, with the addition of the Javascript language you can create a rollover state. This means that the graphic used to display the button can be swapped when the mouse is on top of it, giving you the opportunity to create a more interesting result. It is possible to create more complicated buttons than this, using Macromedia Flash and we will talk about this later. First we should animate our button in our 3D program in order to create our rollover states.

Exercise: animating the button in 3D

An introduction to the simplest animation you can do.

What to do

To animate the button being pressed is very simple. Along the bottom of your program is a frame counter. Below it there is a button called Auto Key. Switch Auto Key on (in earlier versions of 3ds max this was less confusingly called the 'animate' button) and the surrounding viewport box will turn red, this reminds you that you are now in Animation mode. The first thing we need to do is set a Keyframe for the button in its normal position. To do this, select your button and from the top right panel select Motion. Under PRS Parameters, Click on the Create Key > Position. A key will appear on the timeline at 0 (Figure 1.10).

This Keyframe sets our button at that time, in that position. To animate, move the slider on the timeline on to frame 8, and in a side viewport move your button down to look as if it has been pressed. A Keyframe will automatically appear. You can play your animation now and the button will go down. That is all the animation you need to do for actually moving the button. The button will be taking rather a long time to get pressed, eight frames is the equivalent of a third of a second and a bit too slow for our purposes, so now by moving the Keyframes, we will get the button's timing right and bring it back up again. Start by sliding the Keyframe from frame 0 to frame 5, that gives us three frames of animation, which looks and feels better. To return the button to its normal state, duplicate the first key, by Shift-clicking and dragging on it. A new key will appear that carries the same properties as the first key. Put this key at frame 14. If you play your animation now, you will see the button bob down and straight back up again. To make it more realistic, copy your second Keyframe (from frame 8) and drag it to frame 11.

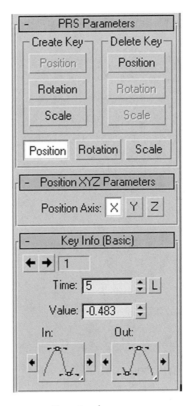

Figure 1.10 PRS Parameters. Creating keys

Now the button will stay down for three frames. Play your animation again (Figure 1.11).

Figure 1.11 Button down

Now our button moves we have created the rollover states that we require. We need to render two frames of our animation, one frame in the up state and one frame in the down state. To do this select the Rendering > Render Menu (Figure 1.12).

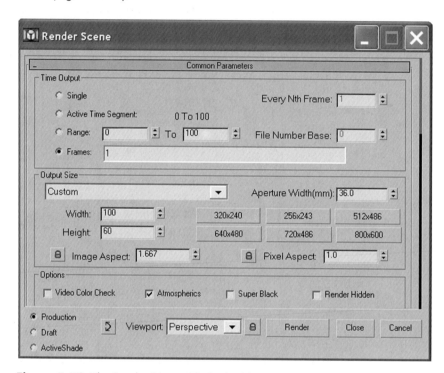

Figure 1.12 The Render Menu. 3D Studio Max

There are a few important points to be aware of here, one is the image size. The size of the image is going to have a direct effect on the download speed of your site. Although broadband is becoming more and more popular you should still always try to keep your graphics down to the minimum size they need to be. Although you can resize a button in HTML, you do not want to have to, as there is no point in downloading a full screen image that is only going to appear in a tiny section of your website. We need to decide what size our buttons need to be, and this would be done in the planning stage of your web page design. In this particular case we will decide that we want our buttons to be nice and big, so I suggest a size of 100 pixels wide and 60 pixels high, as this roughly matches the shape of the button. On a screen this will be approximately an inch across, although it very much depends on the monitor size and the screen resolution. So set the Render Scene palette to the settings in Figure 1.12 or change them to suit your own needs. You may need to reposition the button on the screen using the Pan tool (the hand) and the Zoom tool (the magnifying glass), in order to make the button fit properly on the rendered image. Test it by pressing the

Render button and when you are happy, save the image by clicking on the Disk icon of the resulting image. Select JPEG as the image format and use a quality level of 80. Render and save frame 1 and frame 10.

The other point to remember is the background color. As part of your website design, you should have already decided upon a background color. You can choose your background color to match whatever background color you are going to use in your web page by going to the menu Rendering > Environment > Background Color. The next section will explain why this is a good idea.

Bitmap graphic formats

There are three graphic formats used on the Web, each with different properties and pros and cons. They are the graphics interchange format (GIF), pronounced like 'gift', but without the 't'; the joint photographic experts group (JPEG), pronounced 'jay-peg' and the portable network graphic (PNG), pronounced 'ping'.

GIF

GIF files have been around since the beginning of the Web and have a simple form of compression that means that if the images have large areas of plain color, then they will compress to quite a small size. The main issue with GIFs is that they can only be made out of 256 colors at the most, not full color (16 million). They can be less (in powers of two, like 4, 8, 16, 32, etc.), which helps the overall file size. Generally it is not usual to use GIFs for photographic images, as they can look poor quality and have a very large file size. They are more commonly used for graphic styles like cartoon.

There are a few versions of GIF files that allow other features. You can select a color to be invisible, usually the background, which can be handy for placing your buttons and images over backgrounds of different colors. Another version is the animated GIF, which as the name describes allows you to have multiple frames in a graphic. However, you should be wary of using this for large animations as there is no inter-frame compression, so a GIF with 100 frames in is the same as loading 100 images just for one object, which could take a long time on a normal modem if the graphic is large.

JPEG

The JPEG is the choice format for photographic or highly detailed and colorful imagery. It uses a variable compression technique, meaning that the

image quality is affected when severely compressed. However, you have the choice of varying the amount of compression you want, often specified by image quality (low, medium or high) or by a numerical scale (0–100 or 0–10). In brief, the higher the value, the larger the image, the lower the smaller. I tend to find a compromise between size and quality at medium compression (5 or 50).

JPEGs do not have the option for background transparency so your background needs to match the web page background.

JPEGs can be progressive, which means that they load in three or so phases, the first being very low resolution, the last being the final resolution. This means that users can get an idea of what the image looks like before its completely loading up, as opposed to appearing normally from the top downward.

PNG

PNGs are an improvement on the GIF standard; they use a similar method for compression. However, they are not restricted by the color depth and can be full color. Another great advantage is that they can contain an alpha channel. This is like an extra color layer to the red, green and blue that make up the images. The alpha channel is 256 shades of transparency, which means that your graphics can have clear backgrounds, smooth edges (anti-aliasing) or semi-transparent areas. Although GIF can have a clear background, the edges can look pixilated or blocky, but having anti-aliased edges is the perfect solution (Figure 1.13).

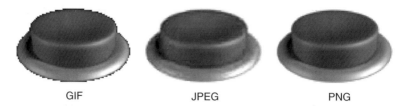

GIF JPEG PNG

Figure 1.13 Enlarged view of a button saved as GIF format (with clear background) on the left, as low quality JPEG (with a white background) in the center, and as a PNG (with alpha-transparency) on the right

With our particular images, the quality of the inner part of the image is not particularly affected between the GIF and the PNG, but the edge is significantly different. As a higher quality JPEG, the compression would be barely noticeable, but of course you have to be certain of your background.

The major problem with the PNG format is not one of quality but one of browser support. The most popular Web browser, Microsoft Internet Explorer does not fully support PNGs. This means that they will display on your page, but the alpha transparency is not supported, i.e. the best thing about PNGs. Hopefully one day this will be rectified. There are methods for getting round this, involving javascript, but they are relatively complicated compared to the issue being solved by Microsoft.

Get your button on the Web

Okay, you have been very patient whilst reading through all the different graphics issues, now to make our two images into a button.

For the purpose of this exercise we will be using Macromedia Dreamweaver MX. The Dreamweaver program is very popular amongst Web designers and is relatively easy to understand. If you have not used it before then I suggest you practice by running through some of the tutorials supplied with the program. At this stage we will not be delving deeply into it. There are plenty of other web page authoring programs that you could use, and you can even assemble web pages online. To do this you would need to get some web space.

Getting some web space

There are various companies on the Web that offer free web space, in return for displaying advertisements on your page. You can search for these on the Web and you will often find that they will have an option to build your own website using pre-defined templates. It is also possible to upload your graphics into them and create links. From a skills and flexibility point of view though, it is going to be better for you to learn to use a proper authoring program, like Dreamweaver, in combination with your web space.

Note *Uploading means sending files to a remote computer, as opposed to downloading, which means receiving files from a remote computer.*

If you have got some free web space, then you will be given an address that will be yours to upload web pages and graphics to. If you use a web page authoring program then you will upload your files via file transfer protocol (FTP). The Web Host company should tell you what your FTP address will be in their instructions. You will put this information into Dreamweaver, along with your password, when you set up a site.

You might have web space provided with your Internet service provider (ISP). As with free web space, you should be able to find out from them what your FTP address will be. It is likely that your password will be the same as the one used every time you log on to the Internet. Often an FTP address is on the lines of ftp.ispcompanyname.com, and you would be required to use your Internet log on name and password to access your web space. Your resulting web page address might be www.ispcompanyname.com/yourname/.

Note	*Web space refers to having an amount of data area on a hard drive of an ISP's computer, known as a server. Often this is a reserved space for you and might be 5, 10, 50 megabytes of data or more. How much space you need depends on how big your web pages are; with graphics generally taking up the most space. A small site with a dozen or so pages should easily fit into 5 megabytes of web space. You always want to try and make your websites as small in data size as possible, as people have to download your pages and you do not want them to have to wait ages for this to happen.*

Domain name

If you want to have a more personalized address for your website then you could register your own domain name, e.g. www.yourname.com or www.yourname.net. There are lots of companies that sell web space (without advertising) and you can usually register a domain name at the same time. Another option you have is just to register a domain name through a company that will link it to your current web space. This can save you money if you already have free space and is a process known as 'Web forwarding.'

There are many extensions you can have to finish your domain name with, e.g. .com, .org, .net, .tv, .info, .co.uk. The first few are general, but Web addresses often end with letters representing different countries. It is up to you what type of address you get, as long as no one else is using it, but they are often priced at different rates. You can own a domain name for a minimum of one year (two years for .info), but you always have the first rights to renew you ownership of the name.

Setting up a website

We are going to create a rollover button in a web page, but before you start this, you need to make sure you have set up your website via Site>New Site menu of Dreamweaver. It is here that you will enter all your details. If you

select the Basic tab, you will be asked to specify a site title and your local file directory and then how you want to connect. Select FTP and then enter your FTP address. You may not need to use a remote folder as your name and password might direct you straight to your folder. It should create a page called 'index.htm', this is always the initial page of a directory in a website, the home page. If you were to type in a domain name in a browser, e.g. www.3dfortheWeb.info, then the page it actually opens up is www.3dfortheWeb.info/index.htm. Once you have set up your site then you have created a web page, so it is time to create your rollover button from your rendered graphics.

Creating the rollover

First of all, set the background color of your page to white, or whatever color you have decided on, by selecting the Modify > Page Properties menu and changing the background color.

Now select the Insert > Interactive Images > Rollover Image menu and find your two button images. If you have not done so already then you'll be prompted to save them inside a folder within your website. It is usual practice to have an Images folder where you keep all your images (Figure 1.14).

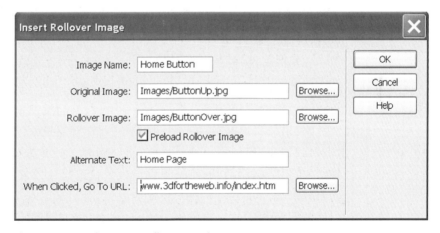

Figure 1.14 The Insert Rollover window in Dreamweaver

You will see from Figure 1.14 that you can name the button and type in the page that the button will link to. The Alternate Text is used by text only browsers but is particularly important for people with visual disabilities as this text can be read by text-to-speech software.

Press 'OK' when you have filled it all in and preview your page in your Web browser (F12 in Dreamweaver). You will see you have a fully working

button with a rollover effect. You can insert more buttons or even copy and paste this one, changing the links to make them point to different pages.

Well done, you have created your first rollover button. To make it more interesting, you could add sound or add more animation, but rollovers with JPEGs only allow for two states and no sound. To get sound and animation into your button you need to use Macromedia Flash MX. Here you can easily create animated buttons from rendered image sequences and add sounds. You can also have many more rollover states like Rollout, Press and Release.

Creating a Flash button

Macromedia Flash is by far the most popular plug-in for Internet browsers. Approximately 97% of all Internet users have the Flash plug-in. This is good news, because Flash is a much more powerful way to create your sites than using HTML. You will note that we did not actually have to do any coding to create a button in Dreamweaver, it created the code for us. As with Dreamweaver I am going to assume that you have made yourself familiar with the Flash interface and gone through at least some of the tutorials. We are going to jump straight into creating an animated button from the animation that we have already created.

First of all go back into your 3D program and render four frames, from the point where the button is up to when it is down. This should be frames 5 to 8, but might vary if you did not follow the tutorial strictly. You need to set the file type to be PNG 24-bit this time, at a resolution of 100 wide and 60 high. From now we will always output as PNG when we are going to put our files into Flash. Flash utilizes the alpha transparency layer which will become very useful in later chapters.

You will notice that when you output these four images they will have been automatically numbered with an extension 0005, 0006, 0007, 0008, etc. This is very useful as Flash will recognize these as a sequence and if we are importing hundreds of frames we will save a lot of time.

Now load up Flash and open the Modify > Document Properties menu (Figure 1.15). Change the size to match our graphic: 100 pixels wide and 60 pixels high. Because our button has a transparent background you can set the background color to anything you like. I have selected white as this matches the rest of the 3D for the Web website. If you set the frame rate to 30 frames per second (fps), from the standard 12 fps then your button will move nice and smoothly. We will talk about frame rates in Chapter 2, as they have an effect on file size and downloading time.

Figure 1.15 The Flash Document Properties window

Now you have set up your document we need to create a button, this is done by creating what Flash calls 'symbols'. Symbols are a way to use the same graphic many times without have to reload a copy of it. Select the Insert > New Symbol menu (Figure 1.16). Type in a name, like '3D Button' and select the Button option, then press OK.

Figure 1.16 The Create New Symbol window

You will see that you have been put inside the button symbol. The timeline has changed from showing normal frames to showing four button states, Up, Over, Down and Hit (Figure 1.17).

What we want to achieve is the animation that we had in our 3D program, i.e. when we place the mouse over the button it smoothly presses down and when we move the mouse out it smoothly goes back up. I will add at this point that you do not have to do this; you might want the button to go down when you press down on it, the 'Down' option. This is entirely up to you, but for the purposes of this demonstration, R-click in the timeline on the 'Over'

Figure 1.17 Inside a button symbol

frame and select Insert Keyframe, or choose the Insert > Keyframe menu after clicking into that frame (Figure 1.18).

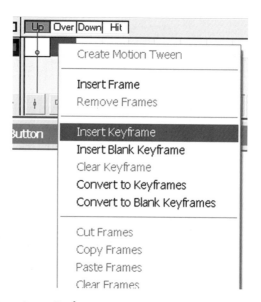

Figure 1.18 Inserting a Keyframe

Now we have created a new Keyframe we need to add another symbol into that frame. Make sure the frame is highlighted and select Insert > New Symbol menu. This time we want to create a Movie Clip instead of a button so select that option. A Movie Clip is a series of frames, such as an animation; these can be labeled and called in Flash's Action Script language. Give it a name like 'Button Down' and press 'OK'. You will see that you have been put back into a normal timeline. What you have to remember is that we are inside our Button Down symbol, which is going to be inside our 3D Button symbol, which will be in the main timeline. It is a hierarchical thing, you see.

Go to the File > Import menu and double-click your first picture, 'Button0005.png' or whatever you called it, once you have found the folder that the file is in. Flash will realize that it is part of an image sequence, so select 'Yes' when prompted by the image sequence question. This will load in the four files into your timeline. If you press Return or Enter on the keyboard you will see the button animate.

Now when this is exported as a Flash .swf file, this animation will play and continuously loop. So we are going to make this stop happening, by doing a small bit of coding! There is nothing to type though, just pressing things.

R-click on the last frame in the timeline and select Actions. This should bring up the Actions – Frame window on the screen. Click once on Movie Control and then double-click on stop. This will make the play head stop in the animation when it reaches this point. That is all the coding you need to do for this bit! (Figure 1.19).

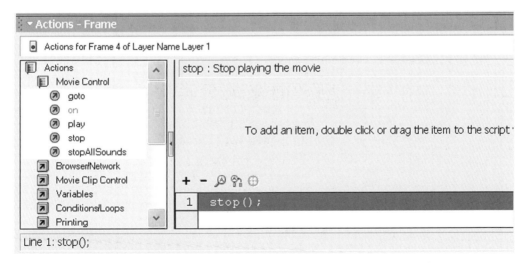

Figure 1.19 Frame Actions window

We have created the Over state of our button, but now we need to show what happens when the mouse is not over the button. We need to create another Movie Clip symbol, via the Insert > New Symbol menu, calling it 'Button Up'. This time instead of importing the bitmap files, we are going to use the ones we have already imported. To find them go to Window > Library menu option. This brings up a list of all the symbols and graphics we have so far, including our four bitmap images (Figure 1.20).

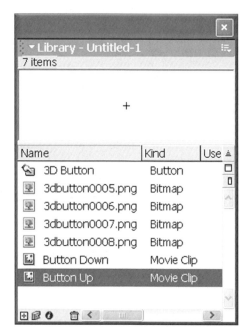

Figure 1.20 Library palette

We are going to drag three of these images into our page, but before we do this we need to create three Keyframes on the timeline. Click in frame 2 and select Insert > Keyframe, and repeat it for frame 3. This Movie Clip is going to be the reverse of the button going down, but we do not need all the 'down' pictures. If the reason is not clear, then carry on and hopefully you will see what is going on. Click into frame 1 on the timeline and then drag your second-to-last bitmap file (3Dbutton0007.png) onto the page. Zoom in using the Zoom tool (magnifying glass) so that your image is nice and big. Select the Snap to Pixels option from the view menu, this will help you align the image. Now position the picture so that the box's top-left corner fits just inside the little cross in the middle of the page. Then select frame 2 and drag and position picture 0006 and finally put picture 0005 in frame three. If you have done this right then when you play the animation the button will not move about, otherwise you will need to adjust the positions, using the cursor keys to nudge them (Figure 1.21).

Figure 1.21 Positioning the 3D button

When you are happy you have got the positions correct, click on the last frame and insert a stop command in action script, as you did before. When you have done that double-click on the '3D Button' button in the Library palette. This will take you back to the button timeline. Now select the first frame and drag your 'Button Up' symbol onto page and position it in the same way as before, with top-left of the box aligning with the cross. Select the Over frame and drag and align the 'Button Down' symbol. That's our button symbol created.

Giving the button a sound

We will now introduce a simple sound to our button, to enhance the tactile nature of it. Select the menu Window – Common Libraries > Sound; this brings up a choice of default sounds. You can insert your own sounds, by importing them first. To use a library sound, click on the 'Over' frame and then find the plastic button sound and drag it onto the graphic on the page. This applies the sound which will play when you rollover the button.

The only task remaining now in Flash is to use the button. Press on Scene 1 to get you back to the main page and drag your 3D Button symbol onto it,

aligning so that it fits neatly. You can now test the button by selecting the Control > Test Movie menu. You should see that it moves down when you rollover and moves back up when you rollout. Close down the test window and select File > Export Movie to save your Flash Player button. You can leave all the export settings that appear as they are and press OK.

Now to see the button in action. Go back to Dreamweaver and load up your index page. Delete some or all of your old buttons if you wish and select the Insert > Media > Flash menu. If you select the Flash graphic that appears, the Properties window should be visible. If not then you can show it from the Window menu. In the Properties window there is a space labeled 'src'. You can type in the address of your link in this space, so your button will link successfully. Finally preview your finished Flash button in your browser (F12) or upload it to your Internet host.

Exercise: making the turtle button

Let us build on what we have learned to make a turtle button. This little chap will pop out of his shell when the mouse hovers over him, and when the mouse is clicked, turn into road kill.

What to do

The turtle is pretty easy to build using the Sub-Object mode. It also introduces a few ideas about Materials in 3D. Like so many 3D objects we will start by creating a Box. Create a Box with four segments in every direction.

Note	*We could build the turtle from half a sphere but there are three things I wish to demonstrate by modeling from a box. Firstly that by good manipulation at Sub-Object mode, round objects can be created, secondly that the topology of your finished mesh can be crucial for materials, and thirdly it is good practice to keep the polygon count down, and the pole of a sphere has far too many polygons for our needs.*

Convert your box to an Editable Mesh and choose Vertex Selection. The vertices will light up blue. By marquee-selecting vertices, we are going to start creating the turtle shell. In front or side view, select the top layer of vertices and use the Scale tool to pull them together. Now use the top view to bring in the corners to something more like an egg shape. Keep moving the vertices till you have a good-looking hemisphere (Figure 1.22).

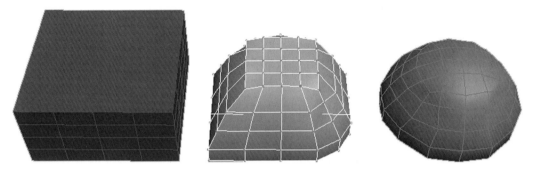

Figure 1.22 Making a turtle shell from a box

Top Tip

This is a great tip for smoothing low polygonal meshes. Select polygon in Sub-Object mode and either 'Control + A', or marquee-select them all, so they all turn red. Scroll down to the very bottom of the R-hand menu to Surface Properties and a box called Auto Smooth. The default for Auto Smooth is 45, but it can be cranked up to 180. Type in 180 and hit the Auto Smooth button, the shell will become rounded and smoother, without adding any more polygons.

Now we will pull up the bottom of the hemisphere to create a shell for the turtle. Select the whole bottom layer of vertices from a side view, and use the Scale tool to bring them closer together, now pull these vertices up to create a rounded lip to the shell. Tweak up some vertices to create room for head, legs and tail (Figure 1.23).

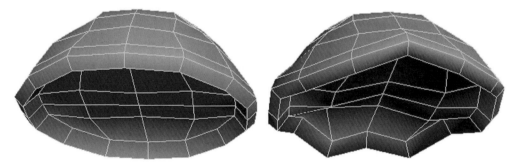

Figure 1.23 The finished shell with gaps for the turtle's body

To make the head, again start with a box, this time with height and width segments of 2 × 2, and with five segments along the length. Once again, tweak the vertices to make a simple head shape. To make the legs, duplicate

the head by Shift + Moving it. Use the Uniform Scale tool to resize this suit-ably to serve as a leg, and then duplicate it three further times. Position the legs and the head under the shell and make a tail from a cone with eight sides and two height segments. Put the tail in place too (Figure 1.24).

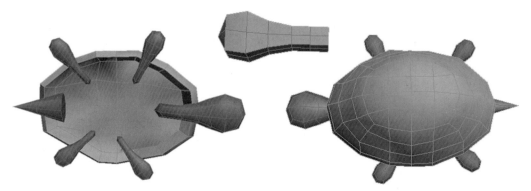

Figure 1.24 Positioning the turtle's body

To create the mouth, we need to use the edge selection in Sub-Object mode. Select the head and in edge selection choose the four edges around where the mouth will be. In Edit Geometry in the R-hand menu, select Chamfer and crank it up a few increments. Each edge will divide into two parallel edges, creating a new polygon between them. Switch to polygon selection, and select all the new polygons (there will be four and the two new triangular faces at the corner vertices). Click on Extrude in Edit Geometry. To pull the polygons backwards, you must use a negative amount. Keep the polygons selected and use the Non-Uniform Scale tool to pull them inside the head. (*Hint*: Pressing the space bar locks and unlocks your selection) (Figure 1.25).

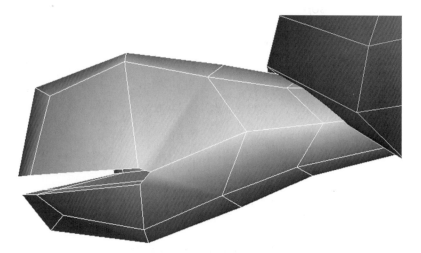

Figure 1.25 The turtle's mouth

Now the turtle is looking pretty good, but it needs eyes and a tongue. For a tongue make a slim box and move the vertices to a good rounded tongue shape, pop it in the turtle's mouth. Make one eyeball from a sphere with 12 segments. We will duplicate this to make the other eye, but before we do that, we will use another great material tool, the Multi/Sub-Object Material.

Open the Material Editor and select a sample slot, click on Diffuse and set the material to a white or off-white shade, these will be our eyeballs. At the top right of this material's parameters is a box labeled Standard, click on this and a Material/Map Browser will pop up. Select Multi/Sub-Object and a Replace Material box will appear. We want to keep our basic white as a Sub-Material, click 'OK' and you will see a number of material option slots have appeared. The default is 10, but you can have as many or as few as you like. The Multi/Sub-Object Material is represented by colored segments on the sample sphere. Choose another sample slot and make it black (for the pupils). Drag and drop that onto the second material slot in the Multi/Sub-Object Material (Figure 1.26).

To translate the material appropriately to the eyeball you have made, select your eyeball and convert it to an Editable Mesh. Choose polygon selection and select all of the polygons, scroll down to the bottom of the R-hand menu to Surface Properties and under Material ID, type 1 to correspond to the white material slot number. Now select the polygons at the top segment and turn the material ID up to 2 for the black pupil. Leave Sub-Object mode and assign your Multi/Sub-Object Material to the sphere. The white will be assigned just to those polygons that you selected and gave the ID 1, and the black will be assigned just to the polygons given the ID 2.

Note *Multi/Sub-Object Materials can be crucial in exporting things with sophisticated materials to Shockwave 3D, and we will be covering that later in the book. Multi/Sub-Object Materials are one of the few supported material types alongside standard Blinn shaders that will export properly. This is one reason why some thought must be given to the underlying mesh of anything you build for export. The polygons must be positioned to enable a Multi/Sub-Object Material to be assigned correctly.*

Now duplicate your eyeball (Shift + Move) to make a copy and position both eyes on the head.

Next we will apply a material to the turtle using a Bump map and UVW mapping. Materials can only be fitted for export to the Web using UVW mapping.

I made a Bump map of a tortoise shell spiral in Photoshop, saved it as a .jpg. A Bump map is typically a gray-scale image that simulates mesh displacement

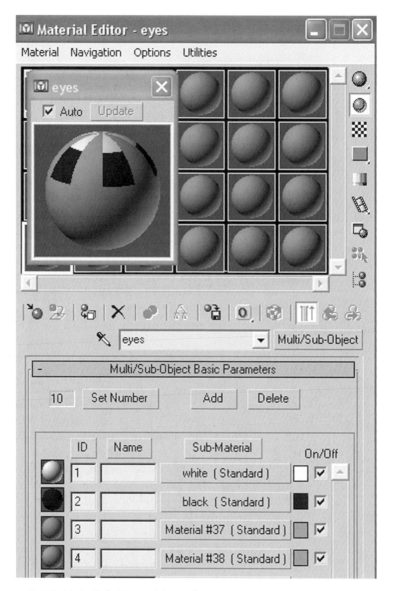

Figure 1.26 Multi/Sub-Object Material

without changing the mesh. When you render an object with a Bump-mapped material, the impression is given of white areas protruding, and black areas receding.

To bring your map into the Material Editor, select a sample slot, and change the basic material to green, then scroll down to the Maps Roll Out. double-click on the 'None' button by Bump map and select bitmap from the Material/Map Browser. You can now browse for your .jpg bitmap. Open it in the Bump map slot, and crank up the Amount to almost as high as it can go.

You should see it changing in the sample slot. (*Hint*: Double-clicking on a sample slot brings it up in a larger window for inspection) (Figure 1.27).

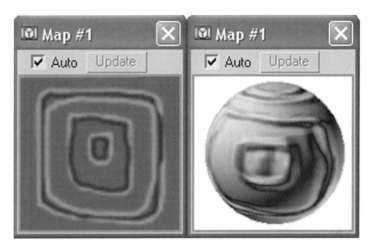

Figure 1.27 Grayscale Bump map. Bump map applied as a material

We want to assign this material to the turtle, to give it an interesting shell. We will do this by combining our knowledge of Multi/Sub-Object Materials with a UVW map. Scroll down the Modifier List and add UVW map to the shell's stack. The UVW map modifier controls how materials appear on the surface of an object by applying mapping coordinates to an object. These coordinates specify how bitmaps are projected onto an object. The UVW coordinate system is similar to the XYZ coordinate system. The U and V axes of a bitmap correspond to the X and Y axes. The W-axis, which corresponds to the Z-axis, is rarely used. Under Parameters for UVW mapping, you will see different ways of fitting your map onto your selected object. In this case, we are going to select Face. This will assign our material to each polygon in our object's structure. (If we had visible edges between the pairs of faces that make up a polygon, the material would be assigned to each triangular face.) Select Face, and assign the turtle-shell material to it. (You will not be able to view the effect of the Bump map unless you render.) You can see how important it is that the underlying mesh works for this technique. A Sphere would have given us the wrong topology.

There is still one more thing to do to make the shell look good; anyone who has kept a turtle knows that whilst the top of the shell is ridged, the bottom of the shell is lighter in color and smoother. Select a new slot in your Material Editor and make a suitable material for the underside of the turtle shell. Go back to the original green material and Click on Standard to bring up the Material Browser. Make this material a Multi/Sub-Object Material just as you did for the eyes, keeping your shell material as a Sub-Material. Drag and drop the under-shell material into the second Sub-Material slot.

Enter Sub-Object mode, select all the polygons in the shell and give them an ID of 1. Now select the polygons on the underside of the turtle. Give them an ID of 2, and the underside will take on the correct material. Choose a nice color or material for the legs, tail and head, and color the tongue in.

It is good practice to label each part of your finished model, as it is hard to identify one box from another, later on. You can re-label any mesh by highlighting the text and typing in a new label (Figure 1.28).

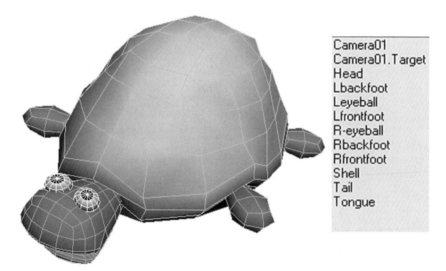

Camera01
Camera01.Target
Head
Lbackfoot
Leyeball
Lfrontfoot
R-eyeball
Rbackfoot
Rfrontfoot
Shell
Tail
Tongue

Figure 1.28 Finished turtle and list of scene contents

Your turtle is finished and just needs animating. In this case we will stay with the default lighting, to keep the turtle looking cartoony and child-friendly.

How to animate a turtle button

For the purposes of creating the simplest button animation, we will need to have our turtle in three states: dormant in his shell, out ready for action and squashed. Now is a good time to set up a camera, as we want to 'lock off' the scene so it will animate smoothly when the three stills are put onto the Web, and unlike the button, we will probably need to use the perspective viewport to animate.

Click on Create > Camera. You will see there are two sorts, Free and Target. Select the Target Camera as they allow you more control as you can position the camera and the target. Click and drag in the top viewport to create a camera and its target. Obviously the target needs to be on your turtle, but

you can position your camera anywhere that gives a nice angle on your subject. (*Hint*: If you click in a viewport and type 'c' it will become a viewport of the camera. Typing 'p' will return you to perspective.)

Although most of our turtle can be animated freely, just as the button, there is one thing we should do to ensure that the eyeballs stay with the head. In the top tool bar there is tool called 'Select and Link' (Figure 1.29).

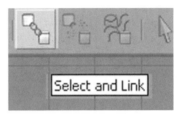

Figure 1.29 The Select and Link tool in 3D Studio Max

Click on it and pick an eyeball. Link it to the turtle's head by dragging the line and clicking on the head. Do the same to the other eyeball. Now if you Move, Rotate or Scale the head, the eyeballs will inherit the same parameters.

Note *By linking one object to another, you create a parent–child relationship, or hierarchy. Transformations applied to the parent are also transmitted to the child object. By linking more objects to both parent and child objects, you can create complex hierarchies. Chains can be created to include ancestors (parents' parents) and descendants (children's children). All complex animation uses the same technique. It is a way of animating called Forward Kinematics.*

We need three states for our turtle, and currently it should be in a good position for the second state, apart from the tongue. So turn on the Auto Key and let us start animating. Move the slider to frame 15 and position the tongue inside the shell. Click on each leg, in turn and under Motion, Click on Position to create a Key. Do the same for the tail. Create a Position key for the tongue hidden inside the body. Now go to frame 20 and create a head Position and Rotation key. When you choose the eyeballs create Position, Rotation and Scale keys at frame 20, and click on the shell and create a Scale key.

Put the time slider at frame 0. In the top viewport, slide all the limbs and the tail back into the turtle's shell, so none can be seen. Do the same to the head – the eyeballs will go with it. Because Auto Key is still on, you have now created your first two button states.

Now move the time slider to frame 30. We are going to make that turtle road kill! Pull out the legs, tail and head a bit more. Slide the tongue into the mouth. Rotate the eyeballs inwards to make the turtle cross-eyed, and use Uniform Scale to make one larger and more popped out. For the crumpled shell, stay in Auto Key and with the shell selected at the Editable Mesh stage, go to Sub-Object mode > vertices. Make sure that 'Ignore Backfacing' is checked and also 'Soft Selection'. Select the six or so vertices at the top of the shell. (*Hint*: pressing Control adds vertices to a selection and pressing Alt takes them away without losing those you have already chosen.) Adjust the slider in Soft Selection so that its range picks up the surrounding vertices (they will turn orange/yellow). In a side view pull the selected vertices down to create a dip in the turtle's shell.

Now by rendering frames 0, 20 and 30 you have created your three button states for export and Dreamweaver (Figure 1.30).

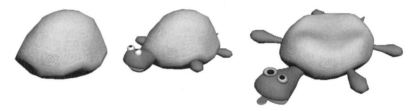

Figure 1.30 The finished three states for Dreamweaver

If we want to render the whole animation to get in-betweens and a smoother animation to export as a series of PNGs, we will have to refine this animation a bit. The PNGs get converted to JPGs in Flash, but we might want to keep the alpha transparency at the moment.

Note	*Because I come from a traditional animation background, I think of animation at the 16 mm filmic rate of 24 fps, or PAL rate (25 fps) or NTSC (30 fps). At 24 fps each 100 frames is roughly equal to 4 seconds. Later on in the book we will be talking about cutting down on file sizes, which will mean reducing the frame rate.*

Because 3D animation data are represented by Bezier curves, unless we control the Keyframes, the animation will float from one Keyframe to the next. Fortunately there are some easy tools to control this. Select a leg from the turtle. You should have created 3 Keyframes at 0, 15 and 30. Take the middle Keyframe at 15 and slide it back to frame 10. Use the Key Mode toggle to make sure you are on the Keyframe and click the Motion button, so you can view the PRS Parameters in the R-hand menu. Under Position and Key Info (basic) you will see two Bezier tangents. These have rollouts to different Key controllers, each representing graph lines of movement (Figure 1.31).

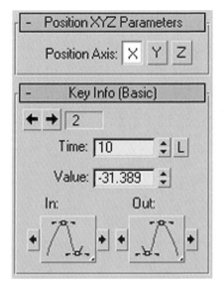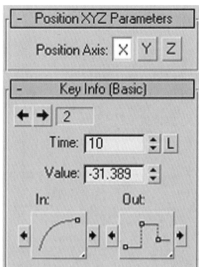

Figure 1.31 Keyframe Controllers > Position Keys. Default and with applied controllers

The default is always Bezier, but for this particular Keyframe we want the leg to ease in to a hold (Step).

Top Tip

These Keyframe controllers can seem very confusing to someone new to animation. The simplest way to look at it is: The more vertical a graph line is; the faster the movement. And the more horizontal; the slower the movement. So a horizontal line is a hold, and a vertical line represents a sudden transition from one frame to the next.

Duplicate this key by Shift-moving it and drag the new key to frame 20. Change the Controllers to Step and Linear. That means the leg will hold its position until frame 20, then speed into the next key (Figure 1.32).

Now play your animation again and you will see that the leg you have controlled will have a much more realistic feel to its motion. Do the same to all the other limbs and the tail. In my animation, I have staggered the legs coming out, so that there is a gap of two frames as they emerge. It is often effective to stagger motion in this way, as we seldom move synchronistically.

The main point here is to add a Keyframes to give holds to animation and use the controllers to give it snap and realism. I added in some more Rotation Keyframes to the head to make it scoop out of the shell and give the

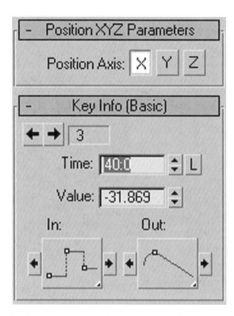

Figure 1.32 Applied controllers for the new key at frame 20

eyeballs room. You can view the finished animation on the website and the file is on the CD.

| Note | *The Rotation and Scale keys have the same controllers in Max 5. All programs have some way of controlling the animation, and it is impossible to avoid using some sort of control if you want to achieve good movement. Later tutorials in this book will take you a bit deeper into how to control animation. Animation is a massive subject, and I am only skimming the surface here with some basic skills. All animation is a matter of timing and observation; there are many excellent books on the subject if you are interested in honing your skills.* |

Render your finished animation at a size of 120 pixels wide and 100 pixels high, position the turtle to fill up the screen by adjusting the Camera that you previously created. Save the image sequences as PNGs.

Converting our turtle into an animated button

We have already made an animated button in Flash, this time we are going to use a slightly different method to achieve the same result. The reason for

this is to make a better introduction to Action Scripting. The more complicated the interactivity is going to be, the more you will have to do some scripting, it is unavoidable, but very useful. Hopefully you will find this method simpler than the previous one.

In Flash, create a New Symbol, a Movie Clip (not a button) and name it 'turtle button'. You will jump straight into it on the timeline. Then import all of the frames that we created as PNGs in our 3D package. You just need to double-click on the first one for you to be prompted to import the range. You might need to import the second range of frames separately if the numbers did not run on consecutively. Now the frames are in, create stop commands on the first, 'middle' and last frames. If you cannot remember, click on the frame, get the Action window up, select Actions > Movie Control and double-click on Stop. The middle frame refers to the frame where the turtle's head has popped out and settled down, not the middle of the time line.

Whilst we are inside the turtle button symbol, we can add some sounds. I am going to use two sounds, a whistle sound when he pops out and a raspberry sound when he is pressed. Import these two sounds (or your own). And then position them on frame 2 and the frame after the 'middle' frame, by clicking on the frame and selecting the sound in the Properties window (Figure 1.33).

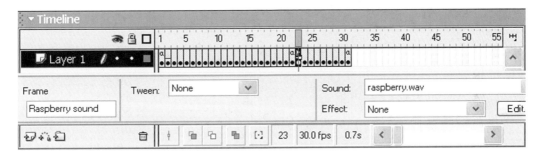

Figure 1.33 Inserting a sound into the timeline

Once you have inserted the sounds you want, click back on Scene 1. You will see that there is no button on the page. We need to get the Library palette up and drag an instance of our turtle button onto the page. Also set the Document Properties to match the size of the rendered image size. In our case 120 wide by 100 high. When you have dragged it on, you will see in the Properties window that there is an opportunity to name the instance. Give it an individual name as this is good practice particularly if you use the button several times, but want to link it to different pages.

Now for the scripting bit. R-click on the turtle and bring up the Action window. Click on Actions > Movie Control and double-click the 'On' command. You

will see a list of options appear with the Release option checked, uncheck it and check Roll Over. Then double-click on Play, this will insert in under the text in the script window. This will start your animation when the mouse rolls over the turtle.

Click on line 3 and then double-click the On command. Uncheck the Release option and check the Press option, then double-click the Goto option. Make sure Goto and Play is checked and change the frame number to 23 (the frame after the 'middle' frame). This will make sure that the turtle will squash, no matter what the state of the animation is.

Click on line 6 and double-click the On command. Uncheck the Release option and check the Roll Out option. Double-click the Goto option. Make sure Goto and Stop is checked and make sure the frame number is at 1. This will reset the animation when the mouse leaves the button. Figure 1.34 shows you the end result of this piece of programming. You can now test the button to see it move when you rollover and squash when you press on it.

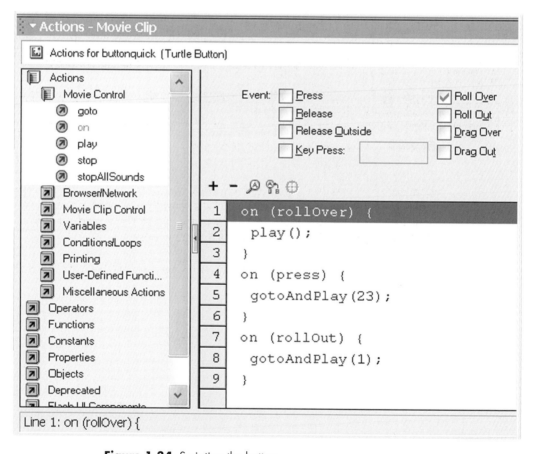

Figure 1.34 Scripting the button

In our previous attempt at creating a button we made it into a link using Dreamweaver. This time we will do it in Flash. Make sure you are clicked on line 9. Double-click the On command as before, but leave the Release option checked. Now click on Browser/Network, below the Movie Control command, you will see a command called getURL. Double-click getURL and type in the address of the page you want to link to, e.g. http://www.3dfortheWeb.info. You can select below that, whether you want it to replace the current window (_self) or create a new window (_blank) to place the page in (Figure 1.35).

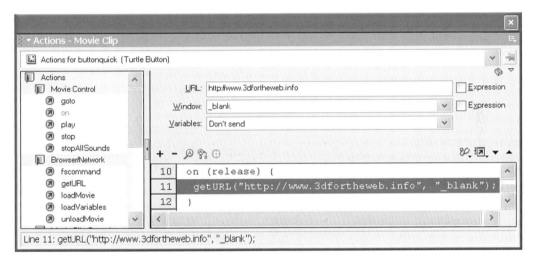

Figure 1.35 Making the button into a hyperlink

And that's it, when you import your file in Dreamweaver you do not need to make it into a link as it is already one. Of course this might not prove to be your preferred method, but if your site is entirely in Flash, and not just a Flash button, then this is the obvious method to choose.

That's it for the turtle as a button, but do not worry, he will be back in later chapters.

Interview with Mach-Parat

http://www.mach-parat.de

Company profile

Mach-Parat is a young, innovative German company that specializes in Flash-based games. They started in August 2002, and had already won the games category at the Online Flash Film Festival OFFF03 in Barcelona less than a year later. Mach-Parat's team consists of Volker Neumann, Jan-Philipp Behrens and Sebastian Deimann.

I first encountered Mach-Parat through their very different looking 'In the Woods' game and have had opportunity to enjoy their clever ideas in games and viral marketing ever since, including their rather wonderful Easter idea for self promotion, The Pixel Egg, which is as a very elegant piece of viral marketing.

Welcome to mach parat´s pixelegg.

This application allows you to color pixel in a matrix. The matrix will be mapped on an egg. Your aim should be to give the egg a face. If the face is finished press the convert-and-send-button. Your artwork will be converted on the fly to the jpg-format and sent to your friend. Of course you will find a copy of the egg in your mail box. Use the cache button to store the current face in the buffer. To return to stored one press the revert button.

Have fun and do not miss to visit the gallery.

The mach parat team

instructions pixelegg gallery

Interview

This interview is with Jan-Philipp Behrens, one of the three permanent members of the company.

Can you describe the background to your company, its aims, ambitions, client base?

Volker Neumann and I met while we worked for a small design company and started some projects. We never had any ambition to work for a larger company and so we started our own business.

We always try to be innovative and look out for new challenges. We want to produce applications that are as attractive as possible. It is nice if a client is satisfied, but what satisfies us are e-mails from users saying that they like what we do. And last but not least we want to have fun while working.

Typically how many people would work on a project?

Most of the time all three of us are involved, although we do sometimes draw from a small pool of freelancers. There have been some jobs with only two people involved, but there is no meeting without all three of us, because communication is an important point of our work. There are a lot of cross-over skills between us, that does not mean that everyone is as good as the other, but it is important for our work that everybody knows what is possible to realize and what is not. We are not specialists, but generalists.

General design and 3D

How did you get started working in 3D Flash games?

It was the time when everybody was working with Flash and Freehand vector style. Vector illustrations were used on every magazine cover and in many TV commercials. That was the point we decided to start with 3D. It was learning by doing. We began to mix 3D style with vector style and what we got was a cute little surrounding that had much more toy appeal than all the others we did before. It was a toy world like LEGO or Playmobil that said, 'Play with me'. Especially for games, it is necessary to create such an attractive surrounding.

How do you come up with the different ideas for your games?

Some of the game ideas are influenced by our clients. The challenge here is to find the right game genre including a solid and convincing story and a graphic style that fits best to the company's corporate design. A helpful tool to come up with ideas and concepts is to build a large archive of different styles and game engines. Internet research helps a lot and it is useful to have a look at the games of the 1980s home computers like the Commodore C64. There are a lot of simple but addictive games waiting to be modified.

Good-looking 3D has an immediate appeal. Do you see it as the way forward in Web design, or just another tool?

3D is just another tool in Web design and at the moment a really strong one, because a new one. And sure it got advantages over the 2D applications on the Web, because it can create spaces which seem to be more realistic. The reason why 3D in the Web is getting bigger and bigger is the result of faster online connections. These allow everybody to be part of the 3D virtual reality. Faster connections are the gigantic step forward for the Web. They offer new ways to spread information. And 3D is one of those ways.

How important do you think interactivity is to your work?

Interactivity is the most important part of your productions. We are not really into linear movies and stories. Interactivity is what fills the user with

enthusiasm and what makes a product attractive. Little interactive gimmicks and small interactive tools have to be in all of our productions.

On average how long do you spend developing your games and how much of that time is pre-production?

The process of developing a game takes between 2 and 6 weeks, depending on the complexity. A serious pre-production takes at least 20% of the work.

How important is sound in your games and who handles that?

The sound is a very important part of a game for two reasons. On one hand it creates the atmosphere and on the other hand it gives a response to the player.

Every game takes place in a little virtual world. To make the world easy to understand you need to build a specific atmosphere. Is it a dangerous world or is it a friendly one. The atmospheric sound supports the story and the graphics.

And the other point is the response. A usual computer has no chance to give a haptic response, so the user often does not know if he has pressed a button already or not. That is the reason why most buttons play a specific sound when they are clicked. In games we have to handle the same problem. In a fast game the player often does not realize if he has collected an item already or not and he does not know how much time he has left to complete the level. The sound offers him the information he needs without breaking the game flow. Try to play a game and turn off the sound and you will see that it is more difficult to succeed.

The sound makes the little virtual world look more realistic, makes it easier to understand its rules and supports the feeling of being part of the game.

A lot of the sounds for our games are recorded and done by Sebastian Deimann.

What aspect of development would you say is the most time consuming?

The most time consuming part of the game development is the graphic and animation, in some cases it takes up to 50% of the whole process.

Your past and future work

Your games reflect a number of different graphic styles who/what are your influences?

We are influenced by a lot of things and people: Der Bauer, Star Wars, Rodney Mathews, C 64 and old video game consoles, Mad Magazin, John Maeda, Gorillaz Video, fairy tales, LEGO, Eboy, Lobo, Toy Story and Chalet.

Out of all the 3D Flash games you have created which was your most challenging, and why?

The most challenging 3D game we did is 'In the Woods'. Actually it was produced as an interactive greeting card for Christmas we send out to companies and friends. We did not want to do anything with Santa Clauses or red nosed reindeers and we came up with a story with little fairies.

The application shows a large old gnarled tree surrounded by glittering snow. Small lights are flying around the tree like fire flies and some of them are heading towards the 'camera' and you recognize that they are fairies. The User has got the possibility to take a short movie of the scenery and to watch it afterwards in 'Super 8' Movie style.

The challenge here was not the 3D elements themselves or the 'movie-engine' but to create a mystic, fascinating and realistic surrounding which was a mixture of different software exports.

If you work with a mixture of different graphic parts, e.g. Photoshop works, 3D modeling and Flash animations the challenge is to bring those parts together in the right way so that they fit. Often it takes a while to synchronize 3D elements and programming. For example, it took us hours and hours to synchronize the Flash-ants on the turning 3D trunk for the game 'Antburner'.

What awards have you won and have they made a difference?

We were nominated as a finalist at the Flash Forward Flash Film Festival in San Francisco in March 2003 and we have won the games category at Online Flash Film Festival OFFF03 in Barcelona in May 2003.

And yes, the awards made a difference. An award shows that your work is innovative. For some clients it is important to know what other clients you have worked for to see if you are serious. But that does not say anything about innovation. An award does. An award is a good argument to get commissions. It is nice to have the official award icons on our website. ☺

Why are your games so important to clients and their websites?

The production of online games is booming in contrast to all other Web productions. The main reasons are that a game makes a website more attractive and people do stay longer on the sites. The games are for free and offer fun, so that the player consumes the advertising for a product or a company of his own accord. On the radio or on TV people have no chance to decide if they want to hear or see commercials or not. Here they have and that has a good effect on the company appearance and builds up an emotional relationship between the player and the company. The possibility of recommending the game to another person with a 'Tell-A-Friend' function spreads out the game and company profits of the so-called viral marketing.

If you add up all these facts and compare it with the costs of other kinds of advertising the production of a Web game is very cheap.

Any special future projects using 3D?

A future project in a soccer game for a large sports Web portal in Germany. It will be again a mixture of different software exports. The characters will be 3D modeled and then animated in Poser.

The user can set his team strategy and challenge others via e-mail. We've already started on this project. Watch out for Microsoccer.

Technique

Why did you choose to use Flash?

Flash has got one big advantage over other software. The plug-in is small and widely used. That is an important fact for the clients, because they want people to enter their website without having to download anything before they can access it. This is although the reason why all our productions run in the Flash 5 Player.

What other software do you use for creating your games?

The main software we use is Photoshop, Cinema 4D, Poser and Swift 3D. Most of our games are done with them. Sometimes we use Freehand but Flash has got strong graphic tools too.

Were there any specific problems you had to overcome?

We have to take care of a small file size and good performance.

Does it vary from project to project?

Yes, one time the file size makes the problems and the other time it is the performance ☺. There is rarely a production without one of the two problems.

How much programming do you use and do you view it as an important skill for designers to have?

We do progam a lot, for us it is a very important skill. There is no interactivity without programming. The programming sometimes takes the half time of one job.

I think everybody who has anything to do with Web design should know what is possible on the Web and with which conditions. I am talking about the old story about graphic designers and programmers: The graphic designer asks if it is possible to launch the Web concept he made. And the programmer says that it is possible, because nearly everything is possible, but not with the small budget of the job. What I want to say is that it is an advantage when the skills cross-over, because Web design goes hand in hand with programming.

How does creating 3D games for the Web differ from creating standard commercial computer games?

One big difference is the file size. We do not want people to load more than 1 megabyte large games. Even if the connections are getting faster. One reason why Web games are so popular is that the users have to wait just a few seconds and then they can have fun, so it is important. The most difficult part of our work to find the right combination of small file size, good-looking graphics and a good performance.

In contrast to standard computer games an online game has to be low in complexity and simple to understand. The user should look at it the first time and immediately he should know the aim of the game and how to play it. Online games are made for the short fun during the day. Nobody wants to fool around with difficult key combinations or wants to read instructions that are longer than 20 lines.

How do you integrate 3D elements into your Flash games?

Most of the 3D elements are fake: short picture sequences, modeled and rendered with any 3D software often including alpha channel and imported into Flash.

The challenge is to combine all the different parts in Flash so that it looks natural. Does the light come from the right place, are the proportions okay and do all animations fit together like we wanted them to fit?

Insights

Which technology do you think will be the leader for 3D on the Web? (For example, Shockwave, Flash, Pulse 3D, Virtools, Anark)

In my opinion Flash is the leading one right now, because of the large spreading of the small size plug-in. Most of 3D elements on the Web are

done with Flash. But Flash has a very big disadvantage: It has nearly nothing to do with 3D. There is no 3D engine like Shockwave has got. To compete in the future 3D Web market Flash will need such an engine, otherwise Flash will be pseudo 3D software for ever, and will lose its big share of market.

In future I think Shockwave will be the leading technology for 3D on the Web. The spreading of its plug-in is making good progress. The Shockwave 3D engine is a strong tool. We already started to get into Director. I am looking forward to the first Mach-Parat Shockwave release.

Do you have any advice for students of 3D Web design?

Everything is possible. Look for the biggest challenge you can imagine for the specific production.

Work so long on one project till you hate it. One month after the project is finished you will love it.

And most of all have fun.

3D has almost taken over the games industry do you think it will become more predominant in Web games?

3D is growing on the Web. It is an enormous element of the so-called immersion (describes the phenomenon that people leave reality and dive into a virtual space). Immersion is the most important reason why 3D has overtaken the games industry.

Chapter 2

Interface design for 3D websites

Website issues

So far we have established how to make some buttons for your web page. Hopefully you have experimented and come up with some interesting buttons of your own, after all, it is your creativity that will make an impressive website. We have said that web pages are basically just buttons and information, whether that is text, pictures or audio. Of course, this is the basis of Internet communication, the idea of the hyperlink where pages of text are joined to other pages by means of an addressed link. The Web is a non-linear construction, unlike books, so when creating websites there need not always be a beginning, middle and end. Although you may have an initial page to your site, it is always possible for people to jump in at any point, thanks to the automatic trawling of search engines. This is one of unique things about the Web, it can be difficult to control the user's actions. In films and books, although you could skip back and forth, people are going to start at the beginning and work their way through to the end. In designing websites you have to be aware that people might join halfway through, so

you need to give them clear opportunities to work out what to do. This might be using an obvious button that allows people to go back to the beginning of the site. If you do not feel that they need to do this then you need to have a continuity of design throughout your site and an interface that is easy to understand and intuitive.

We will get on with a large practical exercise and then talk more about the interface and 3D representation towards the end of this chapter.

Creating a product-based 3D website

There are ways of using 3D on the Web where you can employ all the bells and whistles of your favorite 3D package. You can create some great 3D graphics or recreate realistic products. For the purposes of the next exercise, we have created a hypothetical product: MacHead's One Dose, soluble aspirin. We are going to use a variety of interesting graphics and animations that will help sell the product to the user and explain its purpose. The ideas are the main thing here, and you are unlikely to want to create the same sort of animations, so the explanations of the 3D work will be more general than before.

Let us imagine that we have been given a current product package. The challenge is to get this product across in a website using 3D to sell it. The product looks like Figure 2.1 and a single tablet like Figure 2.2.

Figure 2.1 MacHead's package design

Figure 2.2 The product

Before we do anything, it is important to think about the web page color and the color scheme in general. The actual package is designed in blue, white and gold. It makes sense to borrow the color scheme from the packaging, and use white as a background. White gives a nice, clean clinical feel, suitable for a medicine. First let us deal with the most obvious idea.

Exercise: a realistic approach to 3D

Recreate the product package and make a realistic simulation of the tablet dropping into a glass of water and dissolving, using 3D.

What to do

The product package was created from an Extended Primitive > Chamferbox. This is like an ordinary 3D box with chamfered edges. The reason for having chamfered edges is that no surface in real life has such sharp corners as your 3D program. Look around you now and you should see that table edges, book spines and the keys on your keyboard all catch a soft light at their edges. We want the package to look realistic, and so the edges need softening to mimic reality. Naturally the proportions of the chamferbox must match the proportions of the real packet. The graphic was made in *Photoshop*, but could be scanned from a real product (or for better resolution, digitally photographed) and saved as a TIFF file. It is important that you create a map that incorporates the top and side views of the package.

To bring the graphic into 3D Studio Max, open the Material Editor, choose a sample slot and click 'None' in the Maps Rollout next to Diffuse Color. Select bitmap from the pop-up menu and browse for your graphic. Your graphic will appear as a map at 100% in the Diffuse Channel. Select the Bump map channel, click on 'None' and select Noise. The Map Parameters will appear in the Material Editor. (*Hint*: You can travel up and down the layers of the Material Editor via the 'Show End Result' and 'Go to Parent' buttons (Figure 2.3).)

Figure 2.3 The Show End Result and Go to Parent buttons

Tile the noise map in all directions by a factor of 10. Click on 'Go to Parent' and take the Bump map amount down to 5. This should just take the edge off the graphic's crispness and imitate the cardboard quality of the real life box.

To apply the material to the chamferbox, add a UVW map to its modifier stack and fit the material as a Box map to a good position on the face of the box. Remember that you need to adjust the map to fit at the bottom right so the front of the box will look correct, but the edge faces will need work to make them fit. We will only see three sides of the box, so will ignore the back faces. Add a Mesh Select modifier from the Modifier List and select the side polygons and the small polygons created by the chamfer above it. Add another UVW map and open it out to use the Gizmo to fit the same map to the side (Figure 2.4). The selected faces will turn red and the Gizmo can be scaled, positioned and rotated just as any other object. Match the pattern

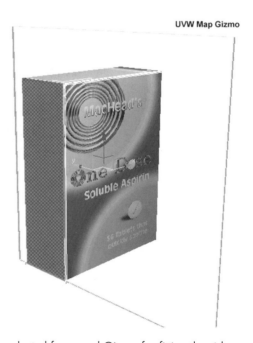

Figure 2.4 The selected faces and Gizmo for fitting the side map

so that it matches the front graphic, and then add another Mesh Select and UVW map to do the same for the top of the box (remembering to add the smaller polygons created by the chamfer to your selection).

This can be quite fiddly, but persevere; the box should now be seamlessly mapped to match the package.

Note	*Those of you who are lucky enough to have the most up-to-date software will have another modifier that could help in fitting materials: the Unwrap UVW modifier. We will be using this later on in the book.*

R-click at the top of the modifier stack and choose Collapse All. This will lock the UVW mapping. Save the package scene, and File > Reset to start a new scene.

Now we will create the rest of our realistic scene and the animation. (We will bring the box into this scene later.) The first thing to do is make a tablet. This is made from a mesh smoothed cylinder with a slot cut into it using Compound objects > Boolean. Booleans are operators used to subtract, intersect or add surfaces, in this case, a slim box with a 'V' at one end is subtracted from the cylinder (Figure 2.5).

Figure 2.5 Creating a channel in the tablet using Boolean

Materials for realistic simulation are very important. The tablet is white with a tiled noise map in the Bump map channel. This gives the tablet a slightly granular effect. There is no shine to the tablet as soluble pills have no sugar coating.

I have decided to keep the glass simple, as I do not want to detract from the tablet dissolving. There are any number of ways of modeling such a simple

glass. I have drawn half the glass as a spline, and used the Lathe modifier to bring it into three dimensions (Figure 2.6).

Figure 2.6 Using the Lathe modifier to create the glass

Meshsmooth the finished model twice, and Shift-Move to create a copy. Turn the copy into an Editable Mesh and eliminate the outside to create the water. Collapse the top layer of vertices and use the Uniform Scale to scale down the water a tiny amount so it will fit snugly into your glass.

There are several methods by which you can create the appearance of glass, the most realistic is to use the Raytrace material. Go to Rendering > Material Editor to bring up the materials if they are not already visible. Select a blank material and click the button that says Standard. Change it to Raytrace from the list then shown. Change the Diffuse Color to a pale blue. This will help the glass be seen against the white background, and is more for effect than reality. Also deselect the Transparency check box and then change the Transparency value to 95. This will make it almost completely transparent, but with a pale blue color.

Make sure the index of refraction value is set to 1.5, which roughly matches the amount that glass refracts light. Click the Reflect check box until it reads 'Fresnel', which mimics the reflection quality of glass. Still in the glass material, open the Raytracer controls panel and make sure that Raytraced reflection and refraction anti-aliaser to switched on. This will give a better quality result inside the reflections and refractions, as the pixels will be smoothed.

The material for the water is going to be pretty much the same as for the glass, but change the index of refraction to 1.33. As the water is thicker than the glass, it will have a much greater distortion even though it has a lower index of refraction.

Note *Using Raytrace does considerably slow down the rendering time of your animation, but it is worth it for the quality of result you get.*

With so many shiny, transparent surfaces, lighting is a crucial factor in making your scene look the way you want it. Make the environment (background) color white, to match with the white web page. This will allow the graphic to float cleanly on site. Keep on making test renders until you have the look you desire. I have added a plane as a floor and used a Matte/Shadow material on it so that the shadow will be visible, but the plane will not. This will help delineate the glass on the page. Position a camera in the scene to look at the glass and change the perspective viewport to that camera's viewpoint (Figure 2.7).

Figure 2.7 The rendered glass

Animate the tablet falling into the glass. (*Hint*: It will be slowed and redirected by the water.) From the Modifier List, add Melt to the stack. Use the Glass Melt effect and animate your tablet melting away. By adding a Visibility animation key to this, we can get a good effect of the tablet dissolving.

To add a Visibility track, R-click the object in the viewport and pick Curve Editor. A new window will pop up: this is the Curve Editor.

Note *The Curve Editor or Track view represents all the animated parameters you have given an object in graph form. It is like an expansion of the timescale slide rule which runs along the bottom of your screen, and offers alternate ways of adjusting any animation keys in your scene. Adjusting the Key Interpolation here will change the curve of your animation. The Visibility track is a simple way into understanding this complex tool, which is at the heart of animation control.*

From the Tracks drop down in the menu bar, pick Visibility track > Add. A Visibility track will appear below your object (Figure 2.8).

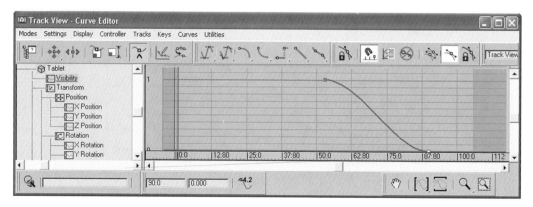

Figure 2.8 Adding a Visibility track in the Curve Editor

Select Add keys and create two keys for your tablet, one for when you want it to start disappearing and one for it to have dissolved completely. (Because we are using this in combination with the Melt modifier, we do not want the tablet to disappear too soon.)

When you first assign a Visibility track to an object, a Bezier float controller is automatically assigned as the default controller. By R-clicking on the keys, you can change the interpolation of the Visibility keys (just as you did for the turtle's PRS keys in Chapter 1).

We want to hold the tablet's Visibility, and then ease into it disappearing. R-click on the first key you created and type in the value 1. (For Visibility, 1 = Fully visible and 0 = Vanished.) Select the 'Step' (hold) tangency for your first interpolation and an 'Ease Out' for the second (Figure 2.9). You should see the curve of your animation in the Curve Editor change. Advance

LIVERPOOL
JOHN MOORES UNIVERSITY
AVRIL ROBARTS LRC
TITHEBARN STREET
LIVERPOOL L2 2ER
TEL. 0151 231 4022

Figure 2.9 Interpolations for the first Visibility key

to the second Visibility key and this time choose an 'Ease In' and a 'Step Out' interpolation, at value 0. (Your curve should resemble that of Figure 2.8.)

Next we will add some Particle Clouds (PClouds) to simulate the tablet dispersing. Create > Particle Systems > PCloud. Choose a Cylinder emitter and Click and drag in the top viewport to create the cylinder that will contain your PCloud. (*Hint*: You may also choose any mesh object as your emitter, e.g. your tablet, but in this case, we want more control of the bubbles as we do not want them floating through the glass!)

There are a lot of different parameters for particles, but if you work through them methodically, they are quite logical and many can be ignored. The particle parameters I have chosen are Particle Type > Standard Sphere, I have assigned the icon a suitable material, and timed the particle animation. (*Hint*: If your computer is not very powerful, it is often better to use a 'Particle Total' rather than 'Rate' as it allows you more control and stops your computer crashing; rates can multiply alarmingly.) The only other parameter that needs to be altered is the particles' direction vector (Figure 2.10).

I have animated the emitting cylinder's size during the animation, and copied it to add two more PClouds with slight variation in material and size.

Figure 2.10 The PCloud particle generation rollout

Top Tip
Adding extra versions with small variations can help particle systems seem more random and less digitally generated.

Again, the only way of checking that the look you are achieving is correct is to keep on rendering and checking. There are too many factors at work here for the viewport to give you an accurate picture. Figure 2.11 shows a rendered still of the final shot.

Figure 2.11 The tablet dissolving

Note *I have used an advertising trick to add subtly to the product's enhancement. By adding an Omni Light inside the glass and increasing the light within the glass as the tablet effervesces, I have lent it a slightly magical edge. There are other additions one could make in the interests of magic or realism. For instance, adding a splash and ripples. Anything is possible in 3D.*

Adding ripples

To add a ripple to the water, select it and use the Ripple modifier. Set Auto Key on, and go to the frame where the pill hits the water. Change the phase very slightly and change it back to 0. This will create two keys, one on frame 0 and one on the frame you are on. Then move on three or four frames and change the amplitude 1 and 2 values to around 100 and 80 or whatever value you think correctly approximates a splash. Then go to frame 90 or so and change the phase to 7, still with Auto Key on. Change the amplitudes to 0 now. This will stop your water appearing to ripple. You might want to put another key in between the third and fourth to better

represent your ripple/splash. You should see your water splash and ripple now, and settle down. The settling down is important if you want your animation to loop.

Merging the box and glass

Now let us merge the previous MacHead's package into the scene. From the Top menu choose File > Merge. A browse window will pop up, find the package scene and select the chamferbox. Click 'OK' and the box will appear in your scene. It will not necessarily be at the correct size and will certainly need rotating and positioning. You may well wish to re-adjust your camera and will need to add lights and move existing lights to make the box look good. This is where Raytracing can really help add to the scene as now the glass and water have something to reflect and refract. The lights I have used in my scene have Shadow Mapped shadows. They are relatively quick to render and have soft edges, making them look fairly natural. There are other types of shadows possible, and also the idea of Global Illumination (where light that bounces off objects is calculated). This can improve the realism of your scene, but has the downside of being processor intensive, and hence slowing down the rendering time.

When you are happy with the look of your scene then you are ready to render it. Choose Save File from the Render Scene window and select portable network graphic (PNG) for the save option, make sure the default 24-bit option is selected. Render all 100 or so frames. These will be imported into Flash in order to create your web page (Figure 2.12).

Figure 2.12 The finished scene

Of course the reason that a realistic approach is the most obvious approach is because it interprets the instructions on the packet to illustrate how the

product is used. It has a classical look drawn from television advertising, and usefully means that a visitor can understand it regardless of text. There are other ways of approaching the product depending on how we wish to get it across. Let us suppose for instance that we want a web page that shows what a fun company MacHead's is, and at the same time implants knowledge of how great and effective 'One Dose' is. For this sort of identity, it seems like a good idea might be to have a character and a game. So meet Headache Jake and his dancing pills.

Exercise: the fun approach to 3D

Creating a character and designing an animated sequence for a simple game or activity.

What to do

I have created Jake from a polygonal modeling. Believe it or not, like the tortoise, he started as a box. He was made by me for a previous animation, where he had lots of hair, but it is easier for this exercise if he is practically bald as in Figure 2.13. You can use the file of Jake from the CD, or make a head of your own.

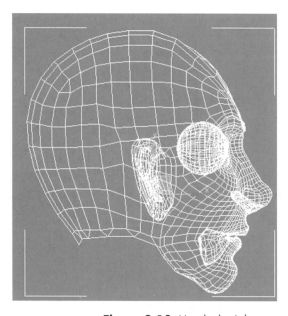
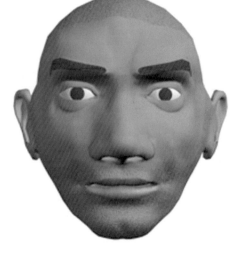

Figure 2.13 Headache Jake

Note *If, like many others, intricate modeling is difficult for you, then there are ways to access models made by others via the Internet, Poser or models that come with your package. These models can be brought into your program and adjusted to suit your needs. There are some sources listed at the end of this book. When using models other than your own, it is essential that you regard the laws of copyright and do not infringe them in any way. There are a lot of generous people on the Web, but it will only stay like that if we do not abuse it.*

Jake looks a bit hung-over and ripe for a headache, doesn't he? Thinking about the brief for a fun page and how to graphically depict a headache, I have decided to create an animation where Jake appears, gets a wince-inducing headache in the form of a gold band around his brow and then shakes it off. The main new animation tool we are going to use is the Morpher modifier. This is a wonderful way of smoothly animating facial expressions including lip sync but can be used for so much more.

Jake is an Editable Mesh, and before we add the Morpher modifier we will create four duplicates of him that we will use as Morph targets. Whenever the Morpher modifier is used, the topology of the targets must be the same as that of the original, so we cannot animate Jake by changing the number of vertices or polygons he has.

Select Jake's head and Shift-Move to create four more copies of him, these will be our targets. Now use soft selection to start giving him a headache. Furrow his brows and start squeezing his brow by band selecting the vertices and uniform scaling them in. Move on to the next target and make him really suffer. Now let us give him a surprised look as relief hits, and for the finale a happy smile of relief (Figure 2.14).

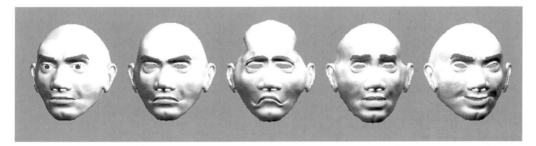

Figure 2.14 The 5 Jakes. One original and four targets for the Morpher modifier

When moving the vertices it is a good idea to mimic the facial expressions and check what happens to your features in a mirror. See how eyes and eyebrows are affected. He looks pretty strange right now, partly because

the eyeballs are linked to the original, so the targets look like masks. Select the original and add the Morpher modifier to its stack.

Click on Load Multiple Targets and choose all the Jakes apart from the original. Click 'Load' and they will appear in the Morph Channel List (Figure 2.15).

Figure 2.15 The Morph Channel List for Jake

Now select all the target Jakes, R-click in a viewport and select Hide Selection; we do not need them any more. Center your viewports on the original Jake and have a play with the sliders in the Channel List. Notice that you can combine the Morph targets to get some groovy expressions. Check that the eyeballs are not pushing through the mesh in any of the combinations, if they are, pull them back inwards a bit. I have also made some rudimentary teeth out of a cylinder and linked it to Jake's head along with the eyeballs. Otherwise when he smiles, you can see there is no back to his head! I have used noise maps in Multi-Sub-Object Materials to give Jake eyebrows, lips and a 5 o'clock shadow.

Now make a smooth band to go round his head (from the top viewport). Give it 40 sides as we need it to be metallic and smooth, and those extra vertices will come in useful. Assign a gold metallic material to the band and copy the tube by Shift-Moving it. Turn the new gold band into an Editable Mesh. Select a jagged half of it at vertex level and click on 'Detach' to create a new object. This will make the broken headband for Jake when his headache goes (Figure 2.16).

Figure 2.16 Jake's broker headband

I have also created a white box and used a number of Omnis to light it and not the rest of the scene, so it disappears into the background. (*Hint*: You can include or exclude objects from a light's influence, under the Light Parameters.) Jake is going to rise up from the box, get his headache when the ring descends and then shake it off.

Turn on the Auto Key (Animate Button) and animate the basic movement for the gold band and Jake's position first. The gold band will need to be replaced by the broken Headband using the Visibility track in Step Mode. Do not forget to Ease Jake into his new Position and Hold him there with the Key Controllers. Now animate the Morph expressions. Remember that they too are Bezier, so you need to put in 0 value keys to control the speed the expressions take hold. Any movement of the sliders creates a key, even if you scroll it up and back to 0. (*Hint*: You can use Key Controls for Morpher by R-clicking on the keys in the Curve Editor. I prefer the more hands-on approach of the sliders in Morpher, so tend to use just those.)

You will find that the gold band does not quite fit Jake's head (unless you are very lucky) so tweak it around until it does. We do not care what it looks like from the back as that will not be seen. The only really important thing to remember is to align the original headband with the broken one when they swap over in Visibility. Animate the eyes by rotating them to anticipate the headache and return to normal at the end (Figure 2.17).

Figure 2.17 Jake shakes off his tension headache

Have fun! This is not an exact science, all animation is subjective. Have you any idea how many different walk cycles there are? I added in a moment for Jake to say 'Yesss' with relief, as I thought it would be fun. When it looks good, render it as single frames, in PNG 24-bit format as before. We will be integrating them into a multiple page website later on.

Creating the 'wow' factor – sexy graphics

Because 3D is so attractive, it is not unusual for a client to want a sexy graphic, or even a new logo created in 3D. These briefs are great fun as they are an opportunity to look at the product as a whole, and think sideways to come up with something with that 'wow' factor. This is where playing with your software pays off. All those accidental buttons pressed and the 'I wonder what this thing does?' moments can be drawn on, and combined with your marvelous graphic skills, to make wonderful things and cover yourself in glory.

In the case of MacHead's One Dose, I was much taken by the gold 'O' of 'One'. The choice of gold for a color was obvious, as it represents a seal of approval. It also looks a bit like a target, and remembering Jake's headband, I thought it would be fun to combine all three elements. What I am after here is to represent the 'feel' of the product. I also decided to loop the graphic as clients love their logo, and a looped graphic is more adaptable.

Exercise: creating a sexy graphic

Creating a small, short looped graphic that will wow the client.

What to do

This is more a step-by-step analysis of the thought processes than a tutorial. Time to use your imagination.

The starting point for this animation was to recreate the gold rings that make up the 'O' of 'One Dose'. They were created in 3D by Shift-Scaling a Torus seven times. Having made the rings (and knowing I wanted to loop them), but not knowing yet what I would create, I set Position, Rotation and Scale Keys at the front and end of the animation. Looking at the rings, I wanted to rotate them, so I started by pushing each alternate ring in a different direction. That looked too prissy so I randomized their rotations, just so it looked fairly chaotic and made a nice silhouette. I created a strong shadow plane as I thought the shadow might be fun and played with transparency and color.

Now I wanted something to generate the disturbance in the rings and chose a Particle Ray to shoot at the center of the rings like it was a target. (Because MacHead's One Dose is renowned for its pain targeting qualities.) For this, I used a SuperSpray and gave it a blue color to match the package (Figure 2.18).

Figure 2.18 First attempt at graphic

But looking at this it was all a bit messy and unstreamlined. I decided to jettison the shadow as it made the graphic take an uncomfortable shape, lose the color and stick to gold to keep it streamlined, and look for something that might just indicate the tight headband of pain.

I grouped the rings and added a Spherify modifier. With just three keys it made each ring push out to a flat band shape and then return to a torus. It really helped the easing back to the original logo, a sort of equilibrium restored. Remembering the effervescing tablet, and mindful of potential sound I added a PCloud bubble fizz just as we did for the dissolving tablet.

The finished graphic is elegant and simple (Figure 2.19). The reflective metallic rings and particles take advantage of the 3D environment, without shouting out 'Hey lookee here', and MacHead's have a potential new logo. All in all the client is delighted – which is just as well, as in this case, the client is me.

Making a website in Flash

We have created three elements for the website for our imaginary medicine, three styles of approach to our advertisement. The first version being a direct and straightforward advertisement, the second, a fun view, which could be interactive and the third being a more symbolic and showy

Figure 2.19 The finished graphic for MacHead's One Dose soluble aspirin

metaphor. It is time to turn them into a Web-deliverable format, and we will use Flash to collect together all our animated frames. You could convert each movie as a Flash movie file and place it on an HTML page, but this is not the most efficient method. The main reason is to do with streaming.

Streaming

Streaming is the idea of not loading a whole movie at once, before playing it, but starting to play it as soon as a small portion is downloaded, allowing the movie to play and download at the same time. If this works well then there are no pauses in the playback of the movie (this applies to digital video as well). So the user does not have to wait minutes before the animation starts. Another idea for streaming in Flash is that you can load a whole section of a movie, e.g. one of our MacHead's versions. This can be playing whilst the other parts of the movie load in the background. If the other versions are on different pages then they will already be loaded when we link to them. Normally when you link to an HTML page, you then have to wait for it to load. Streaming can remove the frustration out of Web browsing, giving a more professional look to your website.

So the best way to set up a heavily animated site would be to create it either mostly or entirely in Flash to ensure that it will play back in the most efficient manner.

Creating a multi-page website

At this stage in our chapter we have gone through various techniques to create some interesting graphics for our website. 'MacHead's One Dose' is, of course, a fictional product, but we want to create a website that has a corporate feel and has a reasonable amount of entertainment. We need to take advantage of the factor that distinguishes the Web from other media, like television and magazines. That factor is interactivity and in our previous chapter we made buttons, which we could use for web page navigation. The fact that they reacted to our mouse made them more exciting. Making a simple advert more exciting and interesting should help enhance any brand. How you do this is entirely up to you (and the sales and marketing department, if you have one!). For our MacHead's product, we have created animations and it would be interesting if we could trigger them in our website. This makes our website more than just an animated advert, the interactivity should help visitors remember, and use, the product.

As we have several sections to our site we want to display them in the most interesting and efficient manner. We have already discussed streaming, but we do not necessarily want just a page-by-page website. It would be good if the brand identity was constantly on display. So we need to have a page set-up that has perhaps two halves, one with the brand title and the other showing our animations. We also need to include buttons in order to navigate between the interactive animations.

Issues affecting the display of websites

There has always been a major issue when designing web pages, and that is the platform that the web page is being displayed in, i.e. the browser, screen resolution and fonts. The most widely used browser by far is Microsoft Internet Explorer, but there are many browsers in existence. While they all do the same thing, they each have individual quirks. We have already talked about Internet Explorer and PNG files, which display fine in Netscape Navigator. Other issues they have are to do with the gaps between the HTML page and the browser edge (the margins). They also display frames differently (frames are web pages within web pages). They each have different amounts of graphics on their interfaces. This is why most pages scroll, and text wraps around to accommodate different screen sizes. In traditional print design, this multitude of display formats is not an issue, generally a designer might design two or three layouts for different shapes of paper or advert space, and these would be stretch proportionally to fit the different sizes of output.

Having a scrolling page is not ideal as you do not get to see the whole page at once and this might well affect the subtle messages of your advertising

design, let alone design issues of balance and weight. Using Flash enables us to overcome most of these issues. We can stretch a Flash movie to fill a browser page, or keep it a size that will display on all screens.

The letterbox format

A popular aspect ratio to use for Flash pages is the letterbox format. This means having a Flash movie that is similar to a cinema projection or widescreen TV in shape. You will find that this will comfortably fit on nearly all users' browsers. The only issue is whether you make your movie stretch to fit the browser window or not. Why is stretching an issue? Well, the extra issue which Flash brings up is the frame rate. Ideally we want our movies to play back at 25–30 fps (frames per second). This may not happen if the movie stretches by too large an amount as slower computers may not be able to display the movie at that speed. There is not a perfect answer to this issue, apart from testing your movie on many computers. The compromise is to decide on a minimum standard of computer setup that a majority of users will have and then make our movie fit that. Although most modern computers can display many different screen resolutions, the minimum that a majority of users will have will be 800 pixels wide by 600 pixels deep. Because the browser will take up a fair amount of space, this will leave an area of approximately 760 × 350 pixels. So this is the space we have to put our movie in, the minimum. We could have it stretch if we want to, but this is a decision we would make when we publish our movie.

The MacHead's website

The following is a general description of how the MacHead's website was put together. As you may not have followed the previous tutorials exactly, what you want may be different. In fact I hope it is different as it is your creativity that is important, aided by the skills you learn in this book. However, all the original files can be found on the accompanying CD, for you to analyze in greater detail.

For our Flash movie I went for a size of 720 × 350 pixels, by setting the document size. This fitted into our possible sizes and had an aspect ratio that I found appealing. As my animation sequences have white backgrounds, I also set the document's background color to white. I then incorporated the various graphics that were created for the package design for our product. This could have been done in various ways, e.g. completely creating the whole page in Macromedia Fireworks or in Adobe PhotoShop. But I decided to import each element separately as a PNG file, so that I could adjust my layout in Flash.

I then used Guides, to help line up the elements. It is also helpful to have the Grid setting on as this also enables better alignment. Figure 2.20 shows the page layout, with some new text written on the right hand side. There was no need to import this as a graphic, as it was easy to type in the text directly. I set the paragraph style to be justified (straight-edged on both sides).

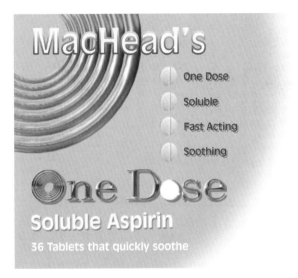

MacHead's One Dose hits pain fast.

MacHead's quick dissolving action ensures the toughest pains and aches disappear.

Made extra strong, you only need One Dose to blast away those pains, no matter what part of the body they might be in, MacHead's One Dose delivers the relief you deserve!

Disclaimer: MacHead's One Dose is not available anywhere, as it is not a real product.

Copyright 2003 by the 3D for the Web team

Figure 2.20 Layout for MacHead's website first page

The last thing to add to my page was the four buttons used for navigation. The first button indicated the above page, the introduction or Home page as it is generally known. The second page linked to the Pill, Glass and Box animation that we made. The third and fourth buttons are for our 'sexy graphic' and our 'Headache Jake' animations.

Note *When talking about Flash pages, do not confuse them with HTML pages. The Flash document will contain many frames, each one could be called a page. For our website, we will only have one HTML page, which will hold the Flash movie, the .SWF file that contains all our Movie Clips (our animations).*

For the buttons, I rendered the pill spinning on its axis. This animation was only 16 frames long and, as usual, was imported as PNG files. The best way to do this is to create a Movie Clip symbol (Insert > New Symbol) and then import the animation frames. Using similar techniques to the latter part of Chapter 1, I made the animation into a rollover button. Instead of converting the symbol to a button, I kept it as a Movie Clip and added a script to it, as shown in Figure 2.21. The script shows that if the mouse rolls over the button then it will play the animation of the spinning pill. It also shows

Figure 2.21 Script for a button on the MacHead's website

that if the mouse is pressed, then the main movie (the _root) is told to navigate to frame 3.

The timeline for the Flash website looks fairly complicated and it is best to analyze the file yourself by opening it up. Figure 2.22 shows how many different layers were used for each graphic. I labeled them, to make it easier to work out what is what. You will see that the whole movie is only 10 frames long. This is because the first three sections are each two frames long and the last section, four frames. The reason to have each section two frames long is so that the movie can continue to play, whilst appearing not to. For example, the script on frame 2 tells the movie to go back to frame 1, 'gotoAndPlay(1)'. It is sometimes helpful to keep a movie playing like this, so that you can use 'Enterframe' events, however, I will not go into that in a deep way at this stage. The last section is four frames because it has two parts to it, the 'Before One Dose' and the 'After One Dose' sections.

Note *One thing to remember about layers is that if you have two graphics on top of each other, then you will only be able to select the graphic on the top layer. To get around this it is necessary to hide the top layer, by pressing the little eye picture whilst having the layer that you want hidden, selected.*

Although the movie is 10 frames long, I did not want all of my graphics to appear all the time. Only the graphics on the left hand side remain throughout the length of the movie, the others appear only when they are needed. For example, only the Pill and Glass animation is visible on frames 3 and 4. These Movie Clips for the middle two sections were also turned into Buttons, using ActionScript. Quite simply, the animations were triggered when the mouse rolls over them, by using a rollover script as in Figure 2.21. Each

Figure 2.22 Screenshot of the MacHead's Flash timeline

Movie Symbol was also made to stop playing, using a 'stop()' frame script on the first frame.

Top Tip

When you import your animation frames into a Movie Clip symbol you will need to drag the symbol from the Library to the Stage. Normally this is a quick process, but when the symbol contains large amounts of graphics there is a significant pause to process this action. Be patient and your computer will catch up. This pause also happens whenever you extend the number of frames for that symbol, however moving the symbol around the Stage does not cause this problem.

The most complicated part of the MacHead's site is the fourth section, as it has two parts (Figure 2.23). The Headache Jake Movie Clip starts automatically. Looking inside the Movie Clip for the animation you will see that there is a frame script which tells it to stop, this happens when the band is

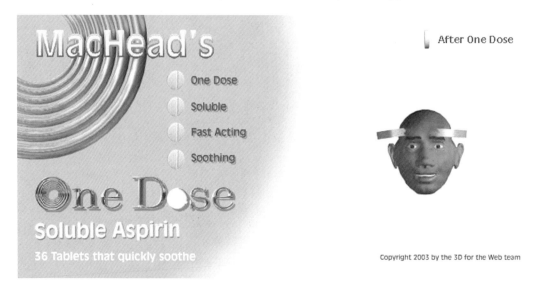

Figure 2.23 Screenshot of the soothing section of the MacHead's website

tightly around Jake's head, on frame 35. This allows you to restart the animation by rolling over the Pill button. You will see in Figure 2.24 that the frame 60 has been extended and that there is another layer on top, which carries on to frame 143. These are there to add pauses in the animation. It was unnecessary to include these pauses in the original rendering of the animation.

Figure 2.24 Screenshot of the MacHead's Flash timeline

Back in the main movie, there is a script on frame 10 in the 'After One Dose' layer. This script checks to see what frame the Jake animation is on. If it is less than frame 105 then the main movie loops around frames 9 and 10, otherwise it will loop around frames 7 and 8. This way there is a clear difference between the 'before' and 'after' states.

Loading screens

Most of the Flash movie has now been described but there is one important issue that has not been dealt with. The graphical content of our website is

very high, as we are relying on the increasing usage of broadband Internet. We have already talked about streaming and how Flash utilizes it, but if we can access all parts of our site at any time, what happens if the Movie Clips haven't loaded yet? The answer is nothing; you will get a blank space where the graphic is waiting to appear. So we need something to tell the user that the graphic is still downloading. This could be a 'progress bar', a graphical representation of the amount of data that has downloaded, or just a graphic informing you that the section is loading. In this case I chose the second option. When the movie jumps to frame 3 for the beginning of the Soluble section, two spinning pills and the word 'loading' appears. These will load very quickly. The movie will not progress now until all of the 'Pill and Glass' Movie Clip has loaded, where upon the loading graphics (which have been converted to a Movie Clip) are told be disappear, using the '_visible' Movie Clip command contained in the frame 4 script.

Finishing off a Flash website

Sound

Although many people have the speakers on their computer switched off much of the time, particularly if they are at work, sound can add an extra level of immersion to your site. In the case of MacHead's One Dose we could add plopping and fizzing sounds for the 'Soluble' section, a magical sound for the 'Fast Acting' section and have Jake sighing with relief for the 'Soothing' section.

You could have a whole soundtrack playing, but this would have to be good as it would add to the download time. Generally, music is reduced down to short clips that loop. However, if done badly then music could be more annoying than it is helpful to the promotion of your site. So you should use it wisely and appropriately, likewise with the incidental sounds.

Optimizing the Flash file

Now the Flash file has been described there are a few things to mention about the final outputting of the movie. The file is big, approximately 2 megabytes, and it should be optimized further by cropping of graphics wherever we can, using layers and rendering only the parts of the anima-tions that change. This always takes a long time but is generally worth it in the end. You should check your imported frames and remove any repeats. As interest in your website depends on people having the patience to view it; you do not want to keep them waiting too long.

LIVERPOOL JOHN MOORES UNIVERSITY
LEARNING SERVICES

A simple way to reduce the file size is in the publishing options in Flash. Here you can set the JPEG compression that will be applied to your movie. However, if you compress it too much then you will lose image quality, so you need to find a balance between file size and quality. JPEG compression settings of around 70–80 usually result in a satisfactory compromise.

When you preview a Flash file, by using the Control > Test Movie menu option, you can select the View > Bandwidth Profiler option to see how a file will load on various connection speeds. You can then see how long it would take to load on a frame-by-frame basis. Using this enables you to adjust your movie, perhaps by making your title screen load up in parts, or making sure that the complicated graphics start to load early. You want to try and make the loading a smooth and hopefully invisible experience. Ideally you will give your audience something to look at straight away, something other than a loading bar. Then you will have made your site successfully streamlined.

Instead of using animated images, the latest few versions of Flash allow you to import video files directly into it. These can be QuickTime Movies (*.mov) or Video for Windows files (*.avi) and many other video types. Flash has its own methods of re-compressing these files. Because of this, it is best not to have them too compressed to start with, so that Flash does not further reduce the quality. This is actually a simpler than using an image sequence, but older versions of Flash do not support this method.

Centering a Flash file

When you publish your movie, it will automatically create an HTML page for you. You could use this web page unaltered or you might want to amend it. The default HTML page will place the Flash movie in the top-left corner of the Web browser. But it would be nicer if it was in the middle of our screen. The best way to do this is to create a table, with three rows in. You can do this in Dreamweaver with a blank page. If you set the tables height and width to be 100% then it will stretch to fill the screen. Make sure the border size is set to 0 so that the table edges do not show. Then import your Flash file into the middle row and make it centered, by changing the properties.

In the case of MacHead's website, I also changed the background color of the HTML page to match the dark blue used in the packaging design. This acts as a picture frame to our design, increasing its strength and prominence. Finally the page was uploaded to our web space. If you do the same then you should have a good-looking site with interactivity and some stunning graphics! (Figure 2.25).

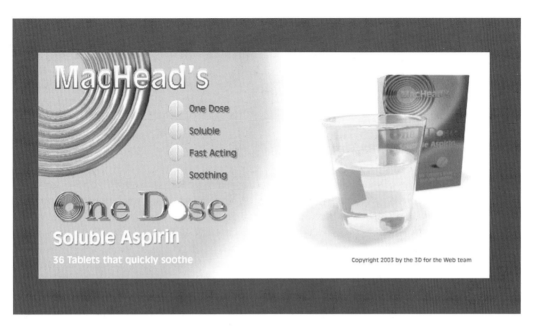

Figure 2.25 Screenshot of the MacHead's finished website

Designing 3D websites

We touched on designing interfaces at the beginning of the chapter. There have been many writers on the subject of interface design and Web interfaces and this book does not pretend to deal exhaustively with this subject. Here is a brief overview of some principles to keep in mind as we plan and build sites.

Signs and symbols

As we have established, buttons are a major aspect of websites. The simplest buttons are just text, but be aware that not everybody on the net speaks your language, and they might still want to appreciate your grand creation. The best way around is to use a symbol or icon to represent ways to navigate your site. Commonly a picture of a house represents a site's home page, and triangle symbols are used to indicate traveling forward and backward in the site. All text and pictures that have meaning are signs and it is important to realize what the symbolism in your website means, not just to you, but what it is likely to mean to others. If you use metaphors that are familiar to Web users then you can be fairly certain that they will be understood, otherwise there may not be any point using them at all. Some level of meaning will have to be transferred through the imagery you use, if you want your site to be truly international.

One way in which to make your links meaningful could be to contain them in a familiar device or object that could be understood. A common way of laying out a site is to give it tab dividers as in a paper folder. You could employ the idea of a remote control, with the idea of changing channels. People could accept this metaphor if it is related to your site correctly. So if I was designing a site selling pies, I might make a button shaped like a pie. If it was travel site; a stop/go signal, and a website that deals with philosophical ideas might draw on thought bubbles, light bulbs or Rodin's iconic sculpture, 'The Thinker', as inspiration.

Generally if you are using 3D for your buttons you will want to have an interesting character or themed objects that react to the mouse, along with the text to describe them.

Establishing the site's message

The Internet is a communication medium, concerned with the transmission of information. How you present that information is your message and the style of delivery is the creative challenge that you have. The style of your site is going to affect how the user perceives you, your company or the company whose site you are creating, so it is important to get this right from the outset.

You need to establish who you want to visit your site and what kind of experience you want them to have when they are there. You also need to decide if integrating 3D will enhance it. If the site's purpose is to impart masses of text information, then 3D may not enhance it at all. However, if you are describing a product for sale then a 360 degree view of it might save you a thousand words of description and be much more useful. A major consideration in creating an impressive site would be to attract visitors and to make them aware of your brand. Attracting visitors must rank as one of the most important results from creating a website. The website you make needs to stand out from the crowd and the only way to do that is to keep pushing the boundaries of current practice and invent something new. Remember, your website is always an advertisement for your skills and so taking care over the design is imperative if you want to make a lasting impression.

Often the role of designer includes educating the client, showing them what is possible, and showcasing is an excellent way to do this. Making some impressive work at your own expense can be the best form of advertising, and be the difference between you getting the clients or your rivals. A 3D interactive makeover of an existing or new site can encourage people to visit, stick with and remember your site. Perhaps the inclusion of a computer game can lead to viral marketing via the powerful medium of word-of-mouth. Maybe there is a new technique that you have invented that you

want to show off to prospective clients. In short, you must offer your visitor clarity, hooks and entertainment.

The interface

If your interface resembles familiar objects or other types of interfaces then you can be reasonably sure that most people will know what to do. However you want to push the boundaries, so I suggest that you start simple and ease people into your site. Keep the style of buttons the same throughout your site. Navigation is one of the most important elements and people need to be guided through your site. If a button reacts to being rolled over by the mouse pointer then people realize that it is going to do something. If a message pops up when you rollover it then they are likely to know exactly what it is going to do. If you can make your buttons and interface do interesting things then you are entertaining the user and keeping them on your site, which has got to be a good thing! You do not have to put everything on the home page though, you can bring elements in throughout the site, which stops the user becoming bored. You are rewarding them for exploring, luring them into other important areas of your website.

It is always a temptation when you have spent weeks or months working on a grand design to keep adding more and more elements. Whilst you are learning new software you can get carried away with what you just found out and be determined to include it. Always be careful about this, your website can become over complicated, with too much happening, or worse, be impossible to navigate. The attention span of the average Web user is very short, particularly if they cannot work out what to do. Frustration will be a major turn-off with an over-complicated site. When you design your interface, test it thoroughly on different people who know nothing about it. You must never do your own testing as you know too much about your work. Get feedback as to what people like and do not like and observe them using it, so you can see where they might struggle. You will be amazed how your guinea pigs cannot find something that you may have thought blindingly obvious!

Good planning is the key to creating an amusing or impressive site, combined with good design and technical skills. The companies interviewed in this book offer plenty of advice. These companies are practitioners at the top of their field and reading these interviews and checking out their websites should help you become a great Web designer.

Interview with Who's We Studios

http://www.whoswestudios.com

Company profile

Who's we is an elite design studio based in Frisco, Texas. The six designers feel passionate about pushing the boundaries in graphic design. They have won numerous awards and their work and website are at the cutting edge of 3D on the Web.

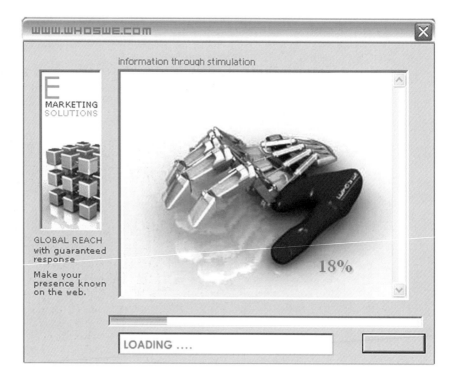

I first came across them when two different students (one from 3D Animation, one from Digital Arts) showed me their site, and in my turn, I have shown their site to many others.

The site is awesome; slick and funny, combining great lighting and sound with a neat interface. Clearly these guys have watched a lot of movies.

Interview

Can you describe the background to your company, its aims, ambitions, client base?

Our company was founded on drive, determination and pure passion. We aim to get bigger every year. Our ambitions are carrying us into video production for the entertainment industry and possibly high-end 3D animation.

We like to get almost everyone involved, but typically, there are usually three main contributors to each project. We get everyone involved in the brainstorming sessions and then usually split the workload by availability.

Do you have separate 3D animators, Flash animators and programmers, or do the skills cross-over?

Everyone here must be fluent in Flash, except for our 3D modelers/animators. 3D applications are very time consuming to allow the typical 3D artist to also delve into Flash. As for programmers, we have one main programmer and two others who are not as fluent, but are strong Flashers, but for the most part, everyone has a double specialty.

Who handles the sound and what impact does sound bring to your sites?

The sound is handled by two people here in our sound studio. Ninety percent of all of our audio is made from scratch. Whether you need custom sound effects, or a complete soundtrack in almost any genre, we can deliver. There are many tracks we have laid down on many of our projects, namely the Handheldgames.com piece which we ended up doing a few mixes for the whole site.

General design and 3D

What is your background? How did you get started in Web design?

Most of us attended art schools. Before Who's We, some of us worked for local print shops and other design companies and marketing firms. We have all been interested in the Web since the late 1990s when it really began to take off.

What do you think is the essence of good Web design? Can you give any general tips?

The essence of good Web design is having a strong foundation in design itself. I would strongly recommend taking a few design classes, as well as color theory classes to strengthen your fundamental knowledge in design.

Without these, your skills may never progress. You must have complete control of your colors, space, composition, aesthetics and usability.

Good-looking 3D has an immediate appeal. Do you see it as the way forward in Web design, or just another tool?

After we leaked out into the design scene, we have noticed some design studios making this movement on building 3D departments. Good 3D will always seem to captivate the masses. If used right, I believe we may begin to see it as the next level of design, the fusion between the two and making it a bit more mainstream.

What/who are your inspirations for 3D?

Our inspirations for 3D are everywhere. It seems as if they are getting younger and younger. Schools all over the world are producing some really good talent, but our biggest inspirations come from the big movie houses with big budgets to really push the envelope when they release their next film.

What is a typical timescale for making a website?

A typical timescale for making a website can be anywhere from a week to a month, but the timescale for a website involving 3D can double that time, sometimes more. Because 3D was so new for us when we created our own site, the constant test rendering and bugs extended our production time to collectively, 5–6 months. Now, with the use of our render farm, we can complete 3D sites in a fraction of the time, but in the end, it all depends on the client and how 'crazy' they want to get.

How much of that time is pre-production and planning?

Pre-production and planning can take anywhere from a couple of days to a few months. Take our Infinium Labs project, it took several months to plan and pre-produce certain elements that were later used on the site. Sometimes, good design must not be rushed.☺

What aspect of development would you say is the most time consuming?

Conceptualization and creative are by far the most time consuming aspects of development. Since we are a creative studio and not a Web design company, our clients pay us to come up with fresh ideas and angles. This process can become very time consuming when a lot of money is at stake. Everything must be methodically structured and PERFECT.

Your past and future work

The Who's We website is very inventive and entertaining. How did you come up with the ideas for it?

For the most part, all ideas came from a typical brainstorming session at the initialization stage of the project. We basically sit at a round table and pitch ideas back and forth, dispute a little, then come to a finalization where we are all happy with the results.

In your opinion what advantages does 3D technology have when creating a seamless interactive interface?

Aesthetics. There is nothing like a nice, clean interface.

How often would you offer clients a 3D solution?

We offer 3D solutions when we feel the client can benefit from them. Not all of our work promotes 3D. Sometimes, good ol' 2D work is more than enough. Some 3D can be very trendy, in which the client will specifically ask for a 3D piece similar to something he has already seen. It is all about giving the client what they want.

What awards have you won and do they make a difference?

We have won several Favourite website Awards, a Flash Forward award, an Ultrashock Bombshock award ... the list goes on, but at the end of the day, what makes a difference is having your passion and working in the field you really love.

Any special future projects using 3D?

The next version of our site will definitely outdo our first one. It will be an innovative concept that you all will have to look out for. ☺

What software did you use to create the Who's We website?

We used two different 3D platforms and about 10 other design applications. You just have to know what combinations of software to use to render the best results.

Does it vary from project to project?

Yes ... but for the most part, Photoshop, Flash and Soundforge typically end up at the top of the list.

How much programming/action scripting do you use in creating your website?

It all depends on the project. If a database is included in the project, that will increase your programming workload. Today, new software releases are making all of the programming much easier to manage your data.

Were there any specific problems you had to overcome?

Yes … many. We had to learn how to optimize 3D and learn how to render it at its optimal settings for the Web. It is much more different than 3D for video production and especially for print. We had to overcome all of these.

Why have you chosen a highly rendered look as opposed to the more familiar vector shaped 3D?

We feel that the raster-based renders can be more impressive since vector shaped 3D is limited to colors and overall impression. The only drawback to not rendering out in vector 3D is ending up with a much larger file size.

Which technology do you think will be the leader for 3D on the Web?

I believe Flash will maintain its lead because of its overall capabilities in terms of interactivity.

Insights

Do you have any advice for students of 3D Web design?

Yes … 3D and Web are often not promoted together in schools. After all, you will never see a 3D student go to school just so they can learn 3D for the Web. It is just not going to happen. If you truly want to learn Web design but still develop the 3D skill set, good luck. Non-vector 3D applications take a very long time to learn. The best advice I can give is to spend most of your time in school developing your design skills. Having a strong foundation in design will help develop every other skill you wish to pursue in the future. Please … trust me on this! ☺

3D has almost taken over the games industry, do you think it will become predominant in Web design?

I think it still has a long way to go, simply because funding a 3D department for a Web studio is very expensive and time consuming. Successful design studios typically must invest in a render farm which is basically a separate network of computers which sole purpose are to render out the images from the 3D applications where everything is modeled and animated.

Does current Web technology allow you to achieve all of your creative ideas, what improvements would you like to see from software?

Faster engines and bigger pipelines so we can go crazy on our ideas. Bandwidth limitation is primarily our biggest stint in creativity.

Parts of your site have a lot of data to download. Do you see this as an issue with the rise of broadband?

No … we love big files. ☺ And for everyone that says big files are bad design practice. Please upgrade into the 21st century and get broadband. Remember, there IS a market for broadband users.

Chapter 3

An introduction to real time 3D

Working in 3D

Up to this point in the book we have been looking at rendering 3D objects in order to create a single picture or animations. When we were in our 3D package we had full control over where we looked, we could move all around the space and view the object from any angle. After just a short while you were able to imagine that that space was part of reality. Working in three dimensions is the natural thing to do as we live in a 3D world, but our resulting output was flat and 2D. It showed an illusion of three dimensions that is convincing because, as humans, we are conditioned to seeing things that way.

We have introduced some interactivity to rendered animations, by using the mouse to trigger their playing. In theory these animations could be very

complex, incorporating many camera angles, zooming in and around. The upside of this is that we can have an almost photorealistic high quality environment, but the downside is file size and flexibility. We are trying to make 3D for the Web and as everyone knows, waiting for huge files to download can be a real turn off. So what can we do about it? The answer is to use a real time 3D engine that will make use of the user's computer graphics (CG) card to display your objects as you move about, changing your camera angle.

3D engines

Working in 3D requires lots of programming to do all the mathematics of converting 3D coordinates into 2D screen coordinates. There are many issues like working with Vector Math, calculating intersecting planes' faces, displaying objects by priority of distance, etc. As designers, we do not want to be worrying about these things, which is where a 3D engine comes in. It is the software that converts your 3D ideas into a displayable form. In your 3D animation package the engine is displaying your creations on screen. The software calculates everything so that you can see your models in real time, just about instantly. This is what we want if we are going to be able to view our animations in an interactive way. Using this idea we can view a whole world from any angle, navigate our way around it and interact with objects inside of it. Great! But it is not perfect, as you might have realized. So far when you have been viewing your objects in your animation package they appear at a much lower quality than after our final rendering, this is the trade-off. The amount of calculation involved in creating an instantaneous 3D environment means that you cannot have the quality that you can in pre-rendered animation. But it is getting better all the time, with the improvement in PC graphics cards and game consoles.

To create objects and worlds for real time interactive 3D we have to be much more careful about how we create things in the first place. The processing required to render your previous animations as high quality images is similar to that of real time processing. The main problem is that your high quality rendering could take up to an hour per frame, but we need to get speeds of around 30 frames per second (fps), matching that of television (NTSC being 30 fps and PAL being 25 fps). How is this possible? The answer is by understanding what slows real time graphics down and using this knowledge to design objects and environments in the most efficient way possible, without having to compromise quality too much.

Maintaining a frame rate

In my experience the most important thing about real time 3D is maintaining a high frame rate. It is this aspect that helps convince the viewer that the

scene they are watching is believable, more so than accuracy of rendering. A good example would be to take a car racing game. These have been around for the last 20 years, and the graphics involved has improved all the time. These games are always high in action and rely on giving the impression of a fast moving world. To convince the human that what they are seeing is a smooth motion and not a series of images, the frame rate needs to be high, that is greater than around 20 fps. Once a frame rate is lower than 20 fps then the motion seems jerky. Although traditional cell animation is often lower than this, you ignore this fact because it is the story and action that is governing your interest. With a racing game there is not going to be much story and the action is dictated by simulating a real driving experience. Ideally a racing game will play at 50–60 fps. This is twice as much as is necessary for smooth animation but ideal as your television is displaying graphics at twice 30 fps due to the way television pictures are made up in two fields, two half-resolution images per frame of video.

Creating content for real time 3D

We have said already that you will not achieve the same quality in real time applications than you will with rendered animation, so let us discuss what you can and cannot do. In theory you *can* have the same quality, but this would require computers thousands of times faster than present day ones, so we need to simplify our scenes in order to attain a decent frame rate.

There are many factors to take into consideration when creating content for interactive 3D, the most important of which is the audience your piece is aimed for and, in particular, the computers they are using. There is a general law about the speed of computer processors called Moore's law. It actually relates to the number of transistors on microchips but is generally used to say that the speed and capacity of computers will double every 18 months. Roughly speaking, this has proved itself to be true over the last 25 years. But how does that help us? You need to decide at what level of computer power you are aiming your project. If it is aimed at the fastest of computers, with the best graphics cards, then you will deny most of the population a chance to use it properly. However, if you make it for the lowest common denominator then it may not be very impressive. You have to find a compromise between impressing and annoying.

Another issue that you need to be aware of is that you will not be creating 3D work that runs through a highly optimized engine, such as a dedicated games engine. If you had the power of the latest consoles then you could go for a lot of detail and complexity that simply is not available on most PCs. It is likely that you will be using another software package to create your work in, such as Macromedia Director (as used in this book), Discreet Plasma, Cult 3D or one of several others. There is always some speed trade-off

with these programs in favor of a more user-friendly approach. Although this could be seen as a handicap, the benefits of ease-of-use outweigh the drawbacks. The skills that you are learning in this book are transferable to the games industry. In effect, we are trying to bring the games industry to the Web.

The more complex your scenes are then the more likely it is going to slow down the performance; so you need to adopt efficient practices when creating your models and worlds. Efficient modeling can be done in many ways and the following section describes what aspects slow your graphics down and what can be done to maintain as much quality as possible, without compromising the frame rate. Exactly what your project is will affect where you need to make the most efficiency saving, but generally a combination of the following concepts is going to be usual.

Number of objects

In a real time 3D scene, the positions, lighting and materials of objects are actually calculated one a time. When they are all worked out, the computer displays them. This happens so quickly that the impression is given that it happens simultaneously, in an instant. However, every object in your scene slows your computer down by a fraction of a second. This may not be obviously until you have hundreds of objects but object count is one of the biggest factors in performance of real time graphics.

If you want to test this speed issue out then create a few hundred cubes in your animation program. You can create a few, then select them and clone that group, etc. in order to achieve this more quickly. When you try and rotate your views you will see how much slower things are, compared to when you had just one cube on screen. You might find that your program changes the objects to wireframe boxes when you rotate the view, which is its way of maintaining a frame rate. Naturally, we do not want this to happen if we are creating an application or game. The object count issue becomes more important when combined with the next issue, polygon count.

Polygon count and face count

All CG cards create objects by connecting points together, creating faces. The simplest shape is a triangle, known as a face. Triangles can be tiled together to make any other shape. So when graphics are displayed in real time (e.g. in a computer game, or in the viewport of your 3D modeling program), the computer is actually displaying hundreds of triangles. It will then use techniques to smooth the view of these triangles, so your objects look less computerized.

As was mentioned in Chapter 1 of this book, in computer modeling programs a polygon is two triangle faces placed together, to form a square. Because the square is a flat shape, this is often confused with a face, and why polygon count and face count are often used interchangeably. In terms of real time 3D graphics, it is the triangle count which is important, as that is what the graphics card actually deals with.

Simple shapes, like cubes, may only have a few polygons. In real life we would consider a cube to have six sides, but in CG terms, it is made out of 12 triangle faces. However, there is nothing to stop each flat side of the cube being made out of a mesh with hundreds of triangles, arranged in a grid. This may not appear to be an issue, but more complicated CG shapes, like human figures can have thousands of triangles. Each triangle that is visible on screen needs to be displayed, so if you have hundreds of humans running about, that will dramatically slow things down. This is particularly so for animated objects, like characters as there is more to calculate, like the new positions of each triangle on the object.

Whole scenes can consist of hundreds of thousands of polygons, if you have created it for a pre-rendered animation. But for real time graphics we need to optimize the detail of your objects, wherever possible in order to reduce the polygon count.

There is another aspect to face count which is possibly confusing. Manufacturers of graphics cards will talk about being able to display millions of faces per second and performing thousands of trillions of calculations per second. That sounds a lot, but 3D graphics are exceedingly processor intensive. The latest 3D cards claim to be able to draw around 50 million triangles per second. But, if you wanted a 50 fps frame rate, then this is a million triangles per frame, or 500,000 polygons per frame. Excellent, you might think, but that is the optimal rate, for the latest graphics cards, which most people will not have.

Other factors affect the speed of your real time application, other calculations that you might be performing in your game or application. A computer game will have many different processes occurring simultaneously, so you always need to be trying to optimize every process. The greater the number of other processes going on then the more you will need to optimize the graphics. This book uses the Shockwave 3D engine, which is part of the Macromedia Director application. Versatile as it is, it is not the fastest 3D engine in the world, as it is not specialized just for games. Because of this I recommend aiming for a total of 25,000 polygons at most. This might even have to be lower, if there is a lot of movement in your scene. An animated object will take longer to display than a still one. In 3ds max you can check the number of triangles in your scene by going to the File > Summary Info menu option.

Texture size

There are two types of memory in your computer, the main system memory and the graphics memory. Generally speaking, these are independent of each other, but some PC's use the system memory for graphics (known as shared memory). The graphics memory is used for displaying the whole screen, displaying any 3D content, using textures in 3D objects and the quality of the textures. Typical graphics cards have between 32 and 128 megabytes of memory. Displaying the screen will take up more memory at higher resolutions and can take up to around 10 megabytes. Textures at full color will take any amount from 12 kilobytes for a 64 × 64 pixel texture to 768 kilobytes for a 512 × 512 pixel texture and a 1024 × 1024 pixel texture will take 3 megabytes of memory. If you include an alpha channel in your texture then it will add another 33% to the file size. All these numbers might seem a little baffling and off-putting, but it is important to keep track of it as you design your scene. So what happens when you run out of graphics memory in your scene? Your application will run very slowly as it tries to use your main system memory as graphics memory, which is a much more inefficient process. So, as you can see, if you want your piece to work well on a 32 megabytes graphics card then you cannot have many large textures. Another issue with this is that the graphics card will grab memory depending on the power of two that the dimensions of the texture fit into (Figure 3.1). This means that, if your texture measured 304 × 413 pixels, it will take up as much memory as a 512 × 512 texture, so you might as well make it that size, or reduce it down to 256 × 256, to be more efficient.

Working all these figures out can seem very laborious, but it is best to keep track of these as you go along. The best thing to do is to test your product on a computer that you know is not top of the range. If it works on that then you can be fairly certain it will work on most computers.

It is always a good idea to use textures that tile where ever you can. An example of this would be brickwork. Although in reality no two bricks are exactly the same, they are approximately, so you can select a square from a photograph of bricks and make them tile. This means you could have a very small texture, e.g. 64 × 64 and repeat it a hundred times to have a highly detailed large brick wall. The point to remember here is that it is the size of the individual texture that uses up memory, and not the amount of area it covers.

Animating textures

You might have a situation where you want a texture to be animated, e.g. a television set. This can be done in a couple of ways, either by having a sequence of images or using a video file. Either way the texture has to be

Figure 3.1 A demonstration of possible texture sizes

updated on every frame, which for larger textures can be a slow process. There is no easy way to avoid this apart from using smaller textures, which will update much quicker.

Another reason why you might want to animate a texture is to show flowing water. Moving the texture across the model, by changing the texture coordinates, can do this. This technique has practically no effect on the frame speed and so can be used. It is also possible to have multiple layers of texture flowing in different directions.

An important point to raise here is that in both of these types of texture animation, you have to do it in Director, with Lingo programming. It does not take a lot of code, just a few lines, but you cannot export this type of animation using the Shockwave W3D exporter.

Shadows

Shadows are great for that added touch of realism and in real life we take them for granted. Without them objects seem to float on top of the ground. The trouble with shadows is that they can be very complicated to achieve. True shadows are calculated by Raytracing, which is the idea of following a line from a light source to the object and then creating an outline on the ground. This is the most accurate form of shadow creation, but also by far the slowest.

Another much simpler technique is to place a soft edged shape below the character or object, if it is moving around the scene. This idea has long been used by computer games and works well enough from a convincing point of view. The black soft edged shape can be placed on a plane, using alpha transparency to fade it into the ground below, this plane is then set to follow the character as it moves around the ground. See Chapter 8 for an explanation of this.

A third method is particularly useful for room environments, where none of the objects is going to move. The idea is that you set your scene up in your 3D software and then render it with all the shadows and illumination that you want. The trick is to render it from the top view down and then from the four side views of your room. These rendered images become your textures, each with various shadows falling upon them. This technique works very well on the photorealistic front, but does mean that you can end up with large textures, which as we have already discussed, can be a problem. It means that you have to keep an eye on the texture size. You could load up all the textures just for that room and remove them when you leave it. This way you could create a large house, with lots of textures. This is discussed in more detail in Chapter 8 of this book.

There are other techniques for real time shadows, that computer game companies use. These make use of the graphics card's ability to cast shadows. The Shockwave 3D engine, although being hugely popular, does not currently support true shadows, and so advanced tricks are required to create accurate shadows. These are unfortunately processor intensive, which leads to the frame rate slowing down. This is why these second and third techniques are often used.

Reflections

This is quite a special case, as you often will not need reflections in your scenes. However, if you do have a pane of glass, a garden pond or a metallic object, you will probably want to have reflections in order to add that touch of realism. There are several ways to do this.

As with shadows, the best way is to use Raytracing, but this time tracing a path from the camera to the object and reflecting off until it meets another object. This needs to be done for every pixel on the screen that has a reflection material on it. This is even more time consuming than shadow Raytracing, and is pretty much impossible to do in real time, particularly because the Shockwave 3D engine does not support it.

The simplest, and effective solution, is to use a reflection map, this is a still picture, which might be a rendered view taken from the object. A reflection map moves around the object as your view of it changes. It gives the illusion of a reflection as you can often see the sky and surroundings in the object. This works best for complicated objects, such as an android, but does not work very well for flat planes as the result can be confusing. Its main advantage is that it is a fast solution.

The next option is probably the best quality, but is still fairly slow. It involves dynamically taking snapshots from a camera point, behind the mirror or reflected surface, every frame. The image is projected onto the reflecting object. The problem here is that this technique uses the computer processor as opposed to the graphics processor. As your computer processor is probably doing many other things, your frame rate could be dramatically reduced. In short you are unlikely to use this technique apart from for very small reflected surfaces.

Deforming objects

Deforming objects are any objects that change shape, Morph or are animated with stretchy skin. This could be a running character, where you have already worked out the walk cycle in your 3D package and exported the animation. If the object has a large number of triangle faces then the amount of time it takes to calculate each new face position is increased. Characters typically have to be as low in triangle count as possible in order to attain a smooth animation. A character with more than 1000 faces may appear to be low in detail, but is already getting large for the purposes of Shockwave 3D and you should try and remove as many unnecessary faces whilst still retaining the look of your character. You could have a higher face count, if there is not much else in your application. But if you

have many characters or a complicated game, you will always have to compromise here.

The trick to creating detail in your objects is to use bitmap images to give the appearance of 3D detail. For example, heads of people should be mainly made up out of these bitmap textures as opposed to thousands of triangle faces for details like ears and eyes. Of course, if sticky out ears are essential to your character then you will put them in. The trick is to reduce polygon count in areas that do not deform in your character, and other flat areas.

Reducing polygon count is discussed later in this chapter, where 3ds max's Optimize modifier is used. Chapter 5 takes you through low-polygon character modeling, meaning modeling deliberately to keep the triangle count low. It is always most important to optimize the face count of objects that change shape.

When you are preparing content for the Shockwave Exporter there are some restrictions that you need to be aware of. You cannot do standard Morphing (changing the form of an object from one state to another) or even Sub-Object deforming (like the pressing down of the turtle's back that was covered in Chapter 1). You have to export these objects in each of their different states and then you would use program Lingo code to do the Morphing. Lingo is the programming language of the Macromedia Director application.

The Metamorphosis kinetic sculpture seen in Figure 3.2 was created entirely in Director, by programming and is an example of a Morphing object.

Figure 3.2 Six screenshots of 'Metamorphosis', an interactive morphing sculpture, by Anthony Head

In Director you can create primitive objects, such as cubes, cylinders and spheres. The Metamorphosis sculptures, involve the deformation of a sphere into two states. The deformed sphere then pulsates between the two states in a smooth manner, depending upon programmed properties, such as elasticity and friction. The project actually involves six sculptures, each with different properties.

The kind of Morphing objects involved in the Metamorphosis projects cannot be exported from 3ds max to Director. You would simply get the original shape, with no animation. However, it is possible to achieve a Morphing animation using bones, giving your objects an internal skeleton structure. 3ds max has two types of system for this, one is called 'bones' and the other is Character Studio Biped. Both can be used for character animation, where your skeletons are 'skinned' by the character object. The information that gets exported is the bone animation as well as the mesh. Shockwave dynamically calculates the deforming of the mesh as the character moves around the scene. This means that it is possible to merge bone animations together, e.g. changing from a running motion to a jumping motion, as the information required for movement is just the bones and the object vertices relation to those bones, that is how strongly their position is affected by the bone movement. This concept forms several chapters of this book.

Exporting to Shockwave

We have talked now about how to prepare your 3D models and objects in order to get them into a 3D engine program, in our case Macromedia Director. You will be exporting a file with an extension .w3D and this file will be imported into Director. From Director we will export a Shockwave file (with the .DCR extension) for use on the Internet. The W3D file you export from your 3D program will not work as it is, it has got to be edited and re-exported in Director.

We have covered a lot of detail that might not seem relevant at this stage, after all we have not made any interactive 3D environments as yet. Even if you only skimmed through it, you can use the information as a reference as you continue. The main thing we have not covered so far is what kind of materials we can successfully export to Shockwave, because unfortunately it is not all of them.

Most of the time when you are creating a model you will probably use a bitmap texture to cover it. This method gives you great flexibility, as you can create your own from photographs or scans. Bitmap textures are what the Shockwave engine understands and uses. However, many of the material maps in 3ds max are not bitmap based, they use procedural textures.

Procedural textures are created using algorithms that create repeating patterns. As you need to keep textures fairly small, you need to be able to use tiling patterns wherever you can. There are two types of procedural maps: 2D and 3D. The 3D maps are more powerful but are not supported by Director, so you can only use the 2D ones, such as checker and swirl. The table below shows some of the 3ds max maps that are compatible with Director. All the maps should be applied as Diffuse maps to appear normally on the model that you have created.

Map name	Extra options	Notes
Bitmap	Noise	Can be most types of imported image, including alpha transparent bitmaps
Checker	Noise, soften	Checker can be a mix of two other maps
Gradient	Noise	A way to blend up to three different map
Gradient ramp	Noise, gradient types (four corners, box, diagonal, lighting, linear, mapped, normal, pong, radial, spiral, sweep, tartan)	Only mixes colors, not other maps
Swirl	Twist, contrast, intensity	Mixes only color

Note *There is an issue with transparency in Director which means that objects that have semi-transparent materials do not intersect correctly. This is due to the Z-buffer, which is the aspect of 3D rendering, which calculates how near and far objects are. Most of the materials above (apart from bitmap) end up including a level of transparency. To get round this deselect materials when using the W3D exporter.*

Putting the knowledge into practice – creating a sound toy

To take us through creating some 3D that will be interactive and real time, it will help to have a practical example to deal with. We want to make something that is interesting and appealing to the user and, for the sake of demonstration, an artifact that will show something of what is possible without being too technically difficult at this stage. Obviously you want to make impressive websites, but there is no replacement for creativity, you need to draw on as many influences as you can and extract them into your own ideas. The following tutorial is very loosely based from the point of view of

3D modeling as I hope that everyone who follows it will come up with his or her own version of its topic, a sound toy.

Sound toys are a type of Digital Art and come in many shapes and forms, but essentially refer to any interactive computer generated artifact that deals with sound and more often than not, vision. The basic idea behind a sound toy is that they encourage the participant to play, and that is a good thing for any website. Fun things give your website traffic, which is surely the aim of anyone wanting a website, to get people to visit and keep visiting. Creating a toy or a game is a popular way to attract people to your website. We will cover concepts involved in game creation later in the book, but first, we now will make a wobbly, stretchy, elastic sound toy that you control with the keyboard.

Exercise: making the sound toy

There are two phases to this exercise, the first is creating some 3D models and placing them in an environment and the second will be applying motions to the objects in Macromedia Director. You already have some modeling knowledge and this section is a chance for you to explore your 3D package without having to worry about accuracy of modeling. The second stage will be your introduction to Director, which has many powerful features that usually rely on knowledge of its programming language Lingo. To make life easier at this stage, the programming has been done for you and you will be able to select actions and sounds for your objects, whilst familiarizing yourself with the Director interface. Finally you will be able to publish your movie as a Shockwave file for use on the Web. Figure 3.3 shows the sound toy included on this CD with this book.

The modeling

It does not matter much which methods you use to create your objects as they are going to end up as fixed meshes. You will not be doing any animation in your 3D program. The objects you create can be as complicated as you like, but you have to be aware of face count, about which we have just talked. I recommend going for an abstract approach as the objects you create will move, but not in an animal-like way, but vibrate and distort. They will have properties of elasticity and friction, combined with different actions like spin and stretch.

You might want to create standard musical instruments, but this is the world of your imagination that we are dealing in so your objects can be anything. You can use this chance to explore some of your 3D packages options for model creation, exploring various modifiers or going crazy with polygonal modeling.

Figure 3.3 A simple example of the kind of sound toy that you could create

Polygonal modeling

You have already done this in Chapter 1 when you created the turtle and Chapter 2 when you created the head character. By creating a box and converting it to an editable mesh, you can Extrude and Bevel polygons (make sure you are in Polygon Sub-Object mode). You can either work to a design from paper or just Extrude and Bevel away at your will. I have created an abstract shape that you can see in Figure 3.4 and then applied the Mesh Smooth modifier to make it aesthetically more pleasing.

Mesh Smooth

Using the Mesh Smooth option often improves the look of your creations, making them more organic in shape. Any object that has unwanted sharp edges can be smoothed off with this modifier. The issue with Mesh Smooth is the resulting face count, so do not increase the iterations too much.

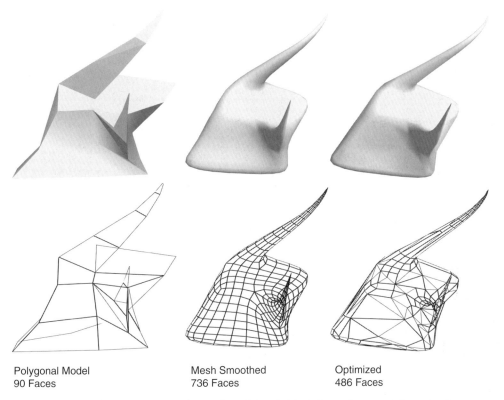

Polygonal Model Mesh Smoothed Optimized
90 Faces 736 Faces 486 Faces

Figure 3.4 A polygonal model with Mesh Smoothing and Optimization

Optimize

In 3ds max you can use the Optimize modifier to reduce your face count, by adjusting the Face Thresh parameter. This can sometimes lead to undesirable outcomes in your models though, particularly if they are complicated, so use it with caution and judge for yourself if you have tried to reduce the face count too far. Figure 3.4 also shows the result of optimizing the shape, there is a significant reduction in face count with only a slight deterioration in the quality of the model. Note that the reduction is more significant on flatter areas.

Another issue with the Optimize modifier is when creating objects which use the Multi-Sub-Object Material. You will use this later in the book to map textures onto a character. The problem with optimize is that it reduces the face count mathematically and not by aesthetics. This means that faces that you might want to stay unchanged can be removed, making it difficult to place the textures where you want them. It can also cause problems if you use it on an animated character as it can stop the mesh bending in the correct places. However, if you are only simply applying a material over the whole object and is not animated then this may not be an issue for you.

Note *For our sound toy we will only be having a few objects in the scene,
 and hence we can get away with relatively large face counts for each
 object. If we were making a computer game with possibly hundreds of
 objects then we would be a lot more thorough in reducing the count,
 with careful modeling.*

Other modifiers

Your 3D package probably has many ways in which you can create and
distort objects. 3ds max has modifiers, such as melt, stretch, spherify, ripple,
relax, noise, taper and twist. In Figure 3.3 the left hand shape was created
by melting a cylinder, which had many height sections, and twisting it. The
six upper floating shapes were just created from spheres that were stretched
and tapered. The bottom right hand shape is a Tube primitive that has been
Mesh Smoothed and the middle shape is a polygonal model.

Mapping

On the shapes in my scene I have used a number of maps taken from the
list in Figure 3.2. To make my objects more interesting, I have used a reflec-
tion map. The map should be one that matches the environment, in my case
a checkered box room. So I used the same map on these shapes as the
room. The effect of this is best when you see it in real time 3D, when you
export your creation as a W3D file. The idea behind the reflection map is
that it always faces the camera, and then moves around the object. This
gives the illusion of a reflective surface. I set the reflection amount down
to 10% as I wanted it to mix with the Diffuse map that I had selected. As
I mentioned earlier, reflection mapping works best on curved shapes.

Exporting to W3D

When you are happy that you have created an interesting setup for your
sound toy, with some interesting shapes and objects, it will be time to export
them. If you have not done so already, make sure that all your objects are
named in a way that makes sense to you. You can only export the scene if
you have the Shockwave Exporter installed on your computer. This is a gen-
erally free plug-in that can be found on your 3D application's website. The
exporter window is different for each 3D application but Figure 3.5 shows
the 3ds max version. You will see the kind of features that you can export.

You export by going to the File-Export menu and selecting Shockwave 3D
Scene Export (*.w3D). The Export window will appear after you have
chosen a file name for your scene. There are several options on the window
that will be already selected for you.

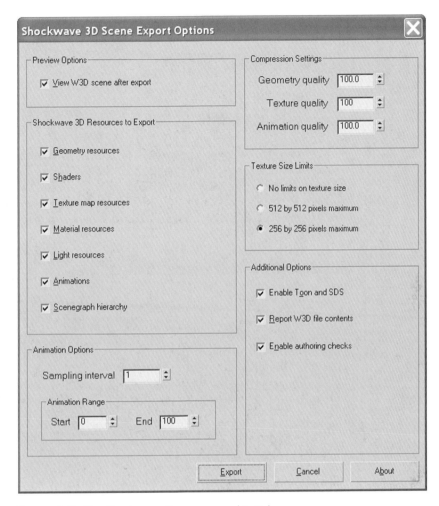

Figure 3.5 The Shockwave Exporter panel in 3ds max

Preview options

This option is very handy as it will show you how your scene will look after you have exported it. You can rotate around the scene by holding the mouse button down and dragging.

Compression settings

These options allow you to reduce the size of the exported file. Experimenting with these can be very useful if your scene is large. You want your file to be

as small as possible so that end users can download it quickly. Be wary of lowering these numbers too much as they could have unwanted side effects on your scene. Compression settings lower than 50% are likely to have a fairly dramatic effect on the quality.

Texture size limits

This is handy to set if you have used bitmaps where you have not edited their size already. It is always best to keep textures at a size that is a power of 2 as mentioned earlier, but these options will resize them. Be aware that if you have a large bitmap, that reducing the size will reduce the quality, but that is part of the compromising you have to make when creating real time content.

Shockwave resources to export

Generally you can keep all of these options checked. If there is no animation in your scene, then none will be exported. There is an issue with Shockwave that makes objects not intersect properly if there is transparency in them. The maps other than bitmap, e.g. swirl, etc., do contain transparency. If you use these maps then uncheck the material resources box. This will not make an obvious difference to your file, but means you will not be able to have semi-transparent objects if they intersect with other objects.

Animation options

In our sound toy, we are not going to do any animation in your 3D package (although there is nothing stopping you experimenting with it). Animation files are generally quite small and so I recommend you keep Sampling to 1 which means the same number of keyframes as you put in. Make sure that the range covers the full length of your animation if you have any.

Additional options

You might as well keep these objects checked as they can give you information about your export. You will probably always get messages indicating that things are wrong, e.g. you will be warned that you have used a non-Blinn shader. However, if it does not look wrong, it is not and you will find that this error appears if you have the Blinn shader selected in your materials.

Now you have set the options it is time to make our scene interactive, using Macromedia Director.

Introduction to Macromedia Director

Director is a multimedia production program and our chosen platform to create our interactive sound toy. Director is responsible for creating Shockwave movies that you find on the Web, often computer games. There is sometimes confusion between Director Shockwave movies and Flash movies. These two programs are similar in what they do and are made by the same company. Traditionally, Director was aimed at creating CD-ROM applications, e.g. educational software with video content and Flash aimed at the Web animation market. There are, in essence, two main differences between these two programs. Flash has superior vector graphic capabilities and Director has superior 3D capabilities. Director is better at incorporating other media, such as various video formats and QuickTime (including QuickTime VR). It is also possible to embed a Flash file into Director, but not vice versa.

We are going to use Director for its 3D capabilities and this is best done with the use of some programming. Where Flash uses a programming language called ActionScript, Director has its own language called Lingo. As this is just an introduction, I have done all the programming for you, but if you are already familiar with Lingo then you will be able to look at and adapt the Lingo scripts for your own uses. Above all this whole exercise has been designed to be flexible and provide a wide variety of results.

The important parts of the Director interface

There is a lot to Director and many ways to use it. As we are only going to be delving into the 3D aspect of this program, we will skip somewhat the detail about all the options and concentrate on the relevant aspects. Figure 3.6 is an enlarged view of the important control buttons you will need to be familiar with in order to navigate easily through the different windows of the application.

Figure 3.6 A section from Director's top tool bar

The first section is the control panel, with the Rewind, Stop and Play options. It is often important to rewind a movie before you play it and so it is a good

habit to always do this. The next contains the buttons for the Stage window, the Cast window, the Score window, Properties Inspector and Library palette.

The Stage

As the name suggests, this is the window where the action takes place. Macromedia Director, for the most part, uses Theater terminology as a way to make its components easier to understand for users. What you see in this window is what the end users will see in the Shockwave movie that you will create from this exercise (Figure 3.7).

Figure 3.7 The Stage window

The Cast

The Cast is where all the objects reside that you are using, e.g. graphics, sounds and Lingo scripts (Figure 3.8). This is similar to the Library in Macromedia Flash. There are many types of media that can be imported into Director, but we shall deal with just a few, the Shockwave 3D (.w3D) file, some sound files (.MP3's or .WAVs) and also some Lingo scripts (Director's programming language) which will be explained later in this chapter.

Certain objects (like graphics) can be dragged on to the stage, creating an instance of that object. When a graphic is on the Stage it is known as a Sprite. Sprites can be controlled through Lingo or by using keyframes in the Score. In our case we will Drag the W3D Cast Member on to the stage, but we will not be moving it about.

Figure 3.8 The Cast window

The Score

The Score is similar to Flash's timeline. It shows two counters, the one going across is the Frame number and the one counting downwards is the Sprite Channel number (Figure 3.9). You could create a Sprite and it would appear

Figure 3.9 The Score window

in Sprite Channel 1 on frame 1. You could then make it last until frame 20, and move it, creating a keyframe. This would be animating in a similar way to Flash and 3ds max. However, for 3D work, we will not use Director this way, our 3D sprite will stay in frame 1 and will not move about the Stage. It is within the 3D sprite that all the action will take place, using Lingo.

The Property Inspector

The Property Inspector displays important information on settings for your Director project (Figure 3.10). If you click on the Stage and then select the

Figure 3.10 The Property Inspector, showing the movie information

Property Inspector you are able to view the Movie properties. It is here that you can set the movie size, which is the pixel size of the Stage. Bear in mind that this has to fit on most people's Web browsers. However, it is possible to set up your movie to stretch to fit the area of the Web browser window, as it is with Flash.

For our purposes the other important feature in the Property Inspector is the Preferred Renderer option. The graphics card inside your computer contains hardware to calculate the display of your 3D content and the Preferred Renderer option will choose from a few different methods that it can do this, namely DirectX, OpenGL and Software. DirectX and OpenGL are graphics standards that programmers use to instruct the graphics card on how to create the 3D display. In the case of Director it is the programming language

Lingo that we use and this is converted to DirectX or OpenGL code automatically. The other option of Software is to let the computer's processor calculate the 3D display. This is always slower than allowing a graphics card to do the job, as the central processing unit (CPU) is not dedicated to graphics calculations. Generally selecting Auto will allow the user's computer to decide whether to use DirectX or OpenGL. In simplistic terms, there is not a lot of difference between the two, but try to avoid selecting Software mode as it is by far the slowest method.

Note *If your 3D scene contains many complicated objects and large textures then you could reach the limit of the graphics card memory (which might be 32 or 128 megabytes). If this is exceeded Director might automatically switch into Software mode and be very slow. This is why you need to consider texture size when creating your scene in your 3D package.*

The Behavior Inspector

The little picture of a gear cog displays the Behavior Inspector. This contains one of the methods you can use to add scripts to your 3D world to control objects within it (Figure 3.11). You can use Lingo scripting to change the position of objects, alter the textures that are mapped on to them, move the camera position, create new objects from scratch as well as more complicated functions. New objects have to be primitive shapes, e.g. cubes,

Figure 3.11 The Behavior Inspector showing how to select a behavior or create a new one

spheres and cylinders which is why we have created our objects in a 3D package. It is a lot easier to create interesting objects this way and get away from the basic shapes.

A behavior is a script that contains commands and calculations to control objects. You would normally have to type this in by hand and learn many commands. For the tutorial described soon and at this early stage in our use of Director we have adopted a simpler method for you to use, where you only have to apply the settings of an already written script.

Making our sound toy move

This tutorial will allow you to animate your static scene, based on physical properties, such as elasticity and friction. Changing these properties on each object will make it move in a different manner. The movement will be triggered by keystrokes. As well as animating your scene, we will import sounds which can be used to correspond to your objects. The process of completing this tutorial will help you familiarize yourself with Director in addition to the creation of your own unique piece of work.

First of all load up the SoundToyNew director file from the CD. This is essentially a blank file but it contains the scripts that we need to use. If you look at the Cast window you will see them listed in cast positions 2, 3 and 4 (Figure 3.12). You will see that each script Cast Member contains a title, an icon and a snippet of the actual code that it contains. The second two scripts

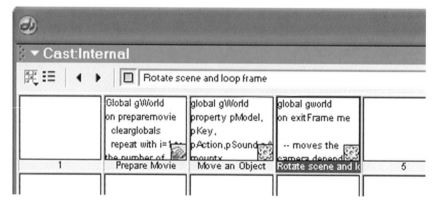

Figure 3.12 The Cast window showing a Movie script and two Behavior scripts

contain the cog icon that we are now familiar with. They are behaviors and will only work when they are applied to the Score. The first script, called Prepare Movie, has a different icon and is not a Score Behavior script, it is a Movie Behavior script. Movie scripts are generally used to create actions

that can be accessed by any other script, or for setting up conditions at the beginning of the movie. In our case it finds out which member is the 3D Shockwave one (which we have yet to import) and then carries out some actions on that Cast Member (to fix the transparency issue if you have used procedural textures in your scene).

Importing the Shockwave 3D .w3D file

At the moment our movie will not work, if you tried to run it (by pressing the Play button) it will error. This is because the Prepare Movie script is trying to apply commands to an object that does not exist, that is, the 3D Shockwave member. So you need to import it. There are a couple of ways to do this, one is to select the space where Cast Member 1 would be (in the Cast window). Right click and select import from the menu. Then find your .w3d file that you exported and press import. It will now be in Cast Member 1 and you will see a thumbnail image of it, along with a Shockwave 3D icon.

Now you have imported it you need to bring up the Stage window and drag the Shockwave 3D member on to the stage. It is now an instance of the Cast Member, referred to as a Sprite in Director. It is at this point, if not before, that we need to decide how big we want our movie to be. We mentioned earlier that the resulting Shockwave Movie can stretch to fill the Browser window, but you may not want to do this, so I suggest a size of 700 pixels wide and 350 pixels high. This should fit on most browsers, but choose any size that you want, bearing in mind what else you might want on your web page, other than the 3D Shockwave movie. You could have your movie open in a new window or completely fill the screen. You would do this by using JavaScript commands in your HTML editor, such as Dreamweaver.

Once you have set the movie size, using the Property Inspector you need to position and stretch the Shockwave 3D member to fill the stage area. You can check with the Property Inspector that it fits correctly by adjusting the settings, which will now refer to the 3D sprite that you have selected.

Using the Score

Now we have our 3D sprite on our stage we need to use the Score to tidy up our movie and make the play head loop around one frame. Make the Stage window visible by pressing its icon on the top tool bar. You will see that in Sprite Channel 1, the 3D sprite is represented by a long bar. Grab the right hand end of the bar and drag it back to frame one. The results in

the Sprite being only visible for one frame, but this frame will be looped so that the 3D sprite is always visible.

Using a Frame Behavior

The next step is to make the movie loop around the first frame. This is a simple Lingo command, 'Go to frame 1' and it occurs every time the play head exits the frame. This command is contained in the 'Rotate scene and loop frame' behavior, but it will not work until it is dragged onto the Score. The correct place to drag it is into the frame square above Sprite Channel one. You will see that there is a Script icon on this row. When you drag the Frame Behavior in it will always be one frame in length, which is what we want (Figure 3.13).

Figure 3.13 The Score window showing the Tempo, Frame Script and 3D sprite

This behavior also has other functions, if you play the movie, by pressing the Play icon, you will see that the 3D scene rotates. This is actually the camera orbiting around the middle of the world. You will also see that moving

the mouse up and down changes the Camera's height. Obviously quite a bit is happening here and if you are already familiar with Lingo then you can look at the script to see how it is done.

Making your objects interactive

Now is the time to make our scene more interesting by bringing it to life. First of all we need to import some sounds. It is generally preferable to create your own sounds. You can use Windows Sound Recorder as a very basic recorder, but there is plenty of Audio Software available. If you do not want to record your own sounds then you can always buy sound sample CDs or download sounds from the Internet. As a starter we have included sounds on the CD with this book, so you can start by importing them from the Chapter 3 folder. Just right click on an empty Cast Member and select import. Then find the sounds (various sound file formats are acceptable including .wav and .mp3), add them to the File List and press import. Your sounds will now appear in the cast. If you imported more than one then each sound will become a Cast Member.

The next stage is to use the script that controls the motions, sounds and triggering. Drag the Cast Member 'Move an object' from the Cast window to the stage, dropping it onto the 3D sprite. A new window should appear showing many parameters as in Figure 3.14.

Figure 3.14 The 'Move an Object' Behavior window

The script for this behavior controls many different properties. All you need to do is select which object in your scene that you want to move, which key you want to trigger the movement and what type of movement you want it to have. You can then select how much motion you want in the three different axes x, y and z. The amount of elasticity and friction will determine the speed and physics of the motion. Finally you can choose a sound and set the volume of that sound. There does not need to be a science to how you choose this, just experiment with different settings. Setting the elastic and friction properties to extremes can have pretty wild outcomes, but it is entirely up to you what you do. Once you are happy with your settings press OK.

When you play your scene the key that you selected will trigger your movement and play the selected sound. If you decide that you are not happy with your settings and want to change them then, making sure you have the 3D sprite selected on the stage, go to the Behavior Inspector and double-click on the behavior. This will bring up the options for you to change.

To make more objects move, just drag another instance of the behavior from the Cast onto the 3D sprite and create settings for another object. Some of the sounds supplied on the CD are musical notes, enabling you to make a more melodic sound toy.

Interview with Eduardo Carrillo

http://www.locombia.net/eduardo/

Profile

Eduardo Carrillo is an independent Web Artist, originally from Columbia; he now lives and works in the UK. I first met Eduardo in 2000, when he was resident artist at London Guildhall, and I have since followed his artistic career with interest. Eduardo relies on funding from Arts bodies to create his Web artifacts. His work ranges from creating films from naïve drawings by refugee children to creating symphonic sound-and-vision 'scapes' in collaboration with the London Sinfonietta. A dedicated fan of all things Web, Eduardo has shown with his Javadance piece that 1 day choreographers and dancers will be able to study a library of dance interactively from any angle.

Interview

How do you describe yourself, professionally?

I am a Digital Artist.

Do you collaborate with other 3D animators, Flash animators and programmers, or do your skills cross-over?

Yes, I work a lot with Lingo programmers. I have to work with producers on many of the projects and I like to involve musicians in the early stages of the process.

3d music - a braunarts / london sinfonietta production

You are now in the SPHERE OF PYTHAGORAS

Use the **Arrow** keys to move around, **Shift+Up** or **Down Arrows** tilts up or down. If the cursor changes to a hand, use the **mouse** to move / rotate the object.

Go through the circular portals to teleport between spaces.

If "collect" glows red when your cursor is over an object, press the spacebar to collect it.

collect:

If 'playroom' glows red, click on 'playroom' to enter the new space and play with your collected objects and sounds...

playroom

General design and 3D

How did you get started in digital design?

First I studied television in Columbia, and then after working for 3 years I decided to study something where I could be more creative. I came to England, and studied for an MA in computer animation. My work is more than just digital design; I am also an animator who creates digital environments and worlds.

What are your inspirations design-wise?

I admire a lot of video games, like 'Black and White' and 'Mist'. These are games that are not just shoot-'em-ups or racing cars, but games that give you experiences when you are playing.

What do you think is the essence of good 3D design? Can you give any general tips?

I believe your work has to be simple and the user must not get lost in the design. Be faithful to the universe that you are creating. The important thing is not to try to impress but to be practical and simple.

How important do you think interactivity is to your work?

I believe that the Internet is a synonymy of interactivity. I cannot imagine, in the future, web pages without interactivity. One of the intrinsic characteristics

about the Internet and video games is interactivity. This will be the future of our art, which will develop around interactivity. You really have to think about the user and how they are going to react with your piece of work.

What aspect of development would you say is the most time consuming?

For me, to get the right idea is the most time consuming part ... it is a lot of trial and error. Once you have conceived the right idea, then it is more or less easy to develop your project.

In your opinion does 3D technology have any advantages over 2D when creating websites?

Yes, it gives the users more possibilities, you can see an object from all the points of view, and also you can immerse the user in a world which you cannot do in 2D. 3D gives you the sense of feeling part of the world.

What are your thoughts on the use of interactive 3D in art?

Interactive 3D in art is at its birth, it will take some time to start to develop its own language. We are just the pioneers of this. It is like video games, now we are starting to see intelligent games, not just shooting and racing. But it took several years to start to develop in different way.

Your past and future work

What awards have you won and do they make a difference?

For me the grants are more important than awards because the grants help you to realize your vision, they give you the money to be free. I was given a grant to make 3D Music, by the Arts Council and The Getty Foundation

gave us the funding for the Java dance project. It really makes the difference because without their money it would have been impossible to make these projects.

How did the concept for 3D Music website come about?

We really worked together with the musician, we met once a week and talked about ideas and concepts and then we developed the work alone. For example we worked with the idea of the Arctic pole and isolation and then we created the room called 'forest glass' in 3D Music. One week later we would meet again and change the work little by little until we felt confident with the universe we created, and so on. It was very organic, the way we worked together.

What are your thoughts on collaboration with other artists?

For me it is very important to work with other disciplines, as I say a good movie is not just the director's work, but the actors, the composers, the art director, the photographer, etc. A good piece of work is not about one person but a group of talented people working together for a vision, the director's or producer's vision. So I always try to involve people from different disciplines in my projects.

Any special future projects using 3D?

I am developing a project in 3D with Amnesty international in which there is a world with interviews of people talking about their personal and tragic experiences.

I am also continuing my work experimenting with dance using motion capture with Roehampton University.

Technique

Can you explain your use of motion capture for your dance examples?

I made 3D scans of sculptures from the 4th century, after having these sculptures in digital form, we worked with a dancer to perform a Javanese dance. We captured his movement and then put in the model that we already had as a 3D scan.

How easy is it to implement motion capture into a 3D project?

One of the big problems of motion capture is the creation of a lot of key frames for the movement. You can, of course, optimize these movements. However, a dancer really sees the difference and to them it is quite important, even though to an animator there is not much change. So you really have to have big files instead of small files.

Are there any specific problems with using motion capture?

You would think using motion capture would be straightforward and you could apply the capture files to the models and everything will work smoothly. This is not the case, you really have to convert the files, and most of the files are quite big. So you really need a super computer or you need to work with movements of no longer than 45 seconds. Then you can tidy the information you have of all the movements together. The other difficulty I found is that motion capture is very good for extreme movements, jumping, running stretching, but it does not work well for gentle movements near to the body, sometimes the sensors do not pick up this gentle movement and treat it like a corrupted file (I am talking about affordable motion capture and not thousands-of-pounds motion capture systems).

Which technology do you think will be the leader for 3D on the Web? (For example, Shockwave, Flash, Pulse 3D, Virtools and VRML)

I believed it will be Shockwave, not necessarily because it is the best but because it has a big company behind this technology; Macromedia.

Do you prefer vector 3D or highly rendered 3D?

I prefer Shockwave that is like vector 3D, it takes less time to downloading and like I say above it will be the future.

Insights

Do you have any advice for students of 3D Web Design?

Just to keep with simple ideas, the simple ideas are the best ones. Instead of trying to explore new technologies try to say something, look for good designers and try to imitate them and then you can add your own voice.

How do you get commissions for 3D work?

Just meeting people, and showing your work to all the people you think can help you. Meeting people is a key factor in the industry, sometimes the clients do not have the time to look for the best one, but for the handiest person. Going to seminars, master classes and meeting with people.

3D has almost taken over the games industry; do you think it will become predominant in Web Design?

Yes, Yes and Yes! I will put my hand on fire over that. When broadband is common in households I believe 3D design will explode. It will be great because then the only limit will be the sky and beyond that, because we won't have to worry about the size of files.

Does current Web technology allow you to achieve all of your creative ideas, what improvements would you like to see from software?

I would like there to be improvements in how sound is handled and for there to be better rendering, a better quality in picture. It would be great if you could use all your particle systems translated into 3D software.

Chapter 4

Designing and making characters

Animation – the chores and the charms

Let us face it animation is hard work, there is so much to think of, and even with all the digital tricks that a computer brings to the party, it takes time. I once added up all the different hats a student needs to wear to make a short animated film. It is quite a list:

- Starting with the *Producer* who has an idea …
- The *Writer* creates the story and dialog.
- *Casting Agent*. The 3D modeler models the characters.
- *Make-up* and *Costumes*. Then chooses materials and maps them onto the characters.

- *Sound* records the necessary tracks and times them.
- The *Director* decides how best to tell the story in terms of location, shots, transitions, compositions and overall style.
- The *Actors* and/or *Animal Wranglers* work out the performance action, timing and delivery.
- The *Photographer* chooses the best camera angle, lens and any camera moves.
- The *Lighting Cameraman* places lights to illuminate the scene and create the right mood.
- The *Set Designer* and *Props* will decide what needs to be in shot and what does not, the age, style and entire look of the set.
- The *Special Effects Designer* is consulted for any 2D to be added afterwards or projected now, and works out any explosions or particle systems.
- The *Compositor* grades the film, matching shots to create an overall smoothness and composites the elements together.
- The *Offline Editor* matches shot to shot with the sound, adding new tracks and pacing the film.
- The *Online Editor* formats the film, adding titles, credits and removing glitches.

And throughout, the Producer budgets for equipment you can afford to do all this on, and timetables the work while selling the film for distribution.

That is up to 17 jobs all with different hats. Oh, and you have to self-cater too. Many of these jobs are staffed by people with decades of experience in their craft. As far as 3D student film making goes, it is worth remembering that the filmmaker's role is not only that of the Director, but also the entire pre-production, production and post-production crew. Feeling daunted?

If animation is such hard work, why undertake the sheer hard graft of it all? Because its magic, that's why.

It is human instinct to communicate, to tell stories and share experiences. Animation has a way of communicating at a most fundamental level. A child walking into a room where a cartoon is playing on television will stop and watch as if drawn by a magnet; the attraction is immediate. That is why cartoon characters are used to endorse products. This same instant appeal is why we have *The Jolly Green Giant* and the *Frostie's Tiger*.

I have a pet theory that all animators are anarchists. They have looked at the world and said 'Preeety good going, God, but what's with the camel?

LIVERPOOL
JOHN MOORES UNIVERSITY
AVRIL ROBARTS LRC
TITHEBARN STREET
LIVERPOOL L2 2ER
TEL. 0151 231 4022

You could not decide one hump or two? And, not to get too heavy, but gravity, couldn't you just have made life just a bit more, well, bouncy?

Come on I can do better than that! What if we took an armadillo and added it to a kangaroo – Now you are talking! And while we are on the subject, get a move on with those Aliens; we need some new blood around here!'

You, as an animator get the chance to play God; a chance to create your own Adam and Eve and put them through their paces.

So here we are. We want to play God, and we want to tell a story. The first thing we need to think about is making a character. As animation is such hard work; you would better love your character, you will be spending a lot of time with them! And this is particularly relevant in 3D because you have to pay a lot of attention to not just how the character looks, but how it is constructed.

Character design

When deciding to cast your animation, the first thing you should think about is your audience. Is your character going to interact with the real world or be part of a kid's game? Realism versus caricature, or entirely imaginary? Always design so that your characters are exceedingly appealing to your audience.

The approach you have decided upon will dictate the proportions of your character. Realistic humanoids are roughly six heads high. Cartoon characters are four heads for more natural looking characters, and two-and-a-half to three heads high for classic cartoon proportions. This is because two-and-a-half heads high is a child's proportion which is naturally appealing – E.T. was not the shape he was for nothing. Most animation is made with a target audience of 6–14 year olds. For the Web, you will have no control over your audience, but you should know whom you want to appeal to most; that demographic is whom you are aiming for.

How to design a character in 3D

Many people prefer to design a character on paper first, and that is certainly what most teachers would advocate in character design. Although I have noticed more and more students today like to roll up their sleeves and build straight into 3D – it depends on your experience.

There are certain cartoon shorthands that can be used:

- Bigger eyes, smaller size = More goofy.
- Small eyes, taller = More intelligent.
- Fat = Lazy.
- Spectacles = Boffin.
- Large Breasts = Foxy woman (no design of a nuclear physicist would include massive mammaries).
- String of Pearls = Domestic woman (Wilma Flintstone, Marge Simpson).
- Baby proportions = Innocence.

Another way of looking at cartoon shorthands is to read them as prejudices. They can (and perhaps should) be subverted. Lisa Simpson's a boffin, but she does not wear glasses. Pinky and the Brain reverse the look for smart and stupid. These are shorthands and *not* rules. Let us have a look at a specific example.

In Figure 4.1, I have designed an archetypical Bully on paper. What are the reasons behind my design? He is almost Neanderthal, with a heavy brow and his knuckles almost reach the ground. He is designed with a big, pugnacious jaw, low center of gravity, and a massive, awesome chest. I have given him small eyes to remove appeal, and an aggressive (but not offensive) logo on his chest. I left the Bully character deliberately square with no mesh smoothing apart from his head. I wanted him to look like a walking crate. The finished model is shown in Figure 4.2.

I have lit him with a massive, scary shadow to make him more daunting. And put a flower in his hand to subvert stereotypes!

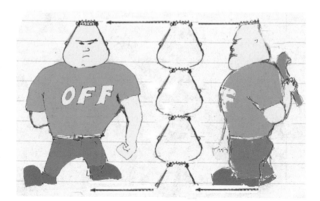

Figure 4.1 Bully designed on paper (three-and-a-half heads high)

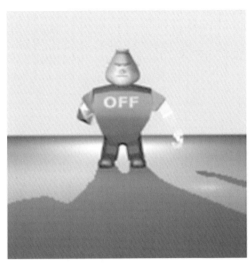

Figure 4.2 The finished Bully model

Modeling in 3D

One way of modeling from a drawing is to scan your drawings and put them into the 3D environment so you can work from them. To do this, create two planes at right angles to each other. Bring in your front and side drawings as bitmaps and assign them as color (diffuse) maps to the planes. Click on the 'Show Map in viewport' icon for each material and adjust their position using UVW mapping. You can then create a box (3 × 4 × 3 segments is usual), convert it to an Editable Mesh and fit the vertices to the drawing outlines in the side and front (orthogonal) viewports (Figure 4.3).

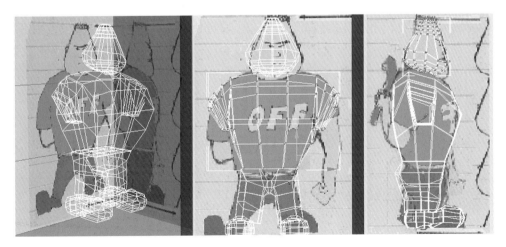

Figure 4.3 How to build a character from a projected drawing in 3D

Note *For animation purposes, it is customary to build a character in 'star pose' (standing with their arms out and their legs apart). The reason for this is that if the mesh is to be animated using deformation techniques (i.e. bones or biped), it is very useful to keep the spheres of influence as separate as possible.*

The finished Bully is made from separate boxes for the legs, arms and chest and a tapered oiltank for the head. His hair is a cylinder (Figure 4.4).

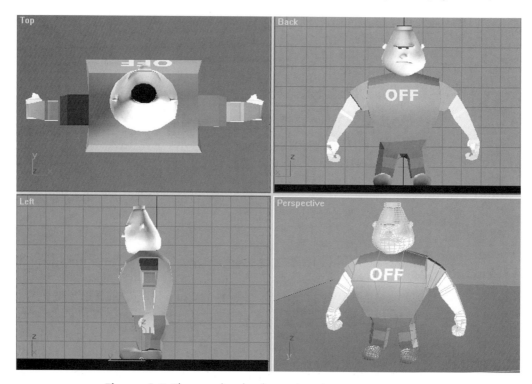

Figure 4.4 The completed polygonal mesh

The eyes have it

Watch any close-up of a lead actor in a movie, and see how their eyes glint. We register and read all emotions in our eyes; they are the window to our souls. Most characters you build in 3D will have eyes, in fact adding eyes to just about anything, makes it a character. In 3D there are two things you want from eyes; that they look great, and are easy to control. This tutorial shows a way of building eyes with lots of character that are fun to animate.

Create a sphere that has 32 segments. Label it R-eyeball. Select the sphere with the Uniform Scale tool and Shift-drag to create a second slightly larger

sphere. Set the hemisphere spinner to 0.5. Call this R-eyelid. Convert this hemisphere to an Editable Mesh to tweak the eyelid vertices at the edge into a nice, perky shape for definition.

Select the original R-eyeball with the Scale tool and clone a third sphere, mid-size between the two others for the pupil. Set the hemisphere spinner to about 0.85 and rotate the pupil so it looks at you from the front viewport. Label this R-pupil. Link the pupil to the eyeball using the 'Link' tool from the main toolbar.

Assign suitable materials to each object, such as a white shiny eyeball, black pupil, etc. Select all three Modified Spheres and copy them to the right to make the left eye. Re-label these 'L' (Figure 4.5).

Figure 4.5 Two basic eyes

Now we are going to add controllers for blinking and orientating the pupils.

Top Tip

For this to work correctly it is essential that the pivot points of all the spheres remain aligned. The pivot point (which represents an object's local center and its place in the local coordinate system) on any object is where the Gizmo is positioned when an object is selected. It is typically in the center of a sphere or cube when first created. To align (or re-align) pivot points use the 'Align' tool in the main toolbar. Select the object you wish to align, click on the tool (which will highlight in yellow) and select the object you wish to align to.

First we are going to add a Dummy to control blinking. A Dummy, helper object is a wireframe cube with a pivot point at its geometric center that does not render. You can create a Dummy by going to the Helpers panel and choosing Dummy (Figure 4.6).

Create the Dummy by Click-dragging midway between the two eyes in the top viewport. Adjust its orientation so that it is aligned on the Y- and Z-axis

Figure 4.6 The Helpers panel

with the pivot points of the eyeballs. Link the two eyelids to the Dummy. Select the Dummy and select 'Local' from the Reference Coordinate System in the main toolbar (where it reads 'View', next to the Scale tool). This will make sure that the Dummy will rotate on the same axis whichever viewport you use. Rotate the Dummy on the X-axis, to check that the eyelids make a smooth blink. (If they do not, then re-align your objects.) Label the Dummy 'Blink-Dummy'.

Now let us add a Dummy to control where the pupils look. In the top viewport create a Dummy that sits in front of the eyes, and some distance away. (This is where the eyes will look at, so imagine a character sitting directly opposite.) Rename this Dummy, 'Lookat Dummy'.

Select the R-pupil and hit the Motion Panel button. In Parameters > Assign Controller, select 'Rotation', click on the '?' button, and select the 'LookAt Constraint' from the Assign Controller menu (Figure 4.7).

Under LookAt Constraint, click on Add LookAt Target, and choose the Lookat Dummy you have created. Your pupil will probably flip to the back of the eyeball. Select the LookAt axis Z, and the pupil will return, there should be a blue line heading away from the pupil towards the Dummy. (If the pupil still does not point the right way, click on Reset Orientation and rotate it into the correct position.) Do the same for the L pupil. Check it is all working by moving the Lookat Dummy and seeing if the pupils follow.

Figure 4.7 The Assign Controller menu

Note *If you think you will need to move the pupils separately at some point,
create two Lookat Dummies, one for each eye and group them after
adding the LookAt Constraint. If you want your character to wink, you
will have to unlink one eyelid, or if it has a nervous tic, make two blink
Dummies.*

These two Dummy Helpers will really speed things up when animating eyes,
now let us concentrate on making them look great. We are going to add a
Space Warp to give the eyes character.

Click on the 'Create' button and choose Space Warps > Geometric/
Deformable. In the top viewport create an FFD box big enough to encom-
pass the R-eyeball and Eyelid. Position the FFD Space Warp to fit over the
R-eye. It will look like a lattice with 4 × 4 × 4 control points. It is a good
idea, under the Space Warp Parameters > Deform, to click on 'All vertices'
here, so none accidentally escapes the FFD lattice (Figure 4.8).

Name this R-eye-FFD box.

Next use the 'Bind to Space Warp' tool from the top menu bar, to bind the
Right eyeball, eyelid and pupil to the FFD Space Warp. (As it binds, the
control vertices of the FFD Space Warp flash white.)

Create another FFD Space Warp and do the same to the left eye.

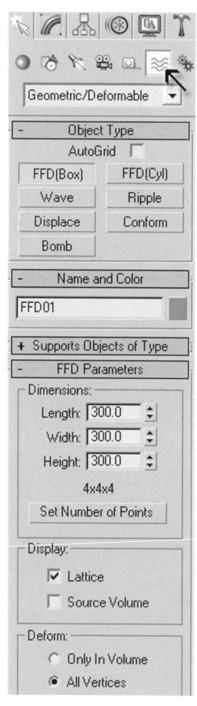

Figure 4.8 The Create > Space Warps panel

Figure 4.9 Here's looking at you, kid

Select the Right-eye-FFD box and under the modify panel open the Sub-Object rollout to select 'Control Points'. By selecting and moving the control points of each FFD Box, you can change the shape of each eye (Figure 4.9).

The eyes should not only look good and expressive, but still animate fluidly using the Dummy controllers, because 3ds max works through the Modifier Stack from the bottom up. (You can hide the FFD boxes when animating, as they get in the way of seeing the expressions.)

Top Tip

You may also want to create a Target Spotlight for your eyes to give them that lead actor glint. You can link this to the Master Dummy as well, so the eyes will always have a keylight.

It just remains to make sure all the links are correct and to link the whole lot to a Dummy so that the eyes are easy to move around en masse. Create a large Dummy over the eyes and call it Eyes-MasterDummy. This will be our Master Dummy.

Because the Blink-Dummy is already controlling the eyelids, and the eyeballs already control the pupils, you should link everything *but* the eyelids and pupils to the Master Dummy (Figure 4.10).

Figure 4.10 The object subtree, showing the linked hierarchy of the eyes

Note	*The eyes can be tricky to resize, so try and resize your character to the eyes rather than the other way around. Also remember that although these eyes look great, they are heavy on polygons.*

Creating a quirky character for Flash

A single character can be fun on the Web. You can make a visitor interact by running looped films in Flash. The visitor can often be fooled into thinking they are interacting far more than they actually are, and you can manage to keep wonderful lighting and high polygon counts in your rendered films. The Who's We and Neostream sites are great examples of this.

In this next exercise, I built the Hitme character specifically for this purpose. He is animated using hierarchical links with bones for deformation, and sports the same eyes that we have just made. I started by making a sketch of the Hitme character (Figure 4.11).

The idea behind the Hitme character, as the name suggests, is that the Web visitor can amuse themselves by tormenting him. When designing the character, I knew that I wanted something that would be fun to animate in extremes. Because I had no restrictions on materials, lighting or polygons, I have used Raytrace materials and a lot of Mesh Smooths giving a high poly count.

Figure 4.11 The original sketch for the Hitme character, and the finished article

I have given the character a spherical body for bounce and expressive hands for waving around; the white gloves will make his hand movements register more (A trick Disney used for Mickey Mouse). I decided against the writing on his stomach, as I want him to appeal globally, instead I have given him glossy stripes that emphasize his roundness, and are reminiscent of Uderzo's *Obelix* or Tenniel's version of *Tweedledum* and *Tweedledee*. The feet are large, as he needs a stable base and will not be walking around. Having built the character in 3D, I thought his throat looked kind of vulnerable and needed breaking up, so I also gave him a red bowtie. Also, I must confess that red bowties have the same effect on me as red rags to a bull; I invariably feel like hitting anyone who wears them. Perhaps my audience feels the same, and if not, hey, I can indulge myself – it is my character!

Creating the Hitme character

Most of the character is made from simple spheres and cylinders. The feet, hands and head are made with polygonal modeling from boxes, and then adding a Mesh Smooth modifier (Figure 4.12).

Before linking and fitting bones to the character, I moved the pivot points on some objects so that the centers of rotation would be in the right place for animation. As shown when you aligned the eyes, the pivot point can be moved to anywhere you want, which is a helpful tool particularly for animating rotations. To move a pivot point, select the object, go to 'Hierarchy'

Figure 4.12 Making the head from a polygonal box, before adding a Mesh Smooth modifier

Figure 4.13 Moving the pivot point

and click on 'Affect Pivot Only' (Figure 4.13). Now you can move the pivot point to any new desired position in a viewport. Click off 'Affect Pivot Only'.

Note *It is essential that any adjustments to pivot points are made before animating, as it is not a parameter that is animatable.*

I dropped the pivot point for the character's body to the bottom of the sphere, and moved the pivot points on his feet to where his ankles would be. The arms pivot from the joints and the lower mandible from the hinge through his jaw (Figure 4.14).

Figure 4.14 Positioning the new pivot points

Before we add some bones for mesh deformation and link it all up, let me explain how linked hierarchies animate in 3D.

Forward and Inverse Kinematics

When you create a linked hierarchy, you are in effect making a series of parent–child links, where the parent drives the child. If you imagine this series of links as tree branches spreading from a single trunk: the trunk is parent to the boughs, the boughs are parents to the branches, and the branches are parents to the twigs. In Forward Kinematics the last link in the chain, the twig, will inherit any rotations you make to any of the parents. Similarly moving the last link, the twig, will not affect any other part of the tree.

In Inverse Kinematics, as the name indicates, the situation is reversed and the child drives the parents. This makes it a wonderful tool for animating walks and allowing characters to interact with objects. For instance, it would be difficult for a character to point to a place on a map if you started by rotating the shoulder joint, then worked your way down the hierarchy to the finger. Inverse Kinematics allows you to move the finger to the correct position and

it solves how the other joints or parents move. I will talk more about this in Chapter 6. We will be animating the Hitme character using Forward Kinematics, because he does not need to walk or interact with any object.

Select the mesh for the hands and the head and lower mandible and freeze it by R-clicking in a viewport and choosing 'Freeze Selection'. The mesh will turn a uniform gray. Freezing the mesh stops us selecting it while we create and adjust the bones. Bones are found under the Create Panel > Systems (Figure 4.15).

Figure 4.15 Creating bones

Note *Bones are a jointed, hierarchical system that can be used to deform mesh objects with the addition of a 'Skin' or 'Physique' modifier. They offer a quicker solution to animating using Forward or Inverse Kinematics as you can apply ready solvers in the program.*

Click on 'Bones' and, in a side viewport, create a row of three bones traveling from the bottom of the head to the jaw-bolt by Click-dragging. Continue following the line of the head and upper jaw with a further six bones. (R-click to stop creating bones.) Now click back on the head of the third bone, and you will be able to create another chain of bones for the lower mandible, emanating from the same jaw-bolt pivot.

Note *The first click in a viewport defines the start of a bone, and the second click defines the start of the second bone. Visually it will look like you have created only one bone, as the bones drawn are merely visual aids defining a linked hierarchy between pivot points. Each new bone created is a 'child' of the previous bone.*

Now create the bones for the hand as shown in Figure 4.16.

Figure 4.16 Positioning the bones

Top Tip
Position hands, or any object that is to be boned, so that the mesh runs parallel to a viewport. Then create all of the bones in that viewport.

Make sure that you check the position of the bones from the other viewports too, the better they fit now, the easier it will be to fit and manipulate the mesh.

Top Tip
The first bone (in this case at the bones in the wrists and neck) are 'Parents'. Each subsequent bone is in a Parent > Child chain. When creating chains of bones, try and connect them in natural chains so the program will label them in sequence and they will be easier to identify later.

Now let us link the whole character together. Typically all characters are linked to a parent that starts at the hip. In the Hitme's character that means linking the feet to the body and linking the neck sphere to the body. Everything else is linked in sequence to the 'Neck' sphere. The bones already have a linked hierarchy, and you only need to link the three parent bones at the wrists and the neck to the next bone in the hierarchy. Thus each

wrist bone is linked to the lower arms, then the lower arms to the elbows, the elbows to the upper arms and the upper arms to the neck. Link the hair and the eye Master Dummy to the nearest bone so they do not get left behind (Figure 4.17).

Figure 4.17 The Hitme head hierarchy

Note that we do not link the mesh for the hands and the head, as they will be bonded automatically to the bones when we have added the 'Skin' or 'Physique' modifier.

Applying the Skin modifier

There are two ways of fitting a mesh to bones in 3ds max: 'Skin' and 'Physique'.

Note *Physique is a modifier that comes with Max's Character Studio and I describe fitting a Mesh with that in the following chapter. I find the Physique interface more adaptable and faster to use, it can be used for bones or biped and exports more easily to Shockwave. However, here we will use the Skin modifier as we do not need to worry about exporting to Shockwave.*

Unfreeze the mesh and add a Skin modifier to the left hand mesh. Click on Parameters > Add, and select the relevant bones from the Selection List. In this case the bones required are Bones 35–52 (Figure 4.18).

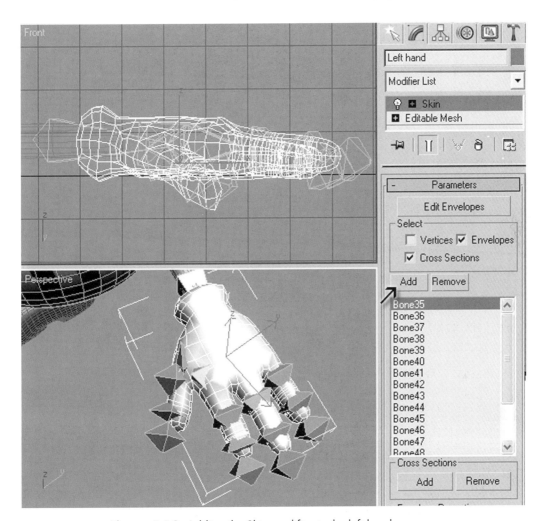

Figure 4.18 Adding the Skin modifier to the left hand

Now click on 'Edit Envelopes' which will highlight in yellow. Click some of your selected bones, one at a time and observe what happens in your viewports. Each bone comes equipped with two default envelopes, an inner, bright red one and an outer dark red one. All vertices that fall inside the inner envelope will be 100% influenced by that particular bone, with a falloff in the outer envelope. If you click on the 'Weight Table' you will see that each vertex has been assigned a weight by the Skin modifier and that Weight corresponds to particular bones. For a vertex to be influenced 100% by a bone, it will be given a value of one. A value of zero means there is no influence.

The reason the Skin modifier deforms a mesh is typically because the envelopes of adjoining bones overlap causing the vertices in the mesh to be influenced by more than one bone. You can change the weights by typing in different values in the table (but that is rather too labor intensive for our uses). There are several other ways of fitting these envelopes and adjusting weights. Select vertices and the middle bone of the middle finger (Figure 4.19).

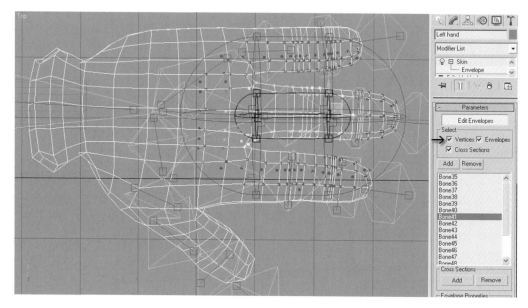

Figure 4.19 Bone 41 with Select > Vertices on

You should be able to see that while the inner envelope is only affecting the relevant vertices in the finger, the falloff in the outer envelope also means that the bone is influencing vertices in the adjacent fingers. We could bring the outer envelope in by selecting its cross-sections and scaling them inwards with the Scale tool or changing the radius, but fitting hands to bones is about as fiddly as it gets when using the Skin modifier, and frankly it is easier to change these settings at vertex level, bone by bone.

Marquee-select all the vertices in the adjoining fingers (it does not matter if you pick up more than were being influenced) and click on the button marked 'Exclude Verts'. They will lose their color and turn into black outlined squares, this means they are now excluded from the bone's influence.

Top Tip
Lining up your hand with the grid in the viewport will make it much easier to marquee-select vertices when fitting the Skin modifier.

Select each bone in turn and eliminate any unwanted influences from nearby bones inside the mesh, so the mesh for each finger is only influenced by the bones running through it. The hand bones can stay as they are, as you want them to assist the finger bones. If you make a mistake, you can select any vertex and assign it to a bone with the 'Include Verts' button.

Check the bones are deforming the mesh well by selecting some bones and rotating them. Now go through the same process with the other hand. (It is not possible to copy or mirror a mesh with bones attached in *Studio Max 5*.)

You can use the same method for fitting the bones in the head of the character, or adjust the envelope size as suggested earlier. The bones should fit a lot more effectively anyway and there is no problem of unwanted overlapping influence as the jaw mesh has its own set of separate bones. The most likely problem, if any, is that some vertices escape having any bone influencing them at all. To correct this, it is necessary to adjust the size of the envelope. To do this, again select 'Edit Envelopes', select the bone and this time click in one of the red squares of a cross-section in the viewport. The cross-section will highlight in pink and the Envelope Properties > Radius spinner is made operable. Crank the spinner up until you have captured any stray vertices that had escaped. This can be done interactively whilst you view the effect in the viewport.

Fit the jaw in the same way, and check everything is working properly.

Animating the Hitme character

Pose your character in a good starting position and save it as your basic character (Figure 4.20). Select every part of the character and each bone and create a Key at frame 0. (You can do this by selecting everything and clicking on the Set Keys button in the bottom timeline menu bar.)

Top Tip
When building a character and setting it up, you must always have an idea of how you will want to animate it. It will not always be the same for every animation you want to do, so it is important to save a version of your character with the hierarchy intact, and keep that file clean. This is even more important if you are creating looped animations as we are here. Make sure you have set up a camera to a position that will allow you to include all of your animations in the frame. (Do not forget to leave room for shadows if you have them.)

Figure 4.20 The basic Hitme character awaiting animation

I have created a number of animations designed for pseudo interactivity. Each is created in a separate file from the basic character. That way, I know that there will be no jerkiness or movement between the different movies when they are played.

There is not enough room in this book to go into all the details of animation and it is well worth investing in one of the books recommended in the appendix if you want to study animation in any depth. However, as a broad 'quickie' introduction let us look at an animation whose file is on the CD.

Top Tip

I have added a blink to the basic character file, as I know I will need the character to blink in every scenario and I can move it to an appropriate place in any animation, or copy it for more blinks. This saves having to create a new blink in every file. If my character had any other consistent tics/traits, I would also add them to the basic file.

Open the basic character file and save a new version called 'Dodge'. Set the timeline frame count to 50 frames. Check that you are running at the PAL rate of 25 frames per second (fps). I have positioned the Hitme character in a three-quarter profile because he looks best this way. There would however be some advantage in filming a symmetrical character head on, as this would enable any motion to be flipped and save time in animation.

The Hitme character is posed with his hands resting on his rounded stomach and gazing stage right. The intention in the animation is to make him quickly dodge backwards and away, and then return to rest.

The first movement in the animation is to get the character to look towards camera. Select the Lookat Dummies and set a key at frame 6. In the Motion

Panel > Key Info (Basic) make this Key a 'Hold In' and 'Ease Out'. Go to frame 8, move the Dummies to make the character look at camera and set another key, this time with an Ease In and a Hold Out. Without adding these extra interpolations to the keys, the eyeballs would slide around under the influence of the default Bezier controllers. (*Animation hint*: all eye movements tend to be fast with holds at the end.)

At frame 14 select the body and again set a key with a Hold In. This is the beginning of the character jerking backwards. Move to frame 19 and rotate the body backwards. Set keys for the first three bones of the neck at 14 as well. These bend backwards with a delay of one frame traveling up the body. (*Animation hint*: this ripple effect is called 'follow through' in animation, where all movements start from the hips and travel outwards, ending at the extremities.) I have also rotated the neck to the character's right as it helps accentuate the movement from the camera angle I have chosen (Figure 4.21).

Figure 4.21 Hitme dodging (frame 19)

As you can see from Figure 4.21, I have balanced this sudden movement backwards by rotating the lower arms forward so his hands help balance him and lifting his left foot. This is a fast movement and he is at full stretch at frame 19. I have held him there for three frames before returning him to his upright position. The hands go back to rest by frame 30 and 31. (*Animation hint*: a staggered movement looks more natural.) At frame 35, the character blinks and looks away, back to where he started. The blink combined with looking up is a classic 'Tch' expression – it has an exasperated 'don't be so childish' feel to it. The blink is created with a slight bounce to the eyelid so that the eyes open wider as the lids come up, and then settle into the normal pose. By copying the keys from the beginning of the rest pose for each part of the body by Shift-dragging in the timeline, I can guarantee that the character has return to his original position. The hold at the end is to allow time for the hair to stop moving as the Flex modifier finishes animating it (Figure 4.22).

Figure 4.22 The animated Hitme dodge

This animation is the shortest and simplest of the examples on the website. The other animations that you will find are for twanging the Hitme's bowtie, making him laugh, and a giant belch. I could have done any number of things to the character: the only limits are your imagination and the file sizes.

Making the animation interactive

By now you will have created some interesting animations for our Hitme character. This is very nice, but how do we actually hit him? He needs to be interactive if he is going to have the desired effect of being an engaging and entertaining character. Essentially, he is going to be an animated button. He will interact with the mouse, which will trigger different animations. It makes sense that pressing the mouse button on parts of Hitme's body makes him perform certain actions, or he could even respond if we just passed the pointer over him.

We are going to use Macromedia Flash to make our Hitme character interactive. There are essentially two ways to output your files as high quality renders. One is to save that animation as a video file, e.g. QuickTime or AVI, the other is to save individual frames. Up until now we have rendered all our animations as individual frames. This had some advantages, in that we could composite layers in Flash, using PNGs with transparent background. Another reason for this was animation quality and compression issues with rendered video. However, the world of animation and Web creation is ever changing and what could not be done well one year, can be done well the next. Such is the case for us. It is now possible to import digital video files and edit them (with regards to where the clips start and stop), adjust the compression and output them at a decent quality with manageable file sizes. What we did with the turtle button was a useful technique, but now we can output files as digital video.

Rendering your animations

With an ever-watchful eye on file sizes, we want to render our animations in the most efficient manner. In the Render Scene window, select the Files button and choose MOV QuickTime File as the Save File type. Click 'Setup' to set the compression options. It should default to *animation* as a compression style, but you will see that there are many more options available. In short, they are all different ways of compressing files. Some are good for full screen video, some are best for imagery that gradually changes, some have very good compression (Figure 4.23). Sticking to animation at 'Best' quality should be fine for our purposes though, as Flash will re-compress the files when we import them into it. Make the motion setting at 25 fps or 30 fps if that is your desired frame rate.

Figure 4.23 The compression settings for a QuickTime movie

Render all your animations in this way. You will need as many animations as you have movements and each movement will go back to the original position of Hitme. We cannot blend animations on-the-fly using this method (we will cover this in a later chapter). We have to go back to the initial state before we can play a new animation. The animations were looped to ensure that our character's different movements merge seamlessly.

Importing the animations

Flash MX 2004 has some improvements when it comes to importing video. As well as adjusting the compression of the imported movie, you can edit it for length. Start a new Flash movie and import your QuickTime Movies, one at a time on to separate layers. Make sure you select the 'Embed video in Macromedia Flash document' option. The next window will allow you to import the entire movie, or edit it first. And the final window will ask you what compression you would like, choose DSL/Cable 512 kilobytes per second (Figure 4.24).

Once you have imported your animations, align them along the timeline so that when one finishes, the next one starts. An example would be Layer One – frames 1–40, Layer Two – frames 41–97, Layer Three – frames 98–160 (Figure 4.25).

When you play the Flash movie, all the animations should play smoothly. You may need to adjust the positions of them if they did not all appear in the same place. Just select the appropriate keyframe, click on the animation and nudge the frames around with the arrow keys.

Figure 4.24 The QuickTime editing window in Macromedia Flash MX 2004

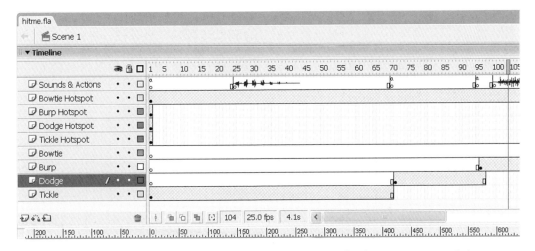

Figure 4.25 The Macromedia Flash timeline for the Hitme animated character

Note *You may want to create guidelines to help you align your animations. Go the View > Rulers menu option. You can then drag guides down and across from the ruler bars that appear. You can adjust the guidelines by selecting and dragging them.*

The next stage will be to add frame actions to make the animations jump back to frame one when they reach the end. Create a new Layer and insert keyframes at the end of each animation. In the Actions window add a 'gotoAndStop(1);' command. This will make sure the character's position is reset allowing the user to select a new animation (a new movement).

Triggering the movements

So how do we get our Hitme guy to react to the mouse? The simplest answer is to use hotspots. Hotspots are just buttons, which will appear over the character. The buttons will be invisible and so become 'hot' or 'interactive' areas of the screen. You will need to have a hotspot to trigger each of your animations. I have simply used a rectangle shape, which has been turned into a Movie Clip symbol. I dragged a few instances of this onto the Hitme character, making sure they appear in four new layers. Scaling and positioning these instances allowed me to specify exactly where the animations could be triggered (Figure 4.26).

Figure 4.26 The hotspots over the Hitme character

The next thing to do is to decide how to trigger the animations. The main options are rolling over the hotspot (on rollover) or pressing the mouse button when over the hotspots (on press). In the featured Hitme character, there are four movements. A Dodge and a Tickle are operated by a rollover command and the Burp is triggered by a Press command (Figure 4.27).

The fourth animation, the bowtie, is slightly more complicated. To add to the tension of the animation, you can hold down the mouse button, which pulls

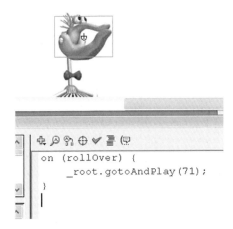

Figure 4.27 The action to trigger the dodge movement

Figure 4.28 Twanging the bowtie

out the bowtie (Figure 4.28). There is a stop command on the frame where the bowtie is fully extended. Then there is a play command twice, in an *on release* action and an *on releaseOutside* action. This way whether the user drags the bowtie or just holds the mouse down, the animation should play successfully. This technique is slightly more interactive than just a simple press.

Interview with Neostream

http://www.neostream.com

Company profile

Neostream is a company that sets new standards in interactive Web design. Originally located in Sydney, Australia, the company was established in 1998, and swiftly started raking in awards including the *World best websites Gold award* for their impressive home site. In 2001 they opened a branch in Korea, and have continued their pursuit of excellence as they expand into game development, and character animation for Web, TV and commercials.

It was seeing Neostream's home site that really confirmed for me that I wanted to write the book you are reading now. Their solid design principles back up an excellent, elegant and totally appealing introduction to the company. I think their character 'Shockboy' is the best example I have seen on the Web of a company's brand being personified. Visit this site, you will love it!

40000 volts

Interview

This interview is with Johnny Choi, their Director of Planning and Communications.

What is your role at Neostream?

Apart from management operations, my primary role at Neostream is to manage and control project communications and oversee project management.

Can you describe the background to your company, its aims, ambitions and client base?

Neostream was established in Australia originally by three founding members who are still actively driving the company. Our ambitions are clear and simple. To be the elite source in providing multimedia services. Although we are much closer to fulfilling that ambition than when we started, there is still much to achieve and barriers to overcome. Our client base is spread throughout the world ranging from large corporations to small start-up companies.

How many people work at Neostream?

Apart from management and administration staff, there are currently nine production members at Neostream.

Typically how many people would work on a project?

Although it depends on the scale of the project, typically a project is comprised of about five people – A project manager (communications and task management), creative director, developer, Flash developer and creative designer.

neostream VII
serious multimedia company

Could you describe your typical work process?

We usually spend at least half a project's overall time in Pre-production, meeting the clients and establishing a project's objective.

Each project is carefully planned before production, so we have identified the key tasks, goals and deliverables. All intelligence and content is gathered, organized and analyzed, then a strategic plan is developed for production to follow. In pre-production we also create a site storyboard and test any design samples that have been developed.

Prior to launch the site is thoroughly tested for overall usability, creative appeal, adherence to project goals and satisfaction of technical requirements.

Do you have separate 3D animators, Flash animators and programmers, or do the skills cross-over?

The main production staff at Neostream each has their primary roles. Although minor tasks can cross-over where it is more efficient, essentially their input towards a project is based on their specialization.

Who handles the sound and what impact does sound bring to your sites?

Sound is usually handled by our local sound production agency. Not all projects include sound production and its feasibility is decided during initial scope and ideation sessions. Where fit, sound certainly adds impact to the overall creative theme and enhances appeal to the viewer.

On your website, you are selling some of your Flash script and sound effects is this for commercial or educational reasons?

The main reason we are offering some scripts and sound loops are due to an overwhelming request from industry fellows and students. There are current plans to develop and release much more items of this nature. We are trying to offer products that are actually useful to students and industry fellows and we are putting a reasonable price tag basically to re-coup development costs and to minimize public duplication.

Technique

What software did you use for creating the Neostream website?

Apart from the usual graphic editing, drawing and Web development software, the main softwares used were Flash MX and 3ds max.

Does it vary from project to project?

Although the main graphic tools and Web authoring software do not change often, 3D programs, sound editing programs and plug-ins are used depending on the requirements and specs set.

Why did you use Flash for your website?

For several reasons. Firstly, it is now a widely accepted Web development software. It was the most feasible means of delivering our website concept for people to see conveniently. Probably the biggest reason is our accumulated knowledge of Flash. We have been familiar with Flash and have experimented with its capabilities ever since we started. Not only do we know what it can do, more importantly, we know what it cannot do.

WARNING: HIGHLY FLAMMABLE

JUST ONE CLICK TO IGNITE
FOR A MIND BLOWING EXPERIENCE APPLY EXCESSIVELY

How much programming/action scripting do you use in creating your website?

In terms of programming, our website involved some unique action scripting. Apart from standard scripting involved in site navigation, scripts were custom developed, tested and adjusted to be applied in bringing the character to life and enhancing user interaction.

LIVERPOOL
JOHN MOORES UNIVERSITY
AVRIL ROBARTS LRC
TITHEBARN STREET
LIVERPOOL L2 2ER
TEL. 0151 231 4022

Were there any specific problems you had to overcome?

Most of what can be seen and experienced at Neostream's website is unique. As with everything else, the main barrier that needed to be overcome was actually making what we had mentally visualized. Character interaction timing issues, optimization and animation sequence timings were the main technical challenge. However, the most difficult problem was to adhere and stick to the site concept and actually deliver the intended visual through the character and animations.

What was the most challenging aspect of bringing the concept of Shockboy to life?

Shockboy was just a 2D metaphor, a symbol and a concept. The main challenge was to induce life into the character and add attributes. Not only the character needed to reflect the characteristics of Neostream, it needed to have a body and soul of its own. We try not to think of Shockboy as just a company mascot but a lively character that will grow with the company.

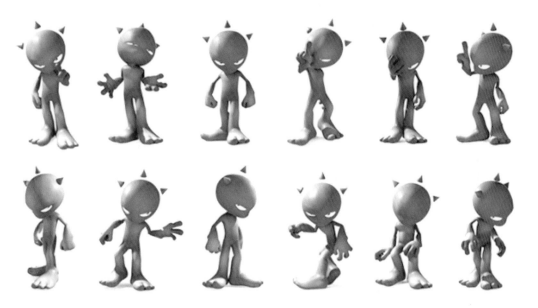

© neostream™ 2003 - 2004. All rights reserved
Character sequence - "Shockboy" imgages courtesy of Neostream.

Chapter 5

Making characters for Shockwave

Chapter Summary
- Deciding how to model and animate
- Animating and exporting using linked hierarchies
- Making a single mesh character
- UVW mapping
- Material mapping the Keystone character
- The Unwrap UVW map modifier
- Interview with Electric Puppet

Deciding how to model and animate

Deciding on the look of your character is only half the problem. When making a character for export to Shockwave, the first thing to decide is how you want your character to animate. You can use linked hierarchies as with the turtle, or deformable meshes, which use 'Bones' or 'Biped', but you cannot use both combined as we did with the Hitme character. Either way if you want to export your character via Shockwave, you will need to keep the polygon count low.

If you are modeling for an interactive character for export to the Web, you must use polygonal modeling.

Note *There are other modeling techniques beside polygonal, such as Nurbs (Non-Uniform Rational B-Splines) and Patch modeling. Both can be used for character modeling: Nurbs modeling relies on joining curved Splines in space to create a smooth surface. It is quite a popular technique for character modeling in Maya, and it does take most modifiers, particularly the Morpher modifier well. Patch modeling is where you create patches, which are a bit like squares of material. Figures are built by stitching these patches together rather like making clothes from a*

pattern. This is a great modeling tool for cloth simulation. Both Nurbs and Patch models tend to be harder to Texture map. In terms of animating for the Web, Shockwave only supports Polygonal modeling, so it is essential that your character is either made this way, or converted to a polygonal mesh before animation.

Animating and exporting using linked hierarchies

To demonstrate a linked hierarchy that will export, let us return to the turtle of Chapter 1. He is fairly low in polygons, and needs only a simple change in mapping to work.

We cannot export a Bump map, so I have created a new bitmap (TIFF) image in a drawing program to give the turtle a texture. By importing that bitmap as a Diffuse map and mapping it to UVW Map > Face, I have given the turtle an exportable shell texture (Figure 5.1).

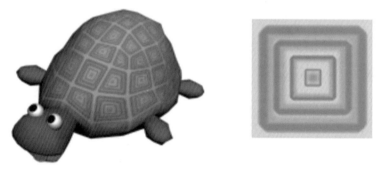

Figure 5.1 The new turtle shell with its bitmap

Check you have a camera set up and put the turtle in a start pose.

Note *You cannot export linked animation unless each individual component of your character is first grouped. Do this by selecting each mesh in turn and selecting 'Group' from the top menu bar. Nothing discernable happens to your mesh, but you will need to re-label each body part, and it will show up in bold type when selected, and with square brackets around it in the 'Select by Name' list (Figure 5.2).*

Before we animate we have to make sure that all the pivot points are in the correct place and that we have linked our turtle parts into an animatable

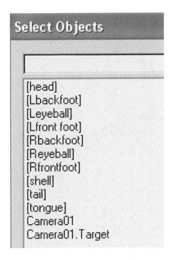

Figure 5.2 The Select Object box with each turtle part grouped

hierarchy. Move all the pivot points on the limbs, head and tail to a good position for rotation, i.e. where they meet the shell, and rotate the pivots to make the Y-axis run along the legs. Then use the Select and Link tool to link each limb and tail to the shell. Link the eyeballs and the tongue to the head, and link that to the shell too. Tick 'Display Subtree' in the 'Select by Name' list to check how it looks (Figure 5.3).

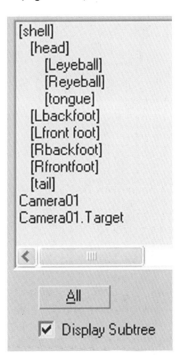

Figure 5.3 The hierarchy with Display Subtree ticked

Great, everything is now set up for animation. Try exporting the turtle now, just to check it looks fine.

Make sure that you have either your Camera viewport operative, or a Perspective viewport. Go to File > Export and select the Shockwave 3D Scene Exporter, name your file and export your turtle as a .w3D file. Keep the Exporter options as the default and your turtle should appear in a window. You should be able to move around the turtle to see it at any angle with the left mouse button depressed.

To exit this window you have to click on the Top right 'X' button. Another window will appear showing a pie chart (Figure 5.4). This indicates what took the most time for the Exporter to compute. We have no animation as yet, so the biggest file size is the geometry of the turtle.

Figure 5.4 The Shockwave Exporter pie chart

Click 'OK' and another window will crop up. This is entitled 'Possible Problems' and is much scarier. But do not panic, this box is *never* empty. There will be a long list of Shaders saying that they will not be shaded the way they are in Max. However, because we have been careful with our shaders using only UVW bitmaps and Standard Blinn Shaders the Shockwave picture we received was a good approximation of the Max rendering (Figure 5.5).

Figure 5.5 The Possible Problems window – you will grow to love this beast

We are going to animate a simple (non-realistic), walk cycle over 7 frames. Set the Time-scale to 7 frames at 25 frames per second.

With the Time slider at 0 frames, click each object in turn and make a rotation Key with the positions at one extreme of the animation. Select 'Local' from the Reference Coordinate System (where it reads 'View', next to the Scale tool). These mean that the 'Y'-axis will run along the feet as we have repositioned the pivot point.

Rotate the right front foot and the left back foot up, and left front foot and right back foot down. Rotate the head to the left and the tail to the right. Give each key an Ease-in and an Ease-out at the Key Info (Basic) rollout for Rotational Keys.

Shift – Click each Key after you have made it, and slide a copied Key up to frame 7. It is important do this as the animation must loop. Now move the Time slider to frame 4, and create new Keys by moving each object to the other extreme (i.e. the right front foot and left back foot down, and the left

front foot and right back foot up. Rotate the head to the right and the tail to the left). Give each new Key an Ease-in and an Ease-out also (Figure 5.6).

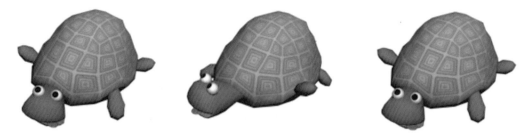

Figure 5.6 The turtle at his extreme positions (frame 0, frame 3 and frame 7)

Play the animation to check it looks good, and then Export it to .w3D format. Your turtle should be waggling along, ready for manipulation in Director. The turtle is about 1300 polygons, and because the animation is simple, it does not take long to export. But notice that still the vast majority of the pie chart is devoted to geometry. One thousand three hundred polygons is just about an acceptable amount for a main character on the Web, but the sort of count one should be aiming for, according to standards set by games companies is to try and keep the count below 1000 polygons. The major problem for the turtle is not just the polygon count, but also the number of separate meshes that make up the figure; this really slows down the Shockwave player. The two main ways of circumventing these problems are to create a single mesh character and use careful mapping to distinguish the character.

Making a single mesh character

A single mesh character is desirable for any interactivity. It speeds things up in Director and makes for fast animation. It is important to make every polygon count, so you must have a firm idea of what you intend to model before you start. Even if you do not draw it, keep reference material to hand and try to visualize the end result. I intend to make a Keystone Cop, as I think he will be fun to animate, and the helmet and moustache should give him a strong silhouette. Later in the book we will put him in our game chapter as the main character (Figure 5.7).

We start with making a box in the Top viewport. The segments should be 3 × 4 × 3. Convert the box to an Editable Mesh. In the Top viewport select all the vertices to the right of the centerline and press 'Delete'.

Select the remaining half and choose the Mirror tool from the main tool bar. A pop-up box will appear called 'Mirror Screen Coordinates'. The mirror

Figure 5.7 Reference drawing for the Keystone Cop

axis should be on X and you need to select 'Instance'. You should see a mirror image of your object appear in the viewports. Click 'OK' (Figure 5.8).

Figure 5.8 The Mirror tool and Pop-up in 3D Studio Max

Click on your original object, to make it operative and the mirror object will now highlight. Because this mirrored object is an 'Instance', whatever we do to our original will be mirrored by the new object. Now we only have to build half a person!

At Sub-Object level, select the polygon that is in the top-middle of the side of your half box. We will extrude this to make an arm.

You can use the Extrude intuitively by clicking and dragging on the slider or by typing in values. As you Extrude, notice that the mirrored object grows a symmetrical right arm to match what you do to the left. Using the Bevel tool in conjunction with Extrude, it is possible to create an arm shape.

Top Tip

Because we are modeling with a view to animating our finished character, it is always a good idea to create more detail where the joints will be, so Extrude just a bit twice at the shoulder, and then Extrude again to make the upper arm. It is hard to make a character deform properly unless there are extra polygons created at each crease for armpits, elbows, knees and thighs (Figure 5.9).

Figure 5.9 Extruded arms and neck

When extruding the neck, be aware that you are creating extra polygons inside the neck. It will be necessary for us to delete these later, as we will want hollow shells like two halves of an Easter egg.

Adjust vertices to make a torso that suits the character by squeezing in a waist, for example. Try to keep the central vertices on a line so that the mirrored object joins the object you are working on.

Still using the same tools (Extrude and Bevel) it is possible to create an entire body. Do not forget that you can angle the Polygons you Extrude using Rotate, and can Select and Move or Scale them if you wish without creating more polygons. (Remember to click on 'Ignore Backfacing' if you are selecting

vertices or polygons from the top or bottom, or you may end up creating a leg when you are working on the neck!)

Model the arms down to the wrists, Extrude and Bevel inwards to push the selected polygons back to create sleeves. Then Non-Uniform Scale the polygons to flatten them into the right proportions for a hand. Remember to add in some extra polygons so the mesh can tolerate deformation later. The hands are made like mittens with only one joint in the fingers. Fingers use up a lot of polygons and one hand will be permanently welded to his truncheon anyway (Figure 5.10).

Figure 5.10 The hand from the top view

Make feet with the 'Extrude', 'Scale' and 'Bevel'. Pick the top polygon and extrude that to give him nice bulbous toecaps. Create a head from a separate box, with just two segments so that it will have the same number of vertices and will attach easily to the neck. It is easier to make a head whole rather than in two halves as it tends to have more features, but you could make it using the Mirror tool as you did the body.

The nose was made by choosing a single vertex on his face, and using the 'Chamfer' tool to create an extra polygon. Then this new polygon was selected and extruded (Figure 5.11).

Now we will join both halves of the body together. Select the right half (either would do) and delete it. Examine this half and check you have a clean edge in the middle; any internal polygons in the middle must be eradicated. (You often make them at the crotch and neck, as you Extrude your original box. Delete them to make a clean edge.) Select your remaining half, and using the Mirror tool, this time create a Copy. It should look just like the Instance you have replaced, but will no longer be affected by what you do to the original mesh.

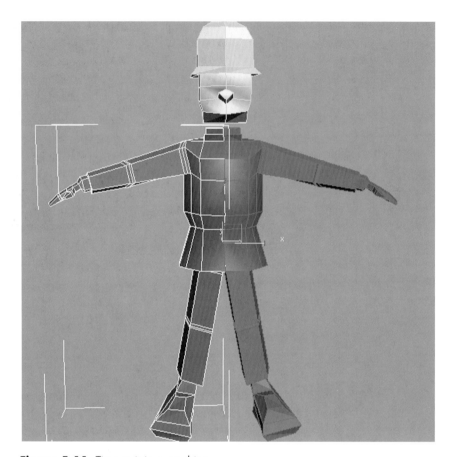

Figure 5.11 Time to join everything up

Go to Sub-Object > Vertex level on this new mesh, and click on the button 'Attach'. It will turn yellow. Now click on your original half of the body. It will show its vertices too. Click off the 'Attach' button. Your body is now one object, but it is necessary to 'sew-up' the seam along its middle.

The easiest way to do this is to select each pair of vertices where they meet and click on the 'Collapse' button. This will collapse the selected vertices into one single vertex. (Be very careful you get all the vertices on the seam and check 'Ignore Backfacing' to avoid stitching your character's belly button to the small of his back.)

Attach the head by the same method, making sure that you delete the polygons at the bottom of the head and the top of the neck to make a clean shell. I then added some ears and the moustache. The ears were made by extruding and beveling a polygon on each side of the head, and the moustache by extruding, beveling and rotating the 'nostril' polygons (Figure 5.12).

Figure 5.12 Ears and moustache

It is generally acknowledged that square, i.e. four-sided polygons take deformation best. One should also try and make sure that there are no corners in the mesh that do not lead to an Edge. There will be some areas in your Polygonal mesh where this occurs. In Figure 5.13 you can see that

Figure 5.13 A corner that does not lead to an Edge at the shoulder. Invisible Edge highlighted

such a corner has occurred where the mesh has been pulled down at the back to create the shoulder line. It is still part of a four-sided polygon, but the polygon itself is a large ungainly shape that could be improved.

In Sub-Object > Edge mode check for any areas that have such corners. The easiest way to rectify them is to find the invisible Edge that runs diagonally through the polygon. Click on the polygon till you find it, it will highlight as a red dotted line. If it does not travel to the corner, as in the illustration, it can be turned to run through the opposite diagonal. Click on the 'Turn' button, which will highlight as yellow, and click on the invisible Edge again. It will turn to the opposite diagonal, running to the corner. Now turn off the 'Turn' button by clicking it again (it is easy to forget to do this), scroll down the Edge menu and find the 'Visible' and 'Invisible' buttons under Surface Properties. With the Edge still selected, click 'Visible'. The Edge will become a white line.

Top Tip

Visible Edges have the effect of 'plumping out' a mesh and it is often worthwhile to go over a newly built model paying some attention to the edges and turning some Invisible edges to Visible.

Now create a truncheon for his right hand by extruding polygons from his palm. This can be a bit fiddley, but try and be economical with those polygons.

Select all the polygons and see how many you have. My Keystone character finished at 990 faces, with a moustache and truncheon thrown in, so he should fit sweetly into Shockwave. Finally use 'Autosmooth' on all the polygons at a value of 180 to round off your figure. He is now ready for mapping (Figure 5.14).

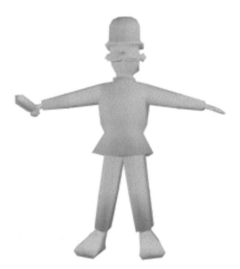

Figure 5.14 The Keystone model before mapping. Total of 990 faces

UVW mapping

I have read a lot of tutorials about UVW mapping and Unwrap UVW mapping in my time, and to be honest they are very hard to follow. This is complex stuff, and the tools (particularly the Unwrap UVW) are less than intuitive. So before we map the Keystone figure, I want to just take a bit of time to talk about mapping in general. If you create a complex shape in a 3D program, UVW mapping is the only way of getting a bitmap material positioned correctly. But the controls for how to fit that bitmap are not good enough for complex shapes.

Figure 5.15 shows a fairly complex shape, to which I have applied a Checkered bitmap (tiled 10 times), using a Box map. It does not look so bad, but the checks are not square, which would mean that any map would be stretched. This is because the default Box fitting is to create a Gizmo that fits the object, and the dimensions of the underlying mesh are not square. This is easily solved by typing in the bitmap dimensions you have chosen. In this case I have put in a value of 256 in all dimensions (Figure 5.16).

Figure 5.15 Checkered bitmap. UVW Box mapping

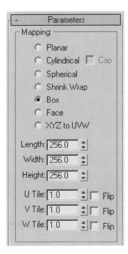

Figure 5.16 Bit map size 256

Figure 5.17 Checkered bitmap. UVW Box mapping, before resizing the Gizmo

Figure 5.18 Checkered bitmap. UVW Box mapping. 256 bitmap and resized Gizmo

Now I have entered in a measurement that is equal for all dimensions, the map looks like this, which is kind of psychedelic, because the Gizmo is now much smaller than the object, so the checks are coming out very small (Figure 5.17).

The size of the checks can easily be changed by opening the UVW mapping modifier in the stack and resizing the Gizmo using the Uniform Scale. Now the checks are square, and the bitmap size is 256 (Figure 5.18).

A lot of tutorials suggest that Cylindrical mapping is the best. So let us see what our object looks like using a Cylindrical map (Figure 5.19).

Figure 5.19 Checkered bitmap. UVW Cylindrical mapping

Whichever way round I turn the Gizmo there is a lot of distortion. Cylindrical mapping does have uses, but it is impossible to control how square the map is except by eye. For this reason, and for this demonstration, I have chosen to use Box mapping. Box mapping has its own inherent problems; the pattern appears on all sides of the 'Box' and so on all sides of the object you are mapping. This was the problem we encountered with the MacHead's package in Chapter 2. We got around it there by using Mesh Select and UVW mapping different sides of the box with different maps. We are going to do a similar thing with the Keystone figure, but are going to use Multi/Sub-Object to select areas for mapping and Unwrap UVW map to adjust the unwanted mapping around the back and sides.

Material mapping the Keystone character

To begin with, we will use a Multi/Sub-Object Material. We need to designate all the different areas that need mapping. I have seven Sub-Material slots chosen: uniform top, uniform trousers, boots, skin, helmet, moustache and truncheon. Select the relevant polygons for each area and give them a designated Material ID. (For example, all moustache polygons are given the Material ID of 3.) For demonstration purposes, Figure 5.20 shows how the Keystone looks with a checkered map.

Assign a UVW map modifier to Your Editable Mesh figure, and type in 256 for the length, width and height. Re-adjust the Gizmo so that it approximately fits the figure. (It does not really matter as we will be fine-tuning this later.)

Figure 5.20 Keystone with Checkered bitmap. UVW Planar mapping, UVW Box mapping and UVW Box mapping with 256 bitmap and resized Gizmo

Now we need to create some materials for the character. I have made all the materials in Photoshop at 256 pixels square. The helmet badge and buttons were made in 3D, rendered and then incorporated into the designs in Photoshop. I have given the uniform a bit of texture to mimic cloth, added a shine highlight for the boots and drawn eyes for his face (Figure 5.21).

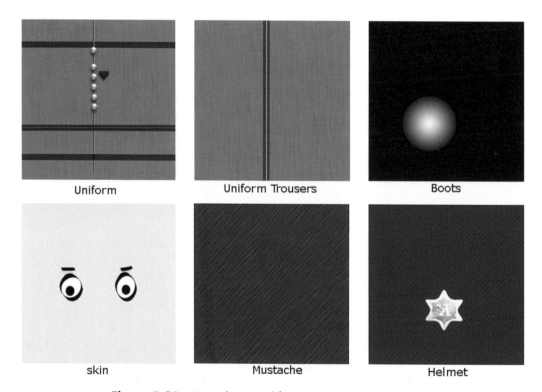

Figure 5.21 Materials created for Keystone model at 256 × 256 pixels

The keystone model and the materials are on the CD that accompanies the book.

Label and keep all these materials in a folder neatly, as if you ever transfer your 3D file to another machine, you need to take the maps with it so it can find them and apply them.

Now let us bring the materials into the Material Editor. The easiest way to do this is to select a sample slot for each one and click on the tiny box next to the Diffuse Color (Figure 5.22).

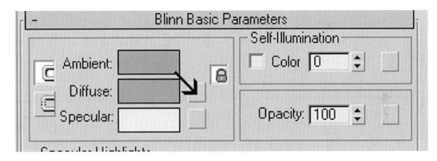

Figure 5.22 Bringing bitmaps into the Material Editor

This brings up the Material/Map Browser and you can choose bitmap and browse for your materials. Click on the Show Map in viewport button for each slot, it will highlight when on (Figure 5.23).

Figure 5.23 The Show Map in viewport button

The next thing to do is put all these Materials into the vacant Multi/Sub-Object Material slots. Open the Multi/Sub-Object Material slot you have assigned to the Keystone character and drag and drop the Materials into the Channels (Figure 5.24).

The materials should now all appear on your model; they should be assigned to the correct areas, but not fitted at all. Frankly the figure probably looks a mess! But fear not, as now, by using the Unwrap UVW we will fit each one snugly to our figure. Let us start with the helmet.

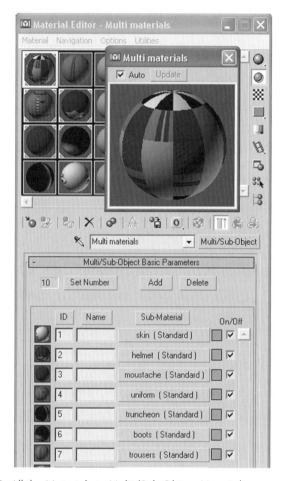

Figure 5.24 All the Materials in Multi/Sub-Object Material

The Unwrap UVW map modifier

Position the Gizmo for the UVW map on the helmet so that the badge is in a good position and size from the front (Figure 5.25).

Looks great doesn't it? But if we look at the back in Figure 5.26, it is a different story.

Because we are using Box mapping, the badge is also appearing at the sides and back of the helmet. We need to get rid of these, and will do this using the Unwrap UVW modifier. Add Unwrap UVW to the stack above UVW mapping and click on Edit under Parameters. One of the scariest windows you have ever seen will pop up – the Edit UVW window (Figure 5.27).

Figure 5.25 The helmet badge fitted from the front, using the UVW map Gizmo

Figure 5.26 The back view

You can zoom in and out using the middle mouse wheel, and might just be able to detect an approximation of what a wireframe of your model looks like when run over by a steamroller. Do not panic. This is the whole model, and for now we only want the helmet and the material we have chosen for it.

At the Top right of the window is a material number (sometimes this is kind enough to call your materials by name, and sometimes it is not, do not ask me

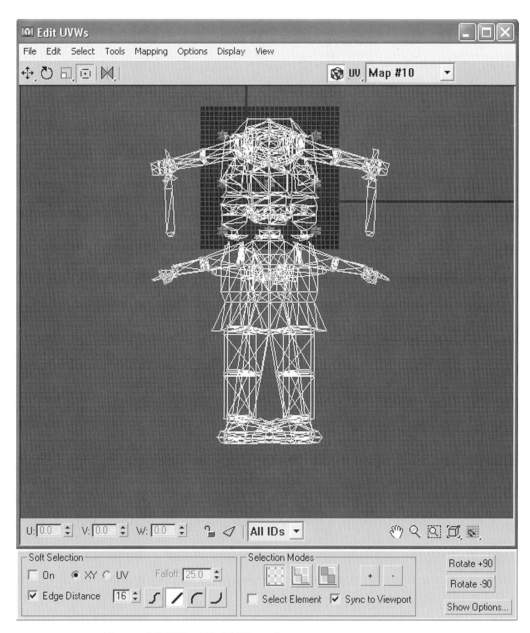

Figure 5.27 The Edit UVW window

why, it is a glitch) keep flipping through these until you get your helmet material as a background. If it is not there (another glitch), you can use Pick Texture to bring your map into the window. It is identical to the one in the Material Editor. At the bottom of the window is a window that says 'All IDs' open this and choose the Multi/Sub-Object Material slot ID for your helmet. In my case it is slot 2. A lot of white lines will disappear; we now are looking at only the helmet UVW polygons. Again it might be almost identifiable (Figure 5.28).

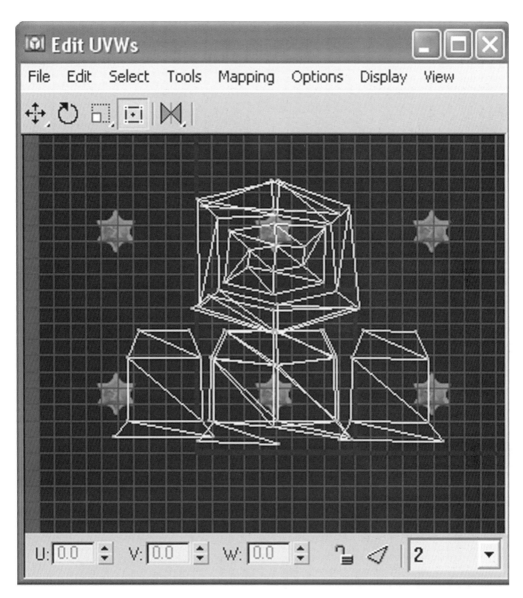

Figure 5.28 The Edit UVW window with only the helmet selected (ID 2)

This window represents all the polygons of your helmet and which bit of the UVW map they have been assigned. It does not look too logical. If you were hoping your model would unfold like an Origami box, think again, sometimes it maps half a polygon in one place and the other face miles a way. But do not despair, once you get your head around it, UVW mapping is great, particularly for low-poly models, because it gives you total control of how each polygon is mapped.

Click on 'Options' in the menu bar of the Edit UVW window, choose 'Advanced Options' and tick the boxes besides 'Constant Update In

Viewports' and 'Highlight Selected Vertices'. This will make it a little easier for us to view the interaction between the polygons and vertices in the window and those on our model (Figure 5.29).

Figure 5.29 Advanced options in the Edit UVW window

Open out Unwrap UVW in the Modifier stack and click on 'Select Face'. Select a Polygon at the side of the helmet, where the badge is showing (and you do not want it). Now click on the triangular Face icon at the bottom of the Edit UVW window. You should now see just one polygon in the window. It is the one that you have selected and you can see which part of the Material map it is picking up. Better yet, if you click off Select Face in the Modifier stack, you can move this polygon in the Edit UVW window and see what is happening in the viewport. You move the whole polygon around the map by making sure all four vertices are highlighted and using the Move icon in the center of the polygon. To Scale it you choose a Corner Vertex, and you rotate it from the middle of an edge. (You can also use the tools on the menu bar but then you have to position the mouse over a vertex to get control.) (Figure 5.30)

It is now an easy matter to move the polygon to a safe place on the map where there is no badge showing. Do this to all the polygons that are showing a badge apart from the front two. (You have to keep clicking back on to

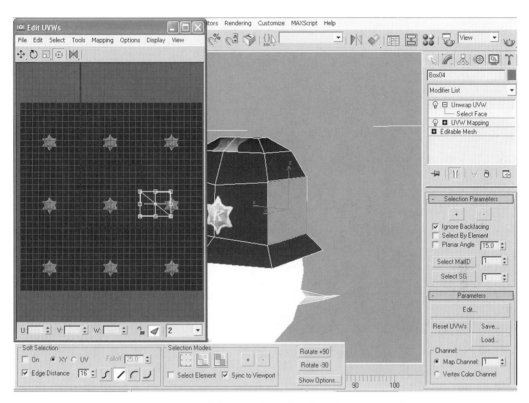

Figure 5.30 One polygon selected in the Edit UVW window

Select Face, or the window will disappear and you have to open it up again with the Edit button in Parameters.) You can select as many faces as you want. Figure 5.31 shows the helmet completely mapped.

Once you have done the entire helmet and you are happy with it, Collapse the stack below the Unwrap UVW map back to an Editable Mesh to lock the UVW mapping. Do this by R-clicking on UVW map in the Modifier stack and choosing 'Collapse To'. You should now have an Editable Mesh below the Unwrap UVW in the Modifier stack.

Now we are going to adjust each map to each part of the mesh, one at a time, just as we did the helmet. One of the great things about this is you can keep on making adjustments at any time, even if you Collapse the Stack down to Editable Mesh, and then find you have missed a bit, or want to change anything, you can always add an Unwrap UVW map modifier to the stack and move things around again. Also, because the maps are taken from the originals as Instances, you can go back into your drawing program and change them and they will automatically update.

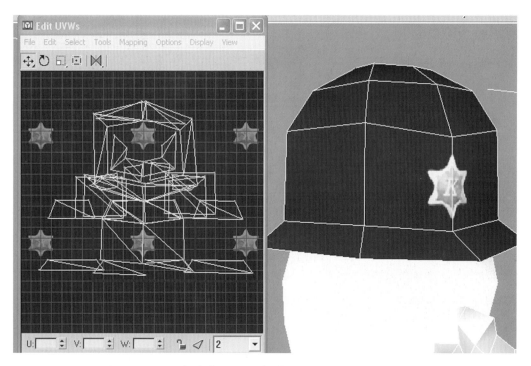

Figure 5.31 The helmet completely mapped

The hardest thing to fit is the uniform. This is because it is relatively big and needs a lot of scaling down. You can do this easily by selecting all the vertices in the window and using the Scale tool (Figure 5.32).

When you get used to the controls, it is fun to be able to play with the mapping. The polygons at the hem of the uniform needed straightening out so that the hemline was even. This was achieved by selecting those polygons and moving the relevant vertices to the right place on the map. I also rotated the polygons on the moustache individually so that the hair growth was always in the right direction. As you get more fluent with the tools, a lot of possibilities open up for fine manipulation of how a material can be mapped (Figure 5.33).

Figure 5.32 The Uniform Unwrapped and the model completely mapped

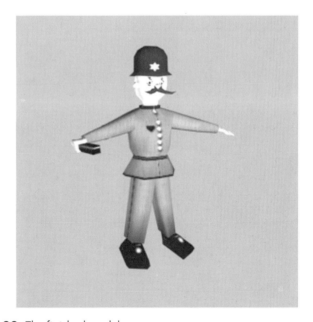

Figure 5.33 The finished model

Interview with Electric Puppet

http://www.electricpuppet.com

Company profile

Electric Puppet is a small, but expanding Web design company based in Germany. It was started by three friends: Andy, Jo and Martin.

Their company website, where a robot called 'sniff' leads the viewer to different worlds was commended in the *Big 3D Flash Web contest*.

The animation of 'sniff' is a delight; these guys have an obvious love of good character animation. Their clever use of giving the viewer little movies to watch as the different segments download is a great example of how to overcome download issues with elegance.

Interview

How did you three get started in Web design?

Andy: I started with my private page www.aliendy.de – as a kind of business card for me and my work. Later I made the design and the underwater photos for a diving website in Mexico: www.divetulum.com. We three were all 3D freelance artists and friends for a long time before setting up Electric Puppet.

Jo: A friend who was a music composer and jazz musician needed a website including sound examples. I knew that Flash had the possibility to implement sound and to fix the look of the page, so I started to learn this program auto-didactically. Before I started working as 3D artist I studied architecture, so that gave me a good foundation for 3D.

Martin: This site was my first real experience with Web design and especially with Flash, before this I only played around a little bit, but did not upload anything.

General design and 3D

What do you think is the essence of good Web design?

Andy: Clear design! The visitor has to be led by the designer. He should be able to find the way easily to the important links (there can be also some 'hidden' links, but only for funny things). The design should look like it is made from one hand. Do not use too much text – nobody reads much text on the Web. I like it if you do not have too much information on one site.

Jo: Be clear; promote play instinct and investigation. Give the visitor something to remind them of you and try to make them want to come back again.

Martin: First of all a website has to be functional, so the visitor can easily reach all the information that the site offers. The rules for graphic design are pretty much the same as in other media.

Why did you decide to use 3D in your web page?

Andy: I have been working in 3D for 10 years now. For the last year I have been rendering 3D scenes in Flash files, so I got the idea to show my skills in a web page with a 3D character. Character animation is my favorite work!

Jo: Our real world, the world we are used to seeing is in 3D, and the Internet is partly a copy of the ideas, news and products in our world. With

a 3D web page you create a platform more accustomed for the human way of seeing things.

Martin: My daily work is 3D – so, for me Flash was the new tool.

Who or what are your inspirations?

Andy: Comics – for sure (Frank Miller!), I like the reduced design very much. But also the big movies, the effects give me a wonderful illusion!

Jo: Most ideas come to me when I take a walk through nature letting my mind float.

Martin: Comics and cartoons. I like the cartoons because of the animation, e.g. the old version of Tom and Jerry or Tex Avery.

Good comics are like films – but not a finished film, more like a storyboard, so there is more space for your own imagination. Films are also very important, e.g. the work of Pixar is always inspirational.

How did you come up with the idea for Electric Puppet site?

Andy: I had the idea to animate a story with a 3D character a long time before it was possible to render it in Flash. But now I also had for the first time the possibility to make the story interactive through the Internet! I wanted to show my skills and put my knowledge into a little story. The visitor should be taken by our robot into different worlds – he is the actor, the visitor shows him the way. Somehow like a reduced version of a game.

Jo: Andy and Martin told me about the idea of a self promoting website in 3D with a robot leading through the menus. Then we took a day, in the

green, thinking about the main structure of the page. To send 'sniff' our robot on a journey to different worlds turned out to be the leading idea. This made it easy to split the work and to enlarge the web page in the future. Also a lot of ideas came up during the project.

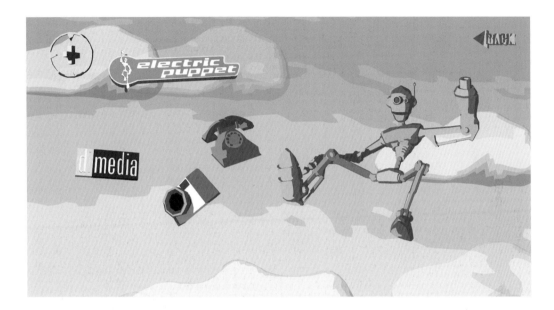

Good-looking 3D has an immediate appeal. Do you see it as the way forward in Web design, or just another tool?

Andy: Sure – you can use it just as a tool – but I think it opens up a new world of design to the visitor. I don't want to say it is better, but that it is different to the 2D-stuff.

Jo: It offers another aspect to the observer. At the moment it is very interesting because of the lack of 3D web pages. 3D is fascinating to people, but it depends on what you do with it; just the fact you are using 3D doesn't lead to a good web page.

Your past and future work

What sort of clients would you like to attract?

Andy: All companies, who need 3D or better 3D characters for their web page. 3D is for children as well as for adults.

Jo: People who need 3D animation and special fx for film, television or Internet. This can range from company or product presentations, feature film to architectural visualizations and interactive buildings.

Martin: Anyone who needs animation and effects. It does not matter, if it's for the Web, television or cinema …

Any special future projects using 3D?

Andy: We would like to continue our page with more worlds ... we already have some ideas, also for a little game with our Electric Puppet robot 'sniff'.

Jo: Expanding the possibility of 3D usage and interactivity in the Web.

Martin: Right now you can visit four worlds with the robot 'sniff'. We had some ideas for other worlds, that we could not build, because of the deadline of the contest, but they will come. A Web game is also planned. It would also be interesting to build a complete new character. So there are a lot of things to do.

Technique

What software did you use for creating the website?

Andy: Softimage XSI, Flash 5 and Adobe PhotoShop.

How much programming/action scripting do you use in creating your website?

Jo: To combine all the animations and interactivity programming is inalienable. So there is also a lot of programming to do.

Martin: All interactive layers are scripted, the rest are background layers, sometimes with scrolling. So, it's more like a jump- and run-game on C64.

Were there any specific problems you had to overcome?

Jo: One of the biggest problems was to get the control over the animation loops in the right time, for Flash programming you sometimes have to think around the corner.

Martin: We had to cut down our ideas, to keep the download time low.

Why did you use Flash for your website?

Andy: For me it's the most powerful tool for bringing 3D to the Web.

Jo: As I worked on web pages with Flash earlier I was already familiar with the usage of Flash. This helped a lot for the programming of the page.

Martin: Flash is a very powerful and quite easy tool. It offers a lot of programming tools and it was the best way to compose all the elements from the swift rendering. Additionally, most people have the Flash player on their computer. So they do not have to download a plug-in before they can visit the site.

Do you use any special plug-in for rendering your 3D animation in?

Martin: All 3D elements are rendered with the Swift plug-in for XSI. It is still not perfect but the best thing right now to connect the two worlds.

Insights

Do you have any advice for students of 3D Web design?

Andy: Don't spend too much time on super-special-effects. Solid animation is a basic requirement. Try to lead the visitor with your animation. A clear design is better than the most overfilled-websites are showing us – more is not always better.

Compositing skills are also very important – you can only make good (and for Internet: small) scenes, if you know, which layers you need only one time (backgrounds) and what you need in the foreground more often. Flash is, in a totally 3D page, only the compositing tool.

Jo: Don't care too much about what tool you use, tools change. Keep looking around other web pages and try to find what you like about them and what not. In 3D Web design many things work together and only in combination can they create a good web page. Therefore, it is a good idea to find friends to help you to achieve the aim together.

Broadband and the future: will size always matter?

Andy: Size never matters (Godzilla showed us the truth, no?)

Jo: One limitation is the file size. Our contribution has a total file size of 7.6 megabytes and it takes about 19 minutes with a 56 kilobytes modem to download it completely. That is hard at the limit. But we divided it into smaller pieces and give the visitor something to look at during loading times. Broadband will give us more liberty to use animation on the Web. But

you still have to keep in mind that not everybody in the world has a fast Internet connection or the right plug-in. So it is a good concept to offer more ways to get the information.

Martin: It will always matter, because when the download time decreases, the file size will increase. I think you will always wait too long.

LIVERPOOL
JOHN MOORES UNIVERSITY
AVRIL ROBARTS LRC
TITHEBARN STREET
LIVERPOOL L2 2ER
TEL. 0151 231 4022

Chapter 6

Animating for 3D interactivity

Chapter
Summary
- A live-action movie
- Biped
- Using Physique to attach your mesh
- Animating the Biped for a game
- The waiting game
- Walk cycles
- Exporting our character
- Importing into Director
- Adding a camera
- Interview with Titoonic

A live-action movie

This chapter is about taking your character model and animating him or her for use in an interactive 3D world. Its main use is for computer games, but it could equally be used for a character on a website that is interactive and responds to the user's actions. Where this differs from the earlier chapters is that we will be creating it for use in Shockwave 3D. Macromedia Director's Shockwave 3D allows the creation of virtual worlds and all the interaction and motion, which is implicated by that. Director has had 3D capabilities for a few years, but it is only recently proving to be popular. The main issue is that not enough developers know how to harness its power. This chapter will get you well under way, and the following two chapters will put you in a strong position to create your own real time 3D interactive content and games.

First of all we will animate our character, and then we will import him into Director applying pre-written behaviors that will allow you to control him in

LIVERPOOL JOHN MOORES UNIVERSITY
LEARNING SERVICES

a simple world. In a sense, you will be creating a live-action movie, where you are the camera operator and Director of the action.

Biped

The simplest way to deform a single mesh character built-in *3D Studio Max* is by using 'Biped' in the *Character Studio* Plug-in. Biped is a sophisticated animation controller that gives us a ready made bone structure. We can fit a Biped to our model and use 'Physique' to attach the mesh. There are several advantages of this over using bones when it comes to Shockwave Export, but the main ones are these:

- Biped enables you to save any animation as a .bip file. This means you could create a dance sequence for say a Biped fitted to ballerina mesh, and transfer that data to any other Biped like one fitted to a hippo or a baby mesh. This ability to separate the animation from the character is a fantastic tool for anyone animating for Director, as it enables the Exporter to stream the mesh and animation separately.
- Physique is far easier to fit and lock down than the Skin modifier. (The Skin modifier does not export in all versions of 3D Studio Max.)
- Bipeds are very easy to set up, with their own built-in Inverse Kinematics (IK). The joints have built-in constraints so knees bend, but cannot twist. They also cannot bend the wrong way. This means there is no chance of suffering bones' dreaded gimbal lock.
- Biped has a built-in footsteps creator for animators that are new to animating. This means you can throw down footsteps like choreographed dance steps for your character to stick to. It is also a superb way of dealing with motion capture data, allowing you to lock feet to the ground and not slide.
- Although Biped delivers a humanoid skeleton, it is more adaptable than you might think. There are options for how many fingers and toes, and how many joints they have, and whether your character needs a tail or a ponytail. The Biped can be adapted to make four-legged creatures too, so it can be adapted to animate most things (apart from jellyfish and multi-legged insects).

To create a Biped, click on the Systems panel > Biped; the button will turn yellow (Figure 6.1).

Click and drag in the front viewport to make a box roughly the same height as your mesh. On release you will find the full Biped skeleton.

Figure 6.1 Creating a Biped

Top Tip
Remember to click the Biped button off after creation. It is very easy to start clicking away at your Biped immediately, accidentally creating little Bipeds, which may be invisible in your scene. These will slow your workstation to a standstill and confuse you later.

A default biped is shown in Figure 6.2, we will now modify it to fit our model. Your Biped will be called Bip01, and will have a structural list below

Figure 6.2 The default Biped

the Root name. With the Biped root still selected, click on the 'Motion' panel button. This is where you will find all the controls for your Biped.

Note	*Biped controls only appear in the Motion panel if a part of the biped is selected in the viewports.*

Click on the little chap that means 'Figure mode'. You must be in Figure mode for fitting the Biped to your mesh (Figure 6.3).

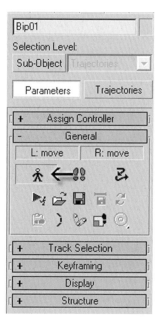

Figure 6.3 Figure mode in Biped

Open the Structure rollout and use the sliders to change the settings to fit the Keystone character. He only needs two fingers with two links, and one toe with one link. Two Spine links is enough, and very importantly, two pony-tails with two links each. These will serve to animate his moustache.

Freeze your mesh by selecting it, R-clicking in a viewport and selecting Freeze Selection. This stops you accidentally picking it up when you are fitting the Biped. Stay in Figure mode and position your Biped inside the mesh. Start with aligning the hips, i.e. the pelvis and the Center of Mass which looks like a small blue diamond in the pelvis. The Center of Mass is the whole body controller and root of the Biped. Position the Center of Mass low in the hips of your figure and then start fitting everything else. You can use Non-Uniform Scale to adjust the size and length of the bones, and rotate the bones to follow your mesh (Figure 6.4).

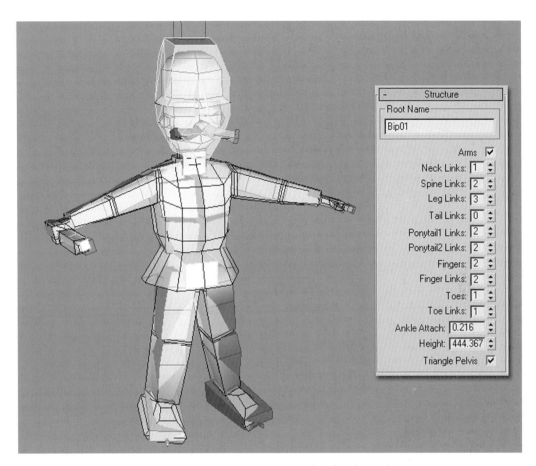

Figure 6.4 The Keystone character with a fitted Biped

Top Tip
The closer you Biped fits your figure, the easier it will be to fit to the mesh. It will also be a lot easier to animate, if the Biped mass approximates the mass of your character. Time spent here will save you time later.

It is important that the Biped joints align with the joints you have created at the arms and legs in your mesh. Also pay particular attention to where they meet the torso.

There are two buttons that are of great help in making sure that the left and right sides of your Biped match; they are the opposite and symmetrical buttons in Track Selection. If you choose the left foot and click on symmetrical, you will also have selected the right foot. Because we built our Keystone

character symmetrically, this means you can fit the Biped on one side and the other side will also fit (Figure 6.5).

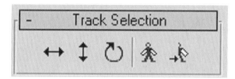

Figure 6.5 The body (Center of Mass) controllers and the opposite and symmetrical buttons in Biped

Make sure the soles of the Biped's feet align with the soles of your mesh and make the Head bigger than the Keystone's whole head and helmet. This means it will be easy to select when animating. Move the Ponytail Links in Biped to a suitable place for the moustache (Figure 6.6). Although they are called 'ponytails', they can be positioned anywhere on the head and prove very useful for lots of secondary animation. (Ears, quiffs, etc.)

Figure 6.6 Fitted ponytail links for animating the moustache

Fit the hands in the top viewport. You can position the fingers just as you did the ponytails. Align the left thumb with the mesh and scale the other finger into a large block to act for all the fingers. (Because the Keystone mesh is effectively wearing mittens.) On the right hand, use one finger to be the front of the

truncheon, and one to be the back. Keep the link halfway down the truncheon, as we can use it to bend the truncheon when animating (Figure 6.7).

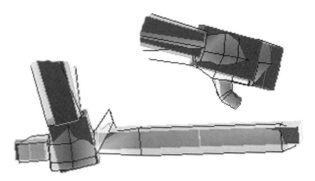

Figure 6.7 Fitted Biped hands and fingers

Check the fitting in all viewports, and when you are happy, unfreeze the mesh.

Using Physique to attach your mesh

Add a Physique modifier to your Keystone Editable Mesh. Click on the Attach to Node button (it looks like a little man with a target at his hip) and select your Biped, Bip01 from the Select by Name List (Figure 6.8).

Figure 6.8 The attach to Node button

The Physique Initialization box will appear, Click Initialize, and the Physique modifier is applied with the default Envelopes that will control your mesh.

Note *This would also work for a series of different meshes. A character can be made of segments and you can still use the Physique modifier. When it comes to Initialization the same rules apply for each segment. Do not attach the head mesh to the Bip01 Head, and the mesh's R-foot to the Bip01 R-foot, etc. as there should be only one Root Node for your character.*

Now comes the fun bit, making sure that your Biped and mesh are a perfect fit. Many people have a lot of problems with this, but actually it is very easy if you do it the old-fashioned way – by vertex.

The Physique modifier has a rollout that lists five sub-selections: Envelope, Link, Bulge, Tendons and Vertex. Because you have fitted your Biped skeleton well, the default Envelopes should already be in good shape. In Wireframe View, Select Envelope and click on a link such as the Bip01 Upper Arm. You will observe two envelopes controlled by that link: an inner, red one and an outer purple one.

The envelopes in 'Physique' work much as the envelopes do in 'Skin' modifier described in Chapter 4. Any vertices that lie within the inner, red envelope will be 100% controlled by that link, the outer purple envelope denotes a level of influence that falls away to nothing. Click on few more links and you will observe that the purple envelopes overlap; this allows the Physique modifier to share the influence of the links in the skeleton to achieve smooth deformation. Thus the Bicep is typically controlled by one link, the Forearm by another and the elbow has a shared influence between the two links. (Because our mesh is very simple, we do not have any need to think about Bulges and Tendons, these are ways of distributing a link's influence to simulate actual flesh.)

Now go into Sub-Object > Vertex mode. Click on 'Select' (it will highlight in yellow) and marquee-select all the vertices in your figure. Most of them will light up as either red or dark red. A few may light up as blue (Figure 6.9). Red vertices are within an inner envelope, dark red are in an outer envelope, i.e. have more than one link influencing them and blue vertices are unattached. If you were to animate your character now, the vertices colored blue would be left behind.

Zoom in on your figure and check for blue vertices, if there is one, select it and click on 'Assign to Link'. Click on the link you wish the vertex to attach to, and it will turn red. Do this for any blue vertices you have, if you have fitted the Biped skeleton well, you really should have very few or none at all.

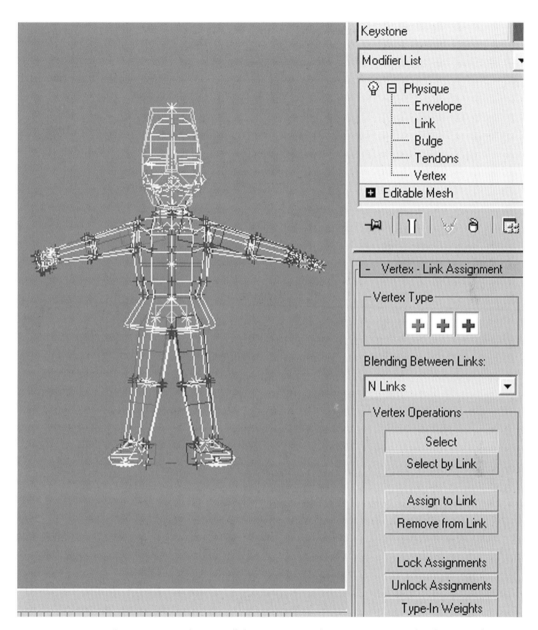

Figure 6.9 Selecting all the vertices in Physique's Vertex Sub-Object mode

Now all the vertices are attached, you may want to fine-tune their adjustments, or your character may be working just fine already! To test how the mesh is deforming under the Biped's influence, we will put him through his paces by throwing down some footsteps. This only means pressing three buttons! (This is simply a test for how the mesh works we will deal with animating the Biped properly in the next chapter. Another way of testing would

be to load an animated BIP file from the Character Studio Plug-in and see how the character responds.)

Select part of your Biped and open the Motion panel. Click out of Figure mode, by clicking on Footstep Mode next to it. The two Footprints will highlight in yellow (Figure 6.10).

Figure 6.10 Creating Multiple Footsteps for a Biped

Under Footstep Creation, click on Create Multiple Footsteps and 'OK' on the pop-up menu for a default four steps. You will see some white footprints appear before your character. The icon for Create Keys for Inactive Footsteps will light up in Footstep Operations. Click on it. Your Biped will jump to

attention. Play the animation and he will walk. He will walk like Frankenstein's monster, or Arnie in Terminator One, but he will walk! To see how the mesh is really behaving click off the Object icon in the Display rollout below, this hides the Biped and allows you to view your mesh cleanly.

Your mesh may look marvelous, or you may see some strange anomalies in it. These are easily adjustable, and can be done with your Biped in any position; you do not have to return to Figure mode to sort him out, but you may prefer to, as this is a good 'splayed' position for selecting vertices.

Suppose when your Keystone walks, the Biped left thigh link is influencing vertices on the right thigh. This will result in an unhappy mesh deformation. To fix it, select your mesh and return to Physique's Vertex Sub-Object Mode. Click on 'Select by Link', and choose Bip01 L Thigh, all the vertices influenced by this link will be selected, if there are any in the right leg, click on 'Select' and select these, then click on 'Remove from Link' and click on the Bip01 L Thigh Link again. It will look like nothing is happening, but if you choose 'Select by Link' again and choose Bip01 L Thigh, you will see that these vertices are no longer being picked up by that link.

Go over your mesh in Vertex Sub-Object Mode checking each link for such anomalies. When you are happy with everything, select all the vertices and click on 'Lock Assignments'. Your Biped will now deform the Keystone mesh, and even better, any animation will Export beautifully to Shockwave, so long as you remember to 'Group' everything.

Animating the Biped for a game

Now your Biped is looking good, it is time to decide what your character will need to do in your game. Almost inevitably you will need your character to get about, and that probably means walking or running (although obviously if your character is a kangaroo or a skateboarder you would be aiming to move them in a different way). Your character will also spend some time waiting, while the person controlling it gives thought to their next move. It is always helpful to create at least one or more 'waiting' actions to give your character life. In real life no one stands totally still unless they are a mime statue or a shop window dummy, and we want the player to identify with your character, not admire it from a distance. In addition, your character will need to perform any other actions that would suit your game. In the case of the Keystone, I have also created a bashing motion and a jumping motion.

The waiting game

Waiting actions are an opportunity for the animator to add personality to their character and if you look at any character-led games you will often be

rewarded with some great animation, simply by doing nothing. If you wait too long with *Rayman* he takes off his head and bounces it like a basketball, and *Mario* falls into an exaggerated slumber. Waiting motions work best if you choose motions that seem appropriate for the character's personality.

There are two 'waiting' modes for the Keystone. First he looks around, and second he taps his truncheon in his left hand. These fit his ever vigilant, briskly officious personality.

Before you begin animating your Biped, either Hide or Freeze the deforming mesh, so you cannot accidentally pick it up when choosing joints to animate. The Biped looks pretty ugly, but you have to keep remembering that you are animating for your character, and not for the Biped (Figure 6.11). The proportions of a well-fitted Biped should help, but sometimes moving one of these clodhoppers around to create movement for a delicate ethereal character is hard to imagine. (Character Studio 4 has some alternative looks for the Biped, but whichever way you slice it, they all look like they have fought the ugly stick and lost.)

Figure 6.11 The Keystone Biped, he may be an ugly critter, but he is ready to animate

Animating using IK

Character Studio's Biped has built-in IK solvers. This means that the character's hands and feet can be moved and locked down and the biped will

solve how the other joints should rotate realistically. Whenever you rotate a joint, you are using Forward Kinematics, whenever you select and 'Move' a hand or foot, you are using IK (Inverse Kinematics). This might sound frightening, but is in fact fairly intuitive to the animator.

Set your timeline to an appropriate length and PAL format. Click out of Figure mode, and at frame 0, put your character in a natural pose by selecting each body part in turn and creating a key using either Set Key button in the Motion panel rollout. The Biped will automatically start setting these keys in Freeform Mode (Figure 6.12).

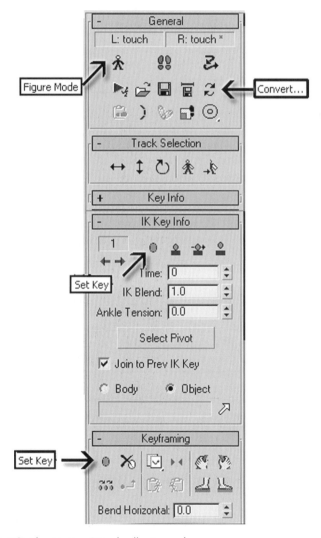

Figure 6.12 The Motion Biped rollout panels

Save your file and keep this clean version of your character to load up before you start animating. We want to loop most of these actions, and keeping a set of clean keys at the beginning means we can copy these to the end to make sure the character loops properly.

When animating your character, first decide whether the feet are going to move. In this case, they are going to remain still, so I have locked them down using the Set Planted Key in the IK Info Panel. (Try to avoid using the 'Anchor Keys', the graphic is misleading as they only fix a hand or foot temporarily and do not change the IK blend.)

Top Tip

Unless you have Set Keys for your character's feet using the Set Planted Key in the IK Info Panel, you will not be able to convert to Footstep Mode (it will be grayed out). But if you have used the Set Planted Keys then the IK blend will have a value of 1.0 and when you convert modes, a footstep will be created at every Planted Key. You can convert back and forth from Footstep to Freeform Mode as often as you like.

If you select the Body Vertical button under Track Selection, you will see that if you pull your character down, it will now bend from the knees and keep its feet in place. Having sorted out the feet, always try and animate from the Hips traveling upwards. All joints in the Biped body are moved with Rotation tool, apart from the hands which are moved with the Select and Move tool, allowing the IK to sort out the rest of the arm joints.

Note *The fact that IK will solve hand and foot motions for the rest of the joints is a wonderful thing, but do try and remember to keep the character's body moving in arcs. Nothing looks as stilted and wooden as hands moving in only one plane. All body movement is created by our bones moving in arcs. Even a simple head turn should have a dip or rise in the middle of the movement.*

Be prepared to take some time on the animation, and try to spread any movements as far as they can go to bring an air of fluidity and naturalness to the motion. For instance, although the Keystone character is tapping his truncheon in his hand, I have spread the movement to his knees to make the motion livelier. The best way to animate is to act out the action again and again, isolating each part of your body as you do, and translating that to the character.

When you are happy with the motion, copy each Key from the beginning of your animation to the end, to create a seamless loop in the action. Check

it is not jumping by playing the animation in a loop and examining it from all sides in the perspective window.

> **Top Tip**
> Always check your animation from every angle; it is all too easy to create a walk in a side view, only to find it is disastrous when viewed from the front.

Now unhide (or unfreeze) your mesh, and hide the Biped by clicking off 'Objects' in the Display panel. Play your animation again and enjoy your character coming to life. When you are entirely happy with the motion, bring back the Biped and save the motion as a .bip file. This means that you have the capability of applying that motion to a different character and allowing you to tweak it for individuality.

Group the Biped with the mesh, name the group (and make sure you name the group consistently for all animations) and export using Shockwave.

Walk cycles

The walk cycle for your character is a critical piece of animation as any player will be seeing a lot of it, and it is really a very short piece of looped action so every key must count. The walk cycle I have created for the Keystone is only 19 frames long at 25 frames per seconds (fps). An average walking pace is usually 12 frames long, or a second for one looped cycle, so the Keystone is walking rather more briskly than most, which is in keeping with his character. He is also looking around a bit as he is ever vigilant for things to bash.

Because we are going to loop the animation and the feet will have to slide back to their starting position, we will be working in 'Freeform' animation. Always start a walk cycle from the midpoint of a pace (called the passing position) where one foot is firmly planted, and the other is halfway through its pace. This is where the body is at its greatest height, and the hands are passing mid-cycle.

I recommend that you look up in a good animation book how a standard walk cycle should be animated and then add variations that give it extra character, such as *Mickey Mouse's* double-bounce walk. (There are a number recommended at the end of the book.) Do not forget that the hips and shoulders also swing from the front view – the hips following the leading leg and the shoulders tilting the other way to compensate (Figure 6.13).

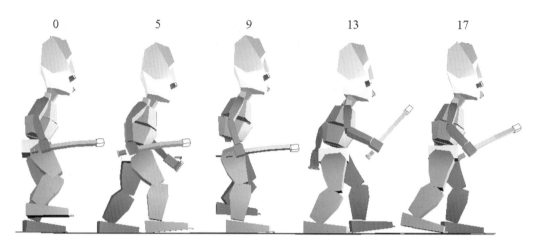

0 5 9 13 17

Figure 6.13 Frames from the Biped 19 frame walk cycle

Getting a smooth slide into the feet is difficult. It goes against the grain for an animator to make the feet slide on purpose; we spend most of our time making certain that they are locked down tight. One way that works is to create two Dummies (one for each foot), and have them slide against the grid in the side viewport so they are even, then make the feet follow. Thus in this walk cycle the left foot Dummy travels back for six frames and six grid squares from the starting point (it is halfway through the pace, remember), and right foot Dummy travels back for 12 frames across 12 grid frames. This allows you to position the feet to follow the Dummies without making a keyframe on every frame. When you are happy the animation is going smoothly, you can delete the Dummy helpers. (Note that you do not link the Biped feet in any way to the Dummies, as your Biped needs to be in world space to export to Shockwave.)

You can view and dissect the finished walk cycle as a Max file on the CD along with the other animations for the Keystone character.

Exporting our character
Building a simple world

Now the animation is complete we need to export our character into Director. Before we do this, we should give him a ground to stand on. The simple way to do this will be to create a plane in the top view that is big enough for our character to walk around on. The ground plane is there to give the character a sense of scale and position. Without it he may as well be floating or treading water. As our character should be about 170 units

tall we need to make our ground plane an appropriate size; 25,000 by 25,000 units should be sufficient, we are only making it for demonstration purposes (Chapter 7 is where we will be investigating world creation in detail). Make sure you name the plane clearly, e.g. 'ground'. Otherwise it will have default name like Plane01, which could be confusing if there are many other planes in your scene.

Once you have created our ground plane, we might as well give it a texture. You could choose one of the standard materials, bearing in mind that they do not all export well (see Chapter 3). Perhaps create a grass material from a photo, or a concrete one. It is best to make your texture a tiling one. The size of the bitmap used is very important and there are restrictions, so generally tiling is the best solution. Apply a UVW map modifier and change the U and V tiling settings to 20. This is how many times the image will repeat. If your material looks too repetitive then decrease the tiling value, until you are happy with it (Figure 6.14).

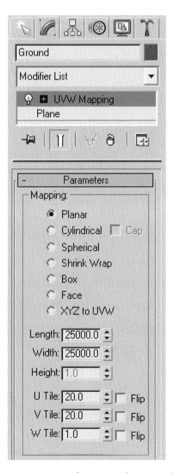

Figure 6.14 UVW mapping settings for a simple ground plane

Note *There is no need to tile in the W direction as the plane is only a 2D shape. In fact, most materials only map in two dimensions, even if they wrap around a 3D object. Some materials, e.g. the Wood material, are 3D. They give you the ability to take chunks out of an object and see how the grain looks inside. The other materials are in effect 'skins' that are stretched over an object.*

If you want, you can add some other objects to your scene to help improve the sense of motion, when he is walking about. The character will not collide into these though, he will walk straight through them. Collision is something we will deal with in Chapter 8, where we will be assembling a game. For now we are just making our character controllable in real time, using the keyboard.

Creating a control box

You have already grouped your character and he has his animation setup. Make a note of the name of the group, in our case 'Keystone'. This will be the name of the model that we are looking to animate in Director. The next thing to do will be to create a control box, this acts like the Master Dummy used in *3ds max* for the eyes, and will be the object that is actually moved. Create a normal box shape starting in the top view that fits the shape and size of our character and in the same position. He will turn around the center point of this box, so make sure its center lines up with the character's center axis.

It is essential that you create the control box in the top view, looking down on the character. This ensures that the axes match with the axes expected by the Director file, which you will be using. If you make this box differently then the character will not walk and turn correctly. This is a compromise solution, allowing you to control a character without you having to do any programming (Figure 6.15).

Figure 6.15 The 'Link' and 'Unlink' buttons in the main tool bar

Create a material that has zero opacity and apply it to the box. Link the 'Keystone' group to this box. Press the Link tool, selecting your 'Keystone' group and dragging the mouse over the edge of the box. Releasing the mouse button here will briefly highlight the box, indicating that it has been linked.

The purpose of the control box is twofold. The first reason is to provide a stable object that we can move around. As our character walks he moves from

side to side, and the rotation of his axes change. This means that when we move him (using Director's Translate command) he would move in a wobbly manner. We want him to move in straight lines, and to turn correctly. In effect he does not walk anywhere, but will stay in treadmill mode, whilst it is the box that he is in that is moved around the environment. This may seem a bit awkward, but it works and the control box has another useful purpose; for collision detection. We will talk about this in Chapter 8, but in essence, the simpler the object that you are testing collisions for, the simpler the calculation is to do this. We always need to be aware of the frame rate so anything we can do to improve time is worthwhile. When creating a game, as we will later, it is not just the character we have to take into consideration, but every computationally expensive element (like collisions, other object movements, scoring system, etc.). As we do not want to see the box, we have made it transparent, but it will export correctly (Figure 6.16).

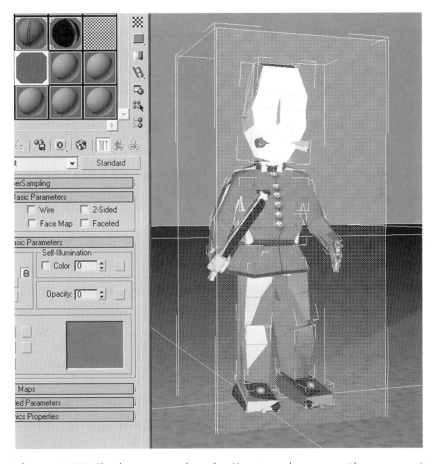

Figure 6.16 The box surrounding the Keystone character, with zero opacity shown in the Materials window

Although you will have created several files for your animation, you only need to put the box on to one of them. This is the file that you will use for all your environment modeling, the other files are only needed for the animation information.

Exporting from your 3D package

You should have five 3D files, a 'master' file, which will be your 3D world, containing your character, control box and any other objects that you have created (e.g. ground plane). The other four files need only contain the character.

Open the 'master' file and make sure the perspective viewport is selected. Go to File > Export and choose Shockwave 3D (.w3d). For this file you need to export all the 3D resources (including animation). However, you only need to set the range to start and end to frame 0. This way the bone structure and mesh deformation information is exported but not the actual animation (Figure 6.17).

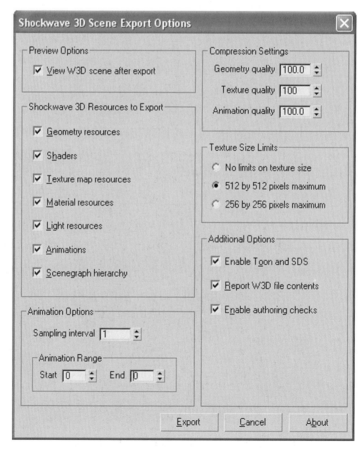

Figure 6.17 The Shockwave 3D Export window, with settings for exporting a still scene

If you have selected the 'View w3D scene after export' option you will be able to preview your character. When you are happy that it has exported correctly you can open one of the files that you have used for your animation. Once again, make sure the perspective viewport is selected before exporting. This is good practice and stops an Orthographic camera being used. In the Export Options window, you can deselect all the resources except for the animations. Make sure the animation range is set to last as long as your animation and keep the sampling interval at 1 and the animation quality at 100.0. Ideally you do not want your animations to be compressed, unless they were really large files (Figure 6.18).

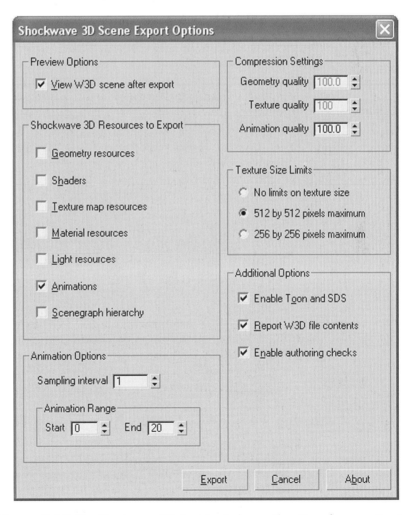

Figure 6.18 The Shockwave 3D Export window, with settings for exporting just the animation

Make sure you give your .w3d files clearly understandable names like 'walk motion' or 'standing motion'. You do not want to get confused later by trying to remember what file does what motion. There will be nothing to preview when you export just the animation, only the background color will be visible. This is perfectly fine and should not worry you. Looking at the exporter's report will show you a file size indicated for animation, probably around 8 kilobytes in size. This means the animation data has exported and you can confidently repeat the process with the other motion files. If the size is zero then something has gone wrong. Make sure you did choose 'Export selected' and that you have selected the correct options in the export window.

Importing into Director

That should be it for now in your 3D package, but if your computer has enough memory, keep it loaded and load up Director. It can be quite handy to have these two programs open at once, in order to quickly alter your scene, but if your computer slows down too much then quit your 3D application.

From the 3D for the Web disk open up the tutorial file 'ControlCharacter.dir' in Chapter 6 folder. This is a nearly blank Director file. It contains just three behaviors, which will enable you to move your character around the simple world that you have created and view it.

Stage 1 – Looping the Director movie

If you have been working through this book chapter by chapter, then it has probably been a while since you have used Director. It is good practice to make sure the playhead of the movie loops around one frame. To do this first open up the Score and the Cast windows from the Window menu. Then select the 'Loop Frame' behavior from the cast and drag it into the frame script window (above the timeline bar and next to the Script icon) and in frame position one. It should only be one frame in length (Figure 6.19).

Stage 2 – Setting up the Shockwave 3D files

Now go to the File > Import menu and import all five of your W3D files (the scene and the four motion files). You should see that the main file has a small image of your ground and character, whereas the other four are blank. Open up the Stage window from the Window menu and drag your scene file (in our case it is called Keystone) onto the Stage. Make sure your movie is at a suitable size, Window > Property Inspector > Movie. I suggest

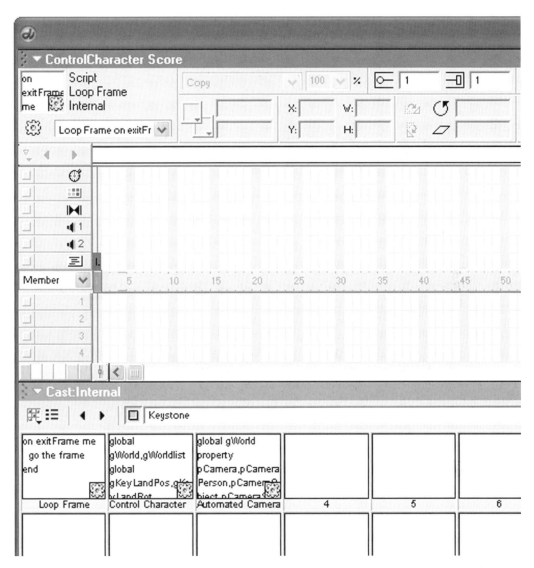

Figure 6.19 Director's Score and Cast windows, showing the position of the Loop Frame behavior

you set it to 640 by 480 for now, as we will not be exporting it for the Web as yet. Stretch your 3D sprite on the Stage to fill the whole window (Figure 6.20).

Check the Score window, you should see the 3D sprite in Sprite Channel 1. It will probably be more than one frame long but this will not matter as the playhead will loop around only frame one.

Figure 6.20 Resizing the 3D sprite to fill the Stage window

Applying the Character Control behavior

If you play your movie at this stage, nothing will happen, as we need to use the Character Control behavior that I have made up for you to use. There is a lot of programming in this behavior but you should not have to worry about it. I have incorporated a degree of customization, giving you options to select, which will be explained in a moment. There are always pros and cons in creating a standard, one size fits all, piece of code. They are fairly easy to use, but troubleshooting can be awkward if there are problems. If you are familiar with Lingo coding then you are welcome to adapt this behavior for your own uses. In essence it is a part of a block-by-block method for creating a game. This will be achieved in Chapter 8, but for now we will get on with just controlling our character.

Drag the Control Character behavior from the Cast to the Stage window and drop it on our 3D scene sprite. A pop-up window should appear with many options (Figure 6.21).

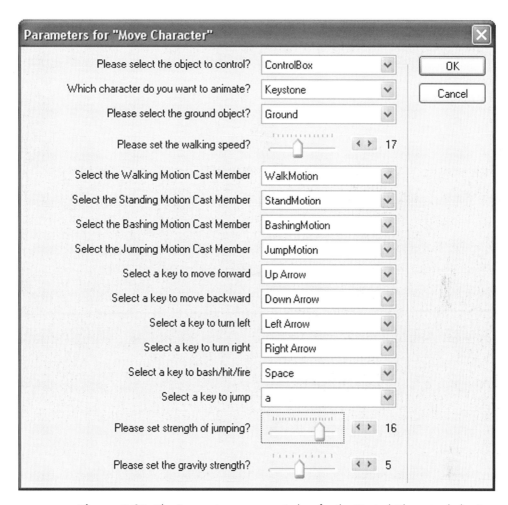

Figure 6.21 The Parameters pop-up window for the Control Character behavior

Select the control box object as the object that you want to control. You should have linked the character to this object, so moving it around means that the character follows it. In other words the character actually stays on the spot and it is the box that moves around.

The character to animate will be our Keystone group that you should have already named. This selection affects the motion settings later on, as the behavior looks for motions that have the same name as the animated character. I should point out that if you select the wrong object, playing your movie will cause an error. The object you select must be the one you animated previously. If you get an error, then cancel it and go to the Behavior Inspector, then select the correct object to animate.

Choosing the ground object is important as this dictates the vertical position of our character. As he jumps up, the behavior checks for the objects that

are below and makes sure that the control box object does not fall down below the ground object. This works even for bumpy terrains (these are discussed in the next chapter). There is a gravity value that forces the character to stick to the ground.

The walking speed is adjustable so that you can closely match the speed of his/her footsteps with the distance that the control box is moved every frame. This figure is in world units and defaults to a value that will be roughly right. If your character appears to be sliding on the ground then you can change this value later, by selecting the behavior in the Behavior Inspector.

The next four options allow you to choose the motions that you should have set up and imported already. These motions have been set up to be triggered by pressing the appropriate keys. When you select the forward key, not only does the control box move forward, the walk motion animation is told to start playing and to loop. This will continue until the key is released. Then the previous animation will play. The previous animation is the standing motion that also loops, but works only when a key is not pressed. When you press the 'walk backwards' key, then the animation is told to play in reverse.

Animation blending

A good thing about Director is that these animations do not just stop and start they blend smoothly from one to the other, known as animation blending. This is a very useful feature, as it will make our character look a lot more believable than if there was an abrupt, unnatural change between the two motions. Blending also happens when the bash motion is played, whereupon the control box is told not to move forward.

The main advantage of blending is that you may have a motion that finishes in a slightly different body motion to the next motion's start position, but it will not be noticeable. Also a motion does not have to be finished playing for it to blend into the next motion. So you can quickly and smoothly change between bashing, jumping and walking (Figure 6.22).

| **Note** | *Animation blending does not occur at the point where a looped animation jumps back to the beginning. It only occurs between two different motions. This means that any looped animations you create in your 3D application must repeat smoothly. You may have done this by careful adjustment of the keyframes, or by copying the first keys to the last frame of the loop. If you did the latter, then you do not need to export the last frame.* |

Figure 6.22 The Keystone character waiting and tapping his truncheon

As the bashing is not looped, it will only play once and return to the previous motion. However, if you keep the bash key held down it does, in effect, loop. What is actually happening here is that the bash animation is being told to play again.

You have a few choices of keys to control the movement, the defaults are the cursor (or arrow) keys. These are the most commonly used keys for moving characters forward, backwards, left and right. You can also select keys to control the bash motion and the jump motion. There is no key to trigger the standing motion as it is triggered by not pressing a key.

The final two options in the pop-up window are to control how the character behaves when he is jumping and falling. This is why we have created a jumping animation that does not actually jump. (See example file on the CD).

With these two controls we can adjust the height of his jump and by changing the gravity setting we can simulate other environments like being on the moon or being in water (particularly if you had created a swimming animation). Also the strength of gravity affects the relative scale of the character. You want him to appear to fall with believable acceleration. You can probably leave these values at their default settings, but you can change them if you want your character to jump higher, or fall in a heavier manner.

Adding a camera

Well, we have finally got an interactive character, which is controllable and moves around a simple 3D world. But, at the moment, if you play the Director file, he will walk off the screen. Not much use to us. We need to be able to see him and using one or more cameras does this.

By default, when you exported your animations you selected the perspective window. This uses a camera, and this camera is exported with the rest of the file information. Without a camera you would not see anything, so there is always a default camera. You can in fact have multiple cameras and either switch between them or have them displayed on the screen at once. An example use of this might be in a racing car game, where you want a split screen effect, allowing two simultaneous players, or a rear view mirror. Alternatively you might have cameras set up in certain positions and the screen displays the nearest character to that camera.

Good camera work is essential, as you do not want to make your game-player dizzy by spinning around a camera too much, or by the view of your character being blocked by objects. As this is quite a big subject we will study it in detail in the last chapter where we will be studying the issues involved in building a 3D computer game. For now we will use the behavior provided in the example file to allow us to view our character.

In the cast you will see the Assign Camera behavior, drag it onto the Stage, which brings up the Parameters window as shown in Figure 6.23.

You will see that there is a choice of camera type, either First or Third person. The difference between these is fairly self-explanatory, either the view is from the character's eyes, or from another person's view, i.e. the camera operator. Select Third, otherwise you will not actually see your character.

Then select your control box object to look at. If you have selected the Keystone object, then you will find that the camera does not follow it properly. This is because the character's position changes relative to its parent object, which is the control box. Essentially the Keystone does not move anywhere relative to the control box, so the camera would stay still if it used

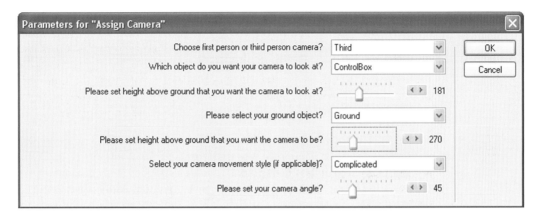

Figure 6.23 The parameters pop-up window for the Assign Camera behavior

that coordinate information. Make it follow the control box, whose parent object is the 'world', which means everything.

The camera will now look at the axis of the control box, this is located at the bottom of the box, but we would normally want to look at eye level. So set the 'height above ground that you want the camera to look at' to the eye height of the character, probably about 180 units.

The reason for selecting the ground object is that the Assign Camera behavior knows not to travel through the ground, which is generally unwanted. So you select the ground object and then set the minimum height that you want the camera to travel to. If you want the camera to be higher than the character then set it above 200 units, perhaps at 300.

There are three choices of camera movement style – manual, simple and complicated. Select any of these to view your character, swapping between them will demonstrate the difference. The 'manual' setting allows you to use the mouse to view around the character and the other two methods travel to a position behind the character. They always point at the selected object.

The last option is the camera angle. A 45 degree setting gives a perspective that is roughly equivalent to that of the human eye, and so feels most natural. Feel free to experiment with this though, to view extreme perspectives.

Now you are free to make your character run around the simple checkered world, and the camera will follow him. We will make good use of this in Chapter 8, by combining your character with a game world.

Interview with Titoonic

www.titoonic.dk

Company profile

Titoonic is a creative game developer and Web production company situated in Copenhagen, Denmark. The company was founded in August 2000 by Peter Holm and Tomas Landgreen. Titoonic produces lively content for the Web and also own Sporkle, an online entertainment service marketed in the Nordic region in partnership with MSN. The owner group and the creative team come from a background in classical animation and graphic storytelling – and eat games for breakfast.

I came across them when I was looking for sites that used Flash in an interesting way. That first visit was one of many as Titoonic creates wonderfully satisfying games combined with excellent character design.

Interview

The interview is with Tomas Landgreen, one of the founders of the company.

What is your role at Titoonic?

I have many different roles at Titoonic. I take part in setting our company's general goals, deciding on strategy, and other 'big' decisions, etc. Apart from that I spend my time on anything from programming, animation (2D/3D), painting and concepts to budgets.

Can you describe the background of your company, its aims, ambitions, client base?

Most of the core employees of Titoonic come from the animation business. When we started, our aim was to do animated characters for the Web.

LIVERPOOL
JOHN MOORES UNIVERSITY
AVRIL ROBARTS LRC
TITHEBARN STREET
LIVERPOOL L2 2ER
TEL. 0151 231 4022

Almost all of our first jobs involved games in some shape, and very quickly our focus began to shift towards games. Ninety-five percent of our projects now are games.

Our ambition is to make entertaining quality games. The more characters, unique universes, beautiful settings and storytelling we can cram into them, the happier we are.

How many people work at Titoonic?

We are 14 at the moment.

Typically how many people would work on a project?

On a typical Web-game production we would have three to five people involved in the process from concept to final game.

Do you have separate 3D animators, Flash animators and Programmers, or do the skills cross-over?

We have both. It's hard to come by people with these cross-over skills. When it comes to games-programming I think that cross-over skills is what

can make the difference between an 'okay' game and an exceptional game. It can also do wonders for the production time of small Web games. If one man can do it all, you save a lot of time on having meetings and communicating this and that back and forth.

Do you ever bring in specialist freelancers?

Not very often, but we do occasionally use freelance animators or designers/background painters.

How important is sound in your games and websites and who handles that?

Sound is very important, unfortunately we don't have enough work to have an 'in-house' soundman, but we have two that we use on a regular basis, for creating music, music loops, special effects, etc. (We also have a few places on the Web where we download sounds. Most of our smaller client projects, and game skins have no budget for custom recorded or created sound.) Final sound implementation is done by our flash-guys, programmers, as well as designers.

General design and 3D

How did you get started in creating 3D for the Web?

I was heading up the 3D department at A-Film in Copenhagen, working on 3D commercials and 3D elements for animated features when I started messing with 3D for the Web. It had an instant appeal to me.

'Normal' 3D work for films and commercials was starting to bore me. We always spend most of our time trying to satisfy a client's need for realistic rendering, cloth animation, hair and other technical difficulties. These were things that were easily solved in any of the large 3D houses, but took a lot of hard work for a small department like ours, and it didn't leave us much time to do the fun parts: the concept, the character designs, the animation and the storytelling.

Because of the bandwidth limitation, realistic rendering was out of the question for '3D for the Web'. Simple character designs and simple rendering will keep the file size down. Focus is on the animation and the storytelling.

How do you come up with the different ideas for your characters and games?

When it comes to me, the idea for a game will often come from a funny sketch of a character, or from a bit of code that I'm trying to put together. For client projects we will often have a 'brainstorming' at Titoonic to come up with ideas. We also have a writer on the regular staff.

How do you decide whether to use 3D in a project?

It depends a lot on the type of project, on the look and style needed and of course on production time and budget issues.

If the project doesn't have a look or graphic style that require a specific animation type, it will typically be the amount of animation (and characters) that decides it. 3D animation is best suited for projects that have large amounts of animation. 3D animation also has unique possibilities for reuse. For example, if you have a game where five characters have the same animations (stand, walk, run, jump, shoot, etc.), it is a lot cheaper to do it in 3D since you can reuse/modify the animations for each character.

Also most of our licensable games that have characters in them (like the snowboard game) use 3D characters, because it makes it very cheap to offer the client the chance to modify, recolor or exchange the character for another one, since the animation can be reused on the new character.

Good-looking 3D has an immediate appeal. Do you see it as the way forward in Web characters?

Well it is definitely one-way forward. I also think that good-looking 2D has an immediate appeal ☺. A well-animated, funny, appealing character, will be a success whether it is done in 3D or chiseled in stone.

How important do you think interactivity is to your work?

It's very important. We haven't done any non-interactive work!

We do have some characters and universes that may very well evolve into 'wepisodes', but I don't think that we will ever make 'wepisodes' like they are seen mostly: non-interactive. Web-content ends up on a computer screen, and the computer is an active media, unlike television which is a

'lean-back-and-enjoy' media. I don't think it wise to try to compete with television-series, without using the strengths of the PC: the possibility for interaction.

On average how long do you spend developing your animations and games and how much of that time is pre-production?

Its very difficult to generalize here, since our projects range in production time from 1 to 24 weeks. Maybe 5–10% is pre-production. A typical custom made Flash game, will take 8–10 weeks to produce, and 2 weeks of that would be spent on the concept and pre-production.

What aspect of development would you say is the most time consuming?

I would definitely say budgets, but this is subjective and misleading ... I really hate making budgets and consequently it seems to take forever, and I can hear every tick of the clock as I type in my wildly inaccurate estimates, as soon as I start animating and programming, time flies.

On most of our games 80% of the work is finished in 20% of the time we have. The rest of the time is often spent testing and adjusting gameplay,

putting the finishing touches, dotting the i's and crossing the t's. Adding all the extra touches that (hopefully) will make this game stand out and be entertaining and memorable.

Your past and future work

Your games reflect a number of different graphic styles who/what are your influences?

We try to use and take advantage of the individual styles of each of our employees, as much as possible. The characters of *Pixar* have always been a great inspiration to me.

Many of your websites consist of cell-shaded 3D, what is your motivation behind using cartoon style graphics?

We love the look, and it does wonders for the file size when comparing it to rendered bitmap style 3D.

How important is storytelling in a website/game and how do you come up with story ideas?

Again it's really hard to generalize here. Some 'abstract' games like *Tetris*, do not need a storyline or character of any kind. In many other games a story can add the extra touch. Everybody loves to hear a good and well-presented story. The problem is often how to integrate it into the gameplay so it doesn't feel forced or annoying.

We had some good experiences with the adventure style games we did for LEGO. They are for a younger audience, and they really liked the format. Adventures, told in animated sequences, with three or four games.

I think it is often quite easy to come up with games to integrate into a good story: much more difficult to have a good game and come up with a story. We have an in-house writer that does the dirty work, but we often start with brainstorming meetings to give him something to go on.

Why are your games important to clients and their websites?

Games make the client customers stay longer at their website, thereby exposing them for a longer time to the brand, messages, etc. And more importantly it can make them come back, and make them send their friends to have a look also.

What awards have you won and have they made a difference?

We won the flashForward Awards for best game and it gave us an opportunity to see NY. And also gave us a lot of free PR. It's hard exactly to guess what clients we wouldn't have had if we hadn't won, but I'm sure there are a few.

Technique

What software do you use for creating websites, animations and games?

3ds max, Flash, Director, Dreamweaver, Photoshop and UltraEdit.

How much programming do you use and do you view it as an important skill for designers to have?

We use a lot of programming, and the more the designers know about programming the easier the communication is. It is even more important to have programmers with animation skills. When programming games a lot of animation is 'programmed' so a games programmer needs to have a good sense of timing and movement to create an entertaining game.

What is the most challenging aspect of 3D Web design?

I think generally, that the most challenging aspect is to get as much content/animation/graphics as possible within the bandwidth limitations.

Why do you prefer to use Flash for your cartoons?

It's a very fast production environment, with a lot of ways to reuse resources, and the file size of vectorized content is minimal.

What frame rate do you typically work at for games and animations?

For Flash games or animation we normally work in 25 fps (the same as VHS, the European television format).

Your high quality rendered animation is of a very impressive quality but contrasts a lot in style to most of your websites. Is this because of the limitations of Web design and do you want to incorporate more of this type of 3D work into your websites?

Yes, that's true. As bandwidth increases (or we move on to producing download games and small boxed CD-ROM games) we will probably use this style more often.

Chapter 7

Building virtual environments

A real and a virtual world

In films you might composite computer generated characters into a real world environment that has already been filmed. Likewise the opposite might be done with human actors being superimposed onto a virtual set, using blue or green screen techniques. Of course, there are also the films where everything is generated by computer. You could use these compositing ideas for your website, but it only really works well for pre-recorded films or pre-rendered animations. The key to our Web creations is interactivity, which means that we want the ability to change camera angles in real time and for our characters to be controllable. We require our environment to have some life and for us to have the ability to explore it.

We have dealt with characters and controlling them already in this book, so now we will deal with the world in which they reside. Whether your Web project requires an interactive map or a computer game that will lure in the visitors, you will need to know how to create an environment for that. If you are making a 3D game, you will need to create the whole world, whether it is a city, a race track or a building.

The main issue with creating an environment is complexity. 3D graphics are all about geometry and the geometry of nature is very complicated. Making dirt and rubble is one of the easiest things to do in real life, but needs an amazing level of complexity to be created in computer graphics (CG). Representing nature accurately is very time consuming. Creating a blade of grass is not a highly complex task on its own, but simulating a field with millions of blades, will take a lot of computing power to display, especially if we want them in real time (Figure 7.1). Also, it takes a lot of time to design and create thousands of objects.

Figure 7.1 A blade of grass

Designing for a game is different from designing for an animation. We need to be able to move around our environment in real time, so we have to employ tricks and illusions to get as near as we can to some sort of realism. You want the scenery of your game to be believable so that the users do not spend their time finding fault, but become engrossed in the experience.

This chapter is all about achieving effects to simulate outdoor environments. We will be covering techniques to create landscapes, trees and water. To

further enhance our landscape we will look at different approaches to skies and clouds, and the overall shape of the environment.

Terrains

If you are creating an environment for use in interactive 3D then you could have just a flat ground; a plane with a texture on it. This is fine of course if your scene is interior, with a hard floor of stone or carpet, but outdoor scenes are more complicated. A natural landscape is rarely flat, but ranges from that of a desert to rolling hills and mountains, full of lumps and bumps (Figure 7.2). This section looks at how the creation of a believable terrain can be achieved and the issues involved. We will explore the level of realism we can expect and what techniques can be employed to make artificial landscape creation into a straightforward operation.

Achieving a landscape or terrain does not have to be a difficult task and there are several ways to achieve it (Figure 7.3). The main concern, as always with

Figure 7.2 A real landscape terrain, Corfe Castle, Dorset, UK

Figure 7.3 An interpreted virtual terrain: *Purbeck Light Years*, interactive art installation of a virtual painting, by Jeremy Gardiner and Anthony Head. Corfe Castle is in the middle of the picture

any real time 3D application, is the polygon and object count. That will be the deciding factor as to how your environment will perform. With a flat plane there is no need to have many polygons, which in turn means that most computers will be able to play the piece at a decent frame rate of around 30 frames per second. A flat plane need only consist of two triangle polygons (put together to make a square), but a terrain is going to consist of thousands to tens of thousands of triangles. How do you decide how many your landscape needs when there is such a range in the power of computers? The answer is, perhaps unsatisfactorily, trial and error testing and compromise. Ideally, your terrain is going to be made of millions of polygons, with minute detail, but this is not practically possible. All you can do is test it on several speeds of computer, unless you are happy to let it work only on the latest graphics cards. As a guide a terrain of around 8000 polygons is going to be fairly detailed, and will work on older graphics cards. If there are hundreds of other objects in your scene then your frame rate will decrease and a high frame rate is part of the key to believability in interactive 3D. It has to *feel* real more than look real.

So, we are going to create a landscape of around 8000 triangles. We will assume it is a square shape, although it could be a rectangle. A grid of 64 × 64 squares will contain 4096 squares, which in turn means 8192 triangular polygons (Figure 7.4). Although working in powers of 2, i.e. 2, 4, 8,

Figure 7.4 A wireframe view of Purbeck Light Years, showing the terrain mesh with 4096 squares

16 ... 64 is not essential when dealing with polygons, it is important for textures. To this end it is handy to use a 64 × 64 grid for the terrain mesh, we can easily double it if we need to.

Note *A texture is the bitmap image that can be mapped onto any shape. In real time 3D you are limited by the fact that you cannot easily create Bump mapping effectively. This means that all 'textures' are smooth, using only visual information to give the illusion of surface quality. A texture is a property of a shader. A shader is equivalent to a Material in 3ds max, and it controls and describes how an object's surface will look, e.g. the shininess, the image, the color, the position of the image, etc.*

Edge of the world

So we are going to make a grid of 64 rows and columns into a landscape, but that is not realism. What happens when we reach the end of that area? You do not want people to be able to walk up to the edge of your 'world' so you will have to find ways of stopping them. You can do this by creating walls or limiting the ability to walk near the edge of the world. You should view this restriction as a way to focus the user into the scene that you have created.

There are several methods of terrain creation and we will discuss a few of them. All of the examples talked about are included as files on the CD supplied with the book. They will allow you to use and enhance the results of these techniques.

Terrain building in a 3D application

Using modifiers

The simplest method to create a terrain would be to use a 3D package. You could create a mesh and apply a Noise modifier (Figures 7.5 and 7.6) or better still a Terrain modifier. This would give you a landscape, with high points and low points. The workings of this involve fractal mathematics and random numbers to create the look of the landscape. This is great for building islands and rolling landscapes but has the major drawback of not allowing the user to specify exactly where or how they create the features of the surface. You cannot usually say that you want a hill here and there; you rely on trial and error to choose the correct seed (the random number used for the calculations). This can be fine, but if you have a specific purpose or plan for your world, it is unsatisfactory. A more personalized solution is needed.

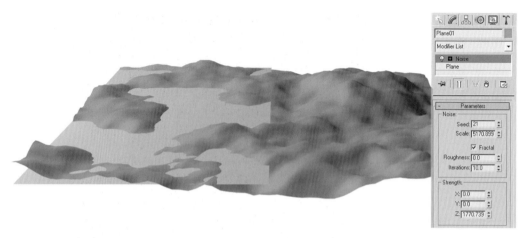

Figure 7.5 A fractal Noise modified plane, with another plane indicating water

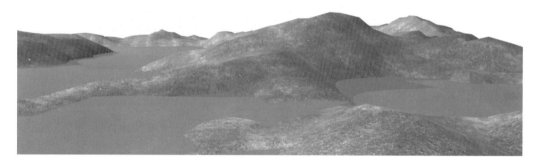

Figure 7.6 A close-up view of the fractal Noise modified plane

Displacement mapping

Using a displacement map on your plane is a method that gives you much more control over your landscape design. The idea is that you have an image that represents the heights of the land that you want simulated. This could be created by hand in a paint program or could use real satellite data. Height or terrain maps are usually color coded in gray scale, with white being the highest height and black being the lowest. Exactly what heights are represented is unimportant in a virtual world, what matters are that they are correct relative to the scale of your other objects and the size of the world. For this purpose, it is advisable to have a height map that uses the full range of 256 shades of gray (Figure 7.7).

The terrain map should always be the same aspect ratio as your grid, in our case 1:1 or square. As a bitmap it needs to be only the same size as our grid, i.e. in image resolution of 64 × 64. When you edit this image you will see that this is very small, but it is as detailed as our landscape. If it makes life easier you can work on a higher resolution image and scale it down when

Figure 7.7 The displacement terrain map use for Purbeck Light Years

you are happy with it. What you need to remember is that this image is not what is going to be seen. This image is only used to change the heights of the vertices in the mesh, to displace it. What you will see in your finished terrain is the Diffuse map, which is the bitmap image of your landscape (perhaps an overhead photograph, or a tiled picture of grass).

Terrain building in Director

As download size is always a concern when creating Shockwave movies for the Web, another way to create your terrain is to generate it entirely in Director. This is not as complicated as you may think and you can apply the same principles as for the displacement map previously described. The example Director file creates a landscape and applies a map to it (Figure 7.8). The processes involved are:

1. Create a plane with a 64 square resolution (or greater, if required).
2. Find the terrain image and check the gray-scale value of each pixel on the image (row by row) and move the y position of the corresponding vertex in the map, multiplied by a vertical scale.
3. Apply a landscape image for color.

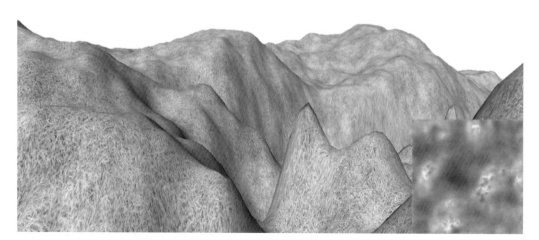

Figure 7.8 A terrain created with the Terrain Generator program, with its terrain map

The vertical scale that the map is multiplied by is calculated by deciding what you want the maximum height of your land to be, in world units. This depends on the scale of your whole world, if a tree is 20 units high then you might want a mountain to be a few thousand units high. The scale is up to you, you just need to remember that you will be navigating over it.

Once you have created a terrain you need to work out what you want on it. Of course, if you are planning a game or interactive environment then you should have already decided this. After all, everything in your world needs to be there for a reason, whether that be esthetic or practical. Also, if you want a character to walk around it then you cannot practically have incredibly steep hills, as this will not be very believable, and can be awkward from a technical point of view. A vertical slope would be something you want to collide with, and a gentle slope something to walk over. Gentle slopes look better as severe changes in heights emphasize the triangular nature of the mesh sides, whereas in gentle elevations the mesh appears smooth and not faceted. CG cards have built-in capabilities to help smooth meshes, but this is just a visual trick and does not mean that the mesh has any more polygons.

Fractal terrains

Landscapes can be created using fractal math. This might sound complicated but there are many software applications that can create terrains in this way. The most popular is Corel Bryce, where you add objects, clouds and weather to your landscapes. The following section provides a description of how mathematical terrains are created.

There are many fields in the study of fractal mathematics, but the fundamental similarity is the concept of iterations. Simply put, iterating means repeating

the same calculation again and again. The fractal element means that these iterations occur at finer and finer levels of detail, in a fraction of the space.

Briefly speaking, a terrain map is created by having a grid of four squares, of random color values. This is then sub-divided, smoothed and decreasingly randomized until the required resolution is reached. Figure 7.9 illustrates this with a terrain map being generated using random fractal generation and smoothing in eight stages.

Figure 7.9 A fractal terrain map being formed. Each stage being divided and replaced with squares half the size with a random variation in tone

The example Terrain Map Generator program allows you to create a terrain map, for use in your own projects. However, as I mentioned earlier when describing the terrain mesh generator in 3ds max, you do not have any control over where the peaks and troughs, the hills and valleys, are located. It is a random process. Often, you might use a random terrain map as a start and then edit the bitmap to create the desired shape of landscape.

Another use for terrain maps of this kind is to make cloud maps. It is a curious quirk that a bit of tweaking of the code for the Terrain Generator makes many varieties of cloud formations. I will leave that to the more Lingo knowledgeable amongst you to adapt the program to do that, and we will discuss making clouds later on in the chapter with other techniques.

Trees

Now we have built a landscape, the next thing to do will be to populate it with some objects. Of course, if we build objects then we need to make sure

we do not crash into them when we are moving around the world. This is essential for any interactive game where you control a character or yourself around the world. We will discuss this in the next chapter, but first we will build some trees. Making trees is a handy way to describe several useful modeling and texturing tips.

In the real world there are many thousands of varieties of trees, and if you want more than one tree in your project, then you will probably want more than one variety. There are several methods for creating trees, each one having its own pros and cons. The methods do not depend on the type of tree you want, but concern how the trees are made. They vary in complexity, both from a creation point of view as well as an aesthetic point of view.

The single plane method

This is a classic technique in the world of game design, and the simplest way to create a believable looking tree. The principle is that simple objects make for fast frame rates and photographic textures make for realistic scenes. So if you place a photograph of an object on a plane, with a transparent border, you can make a reasonably convincing object. The audience does not see a square plane, but the irregular outline of the object on a see-through background, e.g. the shape of the tree. This concept has long been used in 3D games, particularly racing games where trees, spectators and billboards rush past the car. The technique does not stand up to close scrutiny, but when you are rushing past scenery, your brain happily believes the realism of the objects.

Note *As a plane is obviously a flat shape, you might expect this technique to look very odd, as you could walk around an object, and it would appear to be flat. This is overcome by having the objects always face the camera, so that you always see the front (unless the object is meant to be flat). So it works well for trees because they are complicated images that are not particularly recognizable, that is all the leaves look the same, so you are less likely to notice the issue of it always facing you.*

To start this concept you need to get hold of a picture of a tree. It is always best to take your own photographs so you will not have to worry about copyright issues. The next step will be to scan it, if it is not a digital photo, and get it into a photo-editing package. You should then crop the picture down so that only the tree you want is left in view (Figure 7.10). Do not worry too much if there are other trees visible right behind the one you want as you will create what is known as an alpha channel in which you will make everything you do not want to see invisible. By making your picture

partially transparent, you are in effect erasing the unwanted parts. The following description uses Adobe PhotoShop to achieve this, but it should be achievable in other image-editing packages.

Figure 7.10 A cropped photograph of a tree

The simplest method is to use tools such as Color Selection and Quick Mask. This will select an area and allow us to remove it from our picture. First of all, we need to make our image into a floating layer. In the Layers palette you should see that your picture has just one layer and it has a closed padlock icon next to it. This is because it is the background layer and hence cannot be masked in the way we would like. You need to select Duplicate Layer and then remove the background layer by selecting and pressing the trashcan icon at the bottom of the palette. Now you have a floating layer called Layer 1, unless you have renamed it (Figure 7.11). This means that when you erase parts of the image, the alpha transparency is revealed underneath.

Note

Any color in CG is made up of 256 shades of red, green and blue (RGB channels). But you can also have another channel, known as alpha (RGBA). The alpha channel is 256 shades of transparency, from transparent to opaque. This is very useful in the world of compositing and masking. We are using an alpha channel to be a mask, so that we can essentially composite just the tree into our 3D scene.

Figure 7.11 The Layers palette with the background layer

Now you can select Color Range from the Select menu of PhotoShop. You will see your tree represented in Black and White only. Pressing down on your image will select different color ranges and holding down the Shift key will add to a selection (the Alt key does the opposite). You need to select the colors in your image that are *not* in the tree, i.e. not the green leaves. When you accept this selection you will see a moving dashed line surrounding your selected areas. This is unlikely to be perfect and parts of your tree might be selected. This is why we use the Quick Mask tool.

Pressing the Edit in Quick Mask button (near the bottom of the tool palette), converts the selection to a red and orange tint. Everything that is orange or red will be protected and everything else will form part of the selection. It is here that you can neaten up your selection by painting black onto your tree. It is probable that the trunk did not get selected properly, so use a fine brush and paint over these areas. You will see that the dark trunk appears red. This shows that it will not be part of the selection. Figure 7.12 shows a black and white image of a cleaned up mask image. Everything that is black will be transparent, and white, solid. The gray areas will appear semi-transparent.

Figure 7.12 A mask created from the photograph

When you are happy with your mask, go back to Edit in Standard mode and then press the Delete key to remove the selection. You will see a checkered pattern where your image will be invisible (Figure 7.13). This is the alpha layer. Your image is now ready to save.

Figure 7.13 The tree showing the transparent background

You should resize your image to a suitable texture size; I suggest 256 × 256 pixels. Then select File > Save for Web in PhotoShop. You will be presented with a new screen. Select portable network graphic (PNG)-24 as the file type (the default option is graphics interchange format (GIF)). PNG-24 includes the alpha channel information we need. Save the file as TreeFinal.png

There is an example file on the CD called Tree Generator. If you open this up and import your file into it your tree will appear in a simple scene. Feel free to adjust the settings but this is just a file for example purposes.

This method is a compromise, it is the simplest way to create a realistic tree, but is not at all convincing if you rotate it. From a front-on view it looks fine, but when you see it from the side, it is thin, bordering on invisible. This is why the Tree Generator program makes the tree rotate when you move around (using the cursor keys). The trees are always facing you. This technique has been used for a long time in 3D games, and only feels strange when you are very close to the tree (Figure 7.14).

Figure 7.14 The tree mapped onto planes and put into a simple scene, using the Tree Generator program

Two and three plane trees

An advance on this method for tree creation would be to create either one or two copies of the tree plane, and rotate them. If there are two planes in total, then rotate the second one by 90 degrees; if there are three in total, then rotate the second and third by 60 and 120 degrees, respectively. This method gets around the cardboard nature of the plane method, but has one major drawback in Shockwave: it does not render correctly. Normally when you have two objects intersecting, you cannot see behind them, but when an alpha channel is used, the transparency information is rendered after all the models are, often resulting in an visually confusing scene. This is hopefully an issue that will be solved in future versions of Shockwave 3D engine, but as yet remains a problem. Another drawback of this method is that you are increasing the number of objects in your scene, and if you have hundreds of trees this will slow down the frame rate.

Using an image plane is useful on two points; from the realism issue it uses photographs that are obviously generated from nature. The other issue is geometry. This method uses a low number of faces, meaning that you can have many trees in your scene without compromising the speed of the graphics card. However, this may not be the style you want, so we will explore a different type of tree.

A solid tree

If you do not need hundreds of trees in your project then there are other more stylistic ways to create trees. One method would be to use the polygonal modeling methods that you have used so far in this book. You could start with a simple box for the trunk. Then apply the Edit Mesh modifier and reshape it, extruding the polygons to create branches. The foliage could be made with another box that can be reshaped to fit the branches (Figure 7.15).

If you use the Mesh Smooth modifier on each object the look is more natural and with the addition of the UVW map modifier and some appropriate materials, you will have a stylized tree (Figure 7.16). One point to make here is that you do not need to create the branches if you have solid foliage, you just need to create the trunk. However, if you are making a wintry world, then you do not need the foliage, but would need to enhance the branch structure.

This method certainly looks good from the point of view of quality, but it does use a lot of polygons and so it is not advised for large forests. However, if you only have a few trees and you do not want photorealism then this might be the ideal approach to take. Also, remember that geometry adds to

Figure 7.15 A polygon extruded trunk and reshaped box foliage

Figure 7.16 The tree after Mesh Smoothing and the application of appropriate materials

the download time of a Web game, so you would probably only create one tree and use it to clone new ones when your game is loaded. This idea will be discussed in the last chapter.

Forests

It is all very well creating a few trees, but you might want more of a forest effect. There are a few ways to do this easily. The slowest method would be to place each model in your scene, one by one. Naturally, this could take you quite a while if you have lots of trees. There is a plug-in for 3ds max called Forest Lite which enables you to quickly and easily build forests using 'plane' trees, but it is not compatible with Shockwave (this is often the case with third party plug-ins which may save you time if you are creating animations for rendering, but are not supported for Shockwave 3D). You could adapt the Tree Generator program supplied with this book instead.

If you need to simulate a whole forest and you wanted to be able to view it (with thousands of trees) then you could create large long planes with bitmap textures with lots of trees on them. You could create this by adding lots of tree pictures together, or finding the edge of a real forest and using that as an image for your texture. You could then position these planes in rows to create your forest.

The Tree Generator program places trees in random positions, but it is possible to place them precisely by using a map. This idea is used in the last chapter for positioning objects in your scene in an efficient manner.

Water

The depiction of water in an environment can take many forms: whether you are trying to simulate a bucket of water, a sink, a pond, a river, a lake, a sea, a waterfall, a hose pipe, rain fall, ice, steam, condensation and so on. Each type of water has many different properties to consider, e.g. color, refraction, opacity, form, reflectivity and motion. It is through the combination of these properties that you can create a believable surface. In the next few sections we will talk about the techniques that you can use to achieve the desired effect for your various forms of water.

Ocean Wave Generator

This technique is not necessarily practical for a game, due to the amount of processing involved, but it might have a use as a sequence or a special effect.

To make convincing waves, e.g. ocean waves, then you need to employ a technique called Mesh Deformation. The main issue with waves is that they move, as opposed to a terrain, which is fixed. You could make an undulating surface and place it in your scene, but it would look unconvincing and plastic. We need to create a wave pattern dynamically that animates in a natural manner.

The example file, Ocean Wave Generator, does what it says but has many limitations; it is slow and works on small meshes (Figure 7.17). The following paragraphs describe how the program works. It does get quite technical, but this is necessary if you really want to understand this method for creating waves. There are other methods to achieve this, but this would be turning wave making into a specialist subject and you may not ever need to use them.

Making waves

We first create a plane which has a grid resolution of 32 units. This will be the surface that we will undulate. Now we need to understand the mathematics of waveforms and the control we can have over them.

Figure 7.17 Six screenshots of the Ocean Wave Generator

You can use straightforward math to create simple waves effects, adding a few sine waves together creates a more complex pattern which move when the time variable is incremented.

Figure 7.18 shows three sine waves, which have different wavelengths (the distance that the wave repeats) and different amplitudes (the height of the wave). When these are added together a more complex waveform is created.

Figure 7.18 Three sine waves and the result of adding them together

The diagram actually describes one point moving over time. We have created a mesh that has a resolution of 32, meaning 932 × 32 grid of points. We want to animate all of them, with a sine wave that is offset (so that they do not all move up and down at the same time). We can use the coordinate of each vertex as the offset for our sine wave.

The description below shows the principle as an equation (written in shortened English and then in Lingo code). When calculating sine values Lingo

requires radians to be used. This is often a bit difficult for people to understand, as they are more used to working in degrees. Therefore, it is easier to think in degrees and then convert to radians. However, it does take a fraction of a second longer to calculate.

Key:

57.2958 = the number to divide by when converting degrees to radians

wave height equals sine ((time step plus the coordinate) divided by 57.2958) times by the maximum wave height.

Lingo:

waveheight = sine((time + coordinate)/57.2958) × maxwaveheight.

In simplified terms, all you need to do is create sine waves in the x- and z-axis of your mesh and change the y-axis (the height) to the resulting amplitude at each coordinate. The sine waves depend on the coordinates to form. You can then shift this by adding an incremental value to the coordinate, i.e. time.

This creates a simple wave pattern, if you want more complexity then all you need to do is add another sine wave on and adjust the variables. For simplicity change the 57.2958 number to 20. This has the effect of shortening the wavelength, increasing the number will lengthen the wave. If you have two sine waves added together, one with a short wavelength and the other a long wave then you end up with the effect of waves on top of waves. Change the time variable by dividing it by 4 will reduce the wave speed to a quarter, so you could have a fast wave on top of a slow wave. Take apart the Ocean Wave Generator program to decipher more details from this.

This is a fairly naturalistic approach to creating waves for an ocean scene. The major drawback is the computer processing time. Our mesh only contains 1024 vertices and trying to process this is a significant drain on your computer's power. This may already appear slow on your computer. If you increase the resolution of your mesh, then it will slow down even more. This is why it is not particularly suitable for inclusion in a game. You can speed things up by pre-calculating the sine values, but I recommend use this technique sparingly, on small objects.

One reason why this technique is slow is because the program creates and deletes a mesh every frame. It has to do this in order to Generate Normals. Normals are descriptions of the directions that each face is pointing. The description is a vector direction, e.g. vector(0.34, −0.29, 0.87). The vector is an X, Y and Z value between −1 and 1. Without going any further into Vector Math here, the reason why this information needs to be calculated is so that light will shine properly on to the object, and faces will be in shadow

if they are not pointing at the light. This is why you can see light and dark areas on the six images taken from the Ocean Wave Generator. This was used in the Terrain Generator as well.

Flags

A great use for this method is for flags. Flags ripple in a very similar manner to water waves and obviously do not require a mesh anywhere near as big as an ocean. See the Flag program for a simple demonstration (Figure 7.19). It is possible to improve these techniques by including interaction. Instead of a time element creating the waveform, the wind could be variable and gravity and tension could be added to the material of the flag. If the waveform is slower then the substance of the Flag, or liquid is effected. A thick substance like honey would behave in a very different way to water.

Figure 7.19 A still from the naturally waving flag example

Properties of water

One obvious property of water is its ability to reflect light, like a semi-transparent mirror. Any glossy surface will contain reflections, showing the other objects in a scene. However, true reflection is not an inherent property of the Shockwave engine and overcoming this can be a difficult challenge. I will explain some of the methods that should help you on your way to achieving this effect.

Let us first isolate exactly what properties a reflected image has, compared to a normal image, so that we can try to apply these properties. One aspect is its brightness. As we are dealing with reflections on water, the reflected image is going to be darker than the original view, due to the fact that some of the light is absorbed. As well as being darker the image will be affected by the color of the water. But be careful here, most water is not colored unless it is dirty. The sea is blue because it reflects the sky, which is blue. Seaweed and algae can make it look green. Generally the color of your sea will be black but fairly transparent, a puddle or a bowl of water will be completely transparent, but the reflections will affect it. Because it is transparent, the objects below it will show through, this will also affect the apparent color of the water, e.g. sand.

Rippled reflections

If your water is rippled or wavy then this is going to affect and distort the reflected image. This is probably the most difficult effect to achieve convincingly and is not likely to be achievable if you have a large surface of water. It would involve creating our reflected image and texture-mapping it onto our water, which is a mesh being deformed via the methods we covered earlier. It is possible, but may not be a practical solution, as you have to take a screen grab of the image to be reflected and then map it onto the reflecting object (the water or mirror). This process is relatively slow and if the water is moving then the frame rate will probably become unacceptably slow.

As well as the reflected image we would also expect to see light sources highlighting the water, known as specular light. In Director this is the shininess property of the shader and is a value between 0 and 100. Note that with this property, zero has the widest area for the specular highlight and this property changes dramatically between zero and one. After one, the shininess gradually decreases, giving a more satin and eventually matte effect.

Reflection map

A simple method to achieve a reflective type of surface is to use the Reflection map property of the Standard Shader in Director. With this property you can select a texture that is used as the reflected surface on the object that the shader is applied to. This gives it a reflective feel but it does not actually reflect, in the Raytracing sense of the word, it is not a real mirror. This works quite well for metallic surfaces, but is probably not convincing enough for water if there are other objects in the scene. However, it should be alright if you are just reflecting the sky, assuming it has plenty of clouds. You could use the same texture for the reflected image as you have used for the sky. This technique was used with 3ds max in Chapter 3 for the sound art piece. A Bitmap was used in the Reflection map property.

JOHN MOORES UNIVERSITY
AVRIL ROBARTS LRC
TITHEBARN STREET
LIVERPOOL L2 2ER
TEL. 0151 231 4022

The Reflection map works by keeping the mapping coordinates of a texture in the same position as your view of a model as it changes position or shape. This gives the illusion of a reflective surface and works best with shapes that are not just flat planes, but are more complicated, e.g. a kettle. So if the water is rippled, the effect should be reasonably convincing (Figure 7.20).

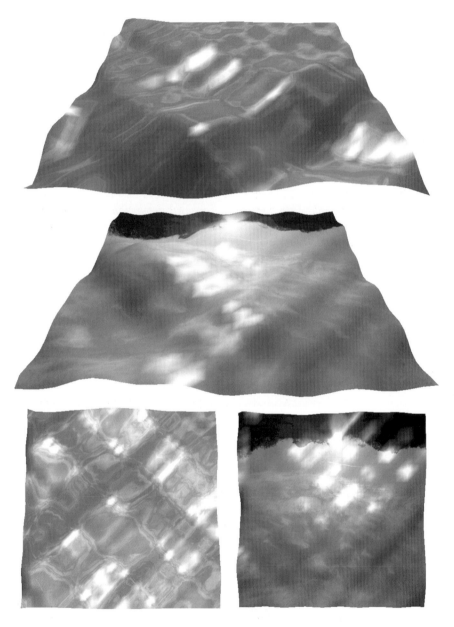

Figure 7.20 A sky texture mapped as a Reflection map (top and left) and a planar map (middle and right), with specular light

Reflections through cloning

If you decide not to use the Reflection map, and your water is meant to be calm, then there is a simple way to achieve perfect reflections. You could use the Mirror function in 3ds max to create a duplicate of all the models in your scene. They need then to be placed below the surface of the water, as far away as they were above the water. This will create a perfect mirror image of your world. The water can then just be a semi-transparent plane that cuts through this, with an amount of shininess which could simulate the sun reflecting the surface. As the water Plane should have a dark color to it, this makes the underwater objects look darker, hence making a convincing reflection effect. This is theoretically, a fairly simple solution, but it does have drawbacks. If your scene already has a lot of geometry then doubling it could slow your whole project down to an unacceptable speed. Also, this effect does not take into account refraction and how that will affect an image. Another problem is that if you want to see other objects below the surface of the water then the mirrored objects are going to interfere with them, getting in the way. Having said this, depending on your own project, this might be the straightforward answer you need.

Sky, clouds and backgrounds

If you are creating an artificial world then there are going to be limitations to your design. You cannot create a real planet with as much detail and objects as you find on Earth, you have to make compromises. The main issue is where the ground ends and the sky begins, but in a virtual world the Earth is flat! If we treated the sky as a flat plane then it would never reach the horizon, there would be a gap between the ground and sky.

Note *In reality the ground does not reach the sky. You could mimic this by having a Sphere for the ground and an outer Sphere for the sky, instead of using distorted planes. This would be fine if we did not have a polygon count issue. To make a believable globe you would need billions of polygons all around it to allow for hills and valleys, far beyond the scope of real time 3D.*

This is why terrains are usually based on planes. You need to decide how to restrict the user from getting too near the edge of your world. Perhaps you use natural barriers like mountain ranges, or artificial ones like houses.

So, given that we have a finite plane for our land, the sky must be created to look natural and believable. There are several methods that can be used

to create a sky for your scene, they mainly involve mapping textures on to shapes. It is the shapes and their positions that are important.

Note *Theoretically, if you wanted to make the whole world as one model with a vertex every meter, then it would require 511,405,027,689, 820 vertices! That is 511 trillion points on its surface. As this is such a huge amount then you would have to use an alternative approach to modeling the whole world. The best method would be to use a database system that loaded in each section of the world as you arrived in it. So only a small area would be visible at any one time.*

Backdrops

The simplest method for a sky is to use a camera backdrop, with a cloud picture on it. A camera backdrop is a bitmap texture that appears behind all the objects in a scene and usually fills up the whole of the screen (Figure 7.21). Changing the camera's viewpoint does not affect the position of the backdrop in relation to the view. Using a camera backdrop is usually fine if you

Figure 7.21 A photo that can be used for a backdrop

have just a plain blue sky, but begins to look unnatural if you use a photograph of clouds as a texture. Because the backdrop always stays in the same position, moving around the scene does not move the view of the clouds, making your environment look odd and unreal. Generally speaking, backdrops are only useful for abstract worlds or environments where the camera's viewpoint does not change (Figure 7.22).

Figure 7.22 The backdrop used with a terrain

Haze or atmospheric perspective

Another issue in the real world is haze. The picture that has been used in the diagram (Figure 7.22) has a significant amount of haze in it. Haze is caused by air pollution and water vapor. As you look further and further into the distance the saturation of color decreases until the land eventually disappears into the sky. This natural effect is actually helpful to our perception of the world and is known as atmospheric perspective. Because we know that air desaturates our real world we can get a sense of scale in a virtual world if haze effect is simulated (Figure 7.23). Without it your scene just will not feel real or rather it will feel small.

Figure 7.23 Using fog to create atmospheric perspective and a sense of scale to the virtual world

Fortunately graphics cards manufacturers have long since understood the potential of haze. It is known as fog, in particular camera fog. Why potential? Well, we know that we cannot display thousands of objects in our scene at once, so by using camera fog, we can fade out the world from the point of the camera into the distance. Once the fog becomes total, i.e. the color set up for the fog, then you do not need to display any objects further than that distance.

You can set near and far distances for the fog, where it starts and finishes. You can then set the camera not to draw any objects further than that distance, this is known as the setting the camera 'yon' property, yon meaning distant but within sight, it is derived from the archaic word 'yonder'.

Note *It is important to realize that fog affects only objects in your scene. The camera backdrop will not be affected as it is not an object. This means that the colors in the background picture remain the same and are not desaturated.*

Texture on a background plane, cylinder and sphere

An alternative to the camera backdrop is to place a texture on an object that is positioned at the back of your scene. In old computer games (particularly car racing games) this used to be a flat plane that scrolled right and left and as you turned left and right. This gave the illusion that you had a 360 degree panorama. A better way to deal with this is to use a cylinder that completely encircles your world. You can wrap a texture on the inside of this shape. You could take photographs and use a panorama-stitching program to create your own photorealistic textures to use in this way. The important point is that your texture needs to match at each end as the left side will meet the right. One restriction of using a cylinder arises from looking upwards. You cannot get away with this method if you need to look up above you as there will be a hole in the sky! But your project may not require looking up, so this could well be the solution you need.

If you are able to look up above you in your world, then you could use a sphere object that has a spherical projection map wrapped on it. You would actually only use a dome part of the sphere, the rest of it being below ground. When creating a texture map for this you have to be careful where the texture meets as it wraps around the sphere (remember that all textures are square in shape). You could use an image-editing program with a polar-coordinate distorting filter. This could turn a texture into a distorted round shape that you could map on your sphere.

Note *This method also causes issues with the fog technique described earlier. As the plane, cylinder or sphere is an object, it will be affected by the color of the fog. This is probably not the result you desire. It is possible to stop the object being affected by fog, but it has problems and involves understanding how z-buffer works. The z-buffer is used to calculate how to draw all the objects in a scene so that they overlap correctly for the distance they are from the camera. This is starting to get into graphics programming territory that this book is not intended to cover. If you are interested, then there are hundreds of articles, papers and books available on graphics programming, a quick search on the Internet will get you started.*

Sky plane

A simple alternative to a cylinder is to have a plane that completely covers the sky, parallel to the ground. This plane could have a cloud texture on it which could even be animated showing the traveling of clouds across the sky. Logically the plane is rectangular and any texture you place on it will also

be rectangular, so it will fit well. There are a few issues involved with this kind of sky. The height above the ground is important. If it is too low and you could literally walk into it whereas if it is too high then you could see the edges of it, forming an unconvincing square in the sky. The higher the sky plane is then the larger it needs to be to cover your world. It will almost certainly need to be bigger than your world.

The main issue is seeing the edge of the plane and if you are near the edge of your world you do not want that to happen. If your sky is large enough then you can use the technique described earlier, camera fog, or distance fog to hide the edge of your sky. You can set where the camera fog starts (i.e. no fog) and where it ends (solid color). The distance is always measured away from the camera and any object in that range will be colored by an amount dependent upon its position from the camera. Using distance fog in this way, usefully hides the edge of the sky plane and works on a sub-conscious level to make us believe that your artificial world is as big as the real world, because of the atmospheric dulling (Figure 7.24).

Figure 7.24 Using a flat plane to create a sky

Although this effect works it is not ideal because the sky appears flat, whereas a real sky has a curvature to it. An improvement on this version would be to bend the plane so that it arcs across the sky in a concave manner. This is a bit like a dome, which could be used as an alternative. The important thing would be for the texture to be mapped in a planar manner. If you do not do this then you will end up with unwanted and unnatural distortions on it. These distortions are even more exaggerated if you decide to use a Sphere as your sky world.

Making clouds

You can use various techniques to create convincing cloud formations for a sky plane. One option would be to use a program like Bryce, which has a cloud generator in it where you can specify the type of clouds you want, e.g. cirrus or cumulus. But Bryce does not refer to a library of sky photographs, it calculates the clouds using fractal mathematics, in the same manner as we did with the Terrain Map Generating program. PhotoShop has a render clouds function, and using this in conjunction with layers, and other filters can produce very believable cloud formations.

It is worth experimenting when making clouds. You could scan paintings, or take close-up photos of grounds. Then by blurring, adjusting the contrast, or selecting different areas, you can build up a cloud image. Of course, you could photograph real clouds. Another useful thing to do is make the image tileable, like the cloud image shown in Figure 7.25. This way you can repeat the clouds when you map them (by changing the scale of the texture) and you could even animate the texture in Director, to give the appearance of the clouds moving. This does not mean creating hundreds of cloud images, but translating the coordinates of the image map.

Skybox

One last option for skies is to make a skybox. This technique can only really be achieved using a 3D package such as Bryce. The idea is that you can create a complete representation of a world from one point of view and project that onto a cube. The cube has six faces and each one has a view from the camera projected onto it. The idea is to use a 90 degree lens and take snapshots at 90 degree intervals in a panoramic fashion. Then you take a vertical snapshot of the sky in line with one of the other sides. You could create a ground image, but you will almost certainly be creating a ground using a mesh. Mapping these five or six pictures onto the sides of

Figure 7.25 The texture map used for the sky in Figure 7.24

the cube may make you think that there will be distortions where they meet. But this technique actually works because of that distortion. The sides match up perfectly to give an illusion of a spherical world. However, when you are in the 3D environment that you have created you have to bear in mind that the skybox works only for one point of view. This means that you need the box to move with the camera, so that you never approach the edge of it, but remain at its center.

Creating a new world

Now we have covered most of the ways to create a world, we might as well combine the various elements to see a complete environment. The final figure in this chapter (Figure 7.26) adds together the Terrain Generator, Tree Generator, and Sky and Water Generator to make a landscape, with atmospheric perspective. The sun moves around this world and casts a changing light, whilst the clouds roll by.

Figure 7.26 A new world, ready to be explored

Interview with Ezone

http://www.ezone.com/

Company profile

Ezone is a games company that specializes in Web games. It consists of two Australian brothers, Simon and Jamie Edis, pictured here with an imaginary third brother in their Lenny Loosejocks creation.

The Edis brothers started Ezone in 1996, while living in San Francisco, USA, but they moved back to Australia in 2000, taking Lenny with them. Their reputation is built on solid game-writing skills and they are relative newcomers to 3D. But as you can see from such games as 'SpaceWombat', working in 3D has not damaged their quirky sense of humor and brilliant use of sound. When I first happened upon Lenny, I was, like many others, drawn by the weird name, but I stayed and played a lot of games because they are such fun. I am convinced that this is Ezone's secret ingredient; they obviously love their work, and their sense of fun comes through in the spontaneous nature of all their games.

Jamie Edis, Lenny Loosejocks and Simon Edis

Interview

When did you start creating games for the Web?

Ezone.com started off as a Web development/hosting company but we realized that it wouldn't be long before that market was saturated. We started making Web games pretty much right when Macromedia Shockwave came out around 1996. Jamie had worked with a program called Macromind Director 1.0 during Film school in Perth, and thought it was a great tool so we got a copy and started experimenting. After a few really basic games we started putting more complex game play and detail into them.

Can you describe the genesis of Ezone? Your complimentary skills as brothers must help!

Each game that we developed we learned something new and the games just kept getting better and better, so much better in fact that clients became interested in our games.

Simon's engineering background made him the perfect programmer. He knows and understands numbers, physics and just general 'technical' stuff you need to program good games. Jamie's skill in drawing, animation, character voices, sound design and music made him perfect for the 'creative' stuff. Combined with a similar bizarre sense of humor, it makes for a very complimentary game-making partnership.

Typically how many people would work on a game project?

On most games just the two of us.

As a small company it takes a long time to develop a game. Do you think there are advantages of being a small outfit?

Actually it's probably faster being a small company, as a lot of people usually equals a lot of meetings and the 'too many cooks' syndrome.

We can remember when we were doing some client work for one of the big studios down in L.A., and Jamie would get frustrated when they wanted us for a meeting. In the time it takes for us to fly down there, drive to the studio and meet with them I could have had all the animation and sounds for the game done.

How long do you spend developing your games and how much of that time is pre-production?

We usually just jump straight into a game and see what works. Although we probably should spend more time planning, Jumping straight in allows for faster development of games. Sometimes you can over plan a project; the

lack of planning can often translate into spontaneous ideas and more freedom. Of course some projects do require and benefit from a good amount of planning. Our games can take anywhere from a week to many months to develop.

How many games will you work on at once?

We usually have at least two going at a time, sometimes more that are in early development phases.

Game design and production

How do you come up with the ideas for your games?

Sometimes they just pop into our heads, other times we look at what type of games we'd like to do and that are missing from our site and develop an idea to fill that gap.

Can you tell us something about Lenny Loosejocks and how it felt adapting him to 3D?

On the one hand it was great to see a 3D model of Lenny walking around, but on the other he's little 'clumsy' to translate into 3D. He's very tall and

skinny and his usual rubbery 2D cartoony moves are difficult to translate into a low-poly 3D character. We may overcome this problem in the future. Meanwhile, stumpy characters such as the Space Wombat seem to suit the current 3D arena that we are working in quite well.

Lenny Loosejocks and Donga ©1999 ezone corporation

The animation quality and sound in your games is always very good, how important do you think it is?

It's pretty much everything.

The Internet has for many years been used as a vehicle for multi-player games, and for several years as 3D multi-player games. How do you see this area affecting the game market in the future?

Multi-player is great in that it adds a new dimension to games, and also raises the replayability factor because of the random human element.

From a playing perspective, what are the most important aspects of a 3D game?

Control. You have to have good control. The player has to feel like the on-screen object is responding instantly to the inputs.

For example, in one of the earliest 3D games we did, you were a turkey and you had to run around pecking control boxes well, we can't even play it now because the controls seem so bad.

What aspects of 3D programming are the most constraining, e.g. texture size, model count, face count and effects? What enhancements would you like to see in 3D graphics technology?

As computers and video cards get faster and faster the technical limitations become less of a factor.

Good-looking 3D has an immediate appeal. Do you see it as the way for-ward in Web design, or just another tool?

We see it more as a tool. There are many applications where 3D is great, but it is not the answer to everything. For example, on our site we thought about having a 3D interface for visitors to decide which game they want to play, but at the end of the day a more traditional approach of just a simple text list is the way to go.

What aspect of development would you say is the most time-consuming?

The finishing touches on a game. Whether it is a client game, or an in-house game, it always seems to take forever to polish it up and package it.

Your future work

Where do you see Ezone going?

No plans to build the company any bigger, just increase revenue! Short-term goal is to find a major site sponsor so we can spend all our time devel-oping great 3D games for the site.

How often do you plan to release a game?

Now that our game engine is pretty solid we would like to release at least one game a month (including client games).

Technique and production

Did you find it hard adapting your 2D animation skills to 3D?

It was a little difficult, as 3D takes a different way of thinking.

But like any new application, spending time with the program (3ds max), pulling apart sample models and just experimenting helped to adapt.

The biggest challenge with the 3D models is keeping the poly count low. A typical character model is around 1000–1500 polys and a terrain we try and keep at around 5000–10,000.

On average how many animations/walk cycles do you make for a character?

Usually at least 7: idle, walk, run, jump, drive, win/happy, lose/sad, however other actions can include: swim, slide, swing, shuffle, push, falldown, surf, etc.

From a technical perspective, what's more important, high quality graphics, or fast frame rate?

Depends a lot on the gameplay. For example, a racing game that looks sharp, but has a slow frame rate and no sense of speed, is not going to appeal a gameplayer. We try to get a good balance.

What software do you use for creating your games?

3ds max for creating the models, Photoshop for the textures, Director for animated sprites, Soundedit for the soundfx and music mixing and 3D Groove GX to put it all together.

Were there any specific problems you had to overcome during the production process?

Probably the biggest challenge is working with cutting edge and beta software. Because 3D on the Web is still at the early adopter stage there are always going to be teething problems. However, when you are involved in a beta program you can be sure when the final version is released, all your games are going to work on it!

Insights

Do you have any advice for students of 3D game design?

Keep games simple. If you can't explain the game concept in one sentence, then it is too complicated. Make it intuitive so players can start off without any instructions, and then introduce challenges once you have hooked the player. But be careful, probably the hardest thing to judge is the pace of challenge and reward. If a Web game is too challenging players will just give up it's not like a console game where they have invested $50 and they want value.

The bigger the audience your game appeals to the better.

The amount of decent 3D Web games on the Web is still few and far between (excluding large download offline games and demos). Assuming this is just for technical reasons do you envisage there being a more integrated 3D Web presence than there currently is?

3D is only going to get bigger. It is almost like the web space is two or three generations behind what is happening in the console world, but we are catching up quickly.

Chapter 8

Making a 3D game

A generic approach

The last several chapters have dealt with topics that can be used in 3D game production. We have covered character building and interaction, implemented keyboard controls and built an environment, using a variety of methods. This chapter builds further on this by introducing a variety of advanced techniques and tips that will aid the development of high-quality 3D games for Web usage. Creating a game is a very specific and individual task. Your game idea will be unique, as will the combination of methods you need to make it. This chapter takes a generic approach, by providing many options and techniques covering the various issues involved in game design and development. Practical examples, referred to by this chapter, are provided on this book's accompanying CD. You can take apart these examples and use them for your own games. On the book's website, www.3dfortheweb.info, you will see some of these examples as Shockwave files, integrated into the website. The website will also feature a full game, which this chapter refers to. It includes the characters from this book and many of the techniques discussed.

Marketing and financing

You will have read the interviews in this book, many of which are from companies who view games as an important aspect to their website portfolio.

Games are a very useful marketing tool but can also be very complicated to create. Web games generally tend to be fairly simple games, akin to arcade games. Theoretically, there is no reason why they cannot be as good as any professionally created game. The main obstacle is development time and expense. Time is money and the cost of development has to be balanced against the reward for making it. Many Web games are not sold, but given away, with the intention of retaining visitors to the site. It is the advertising money that finances these projects.

There are other ideas for the financing of the games, e.g. subscription. You could create the first level of a game and get your customers to purchase further levels. Alternatively you might make the game available only by paying a subscription and they would have to log on to play it. The main difference between this concept and that of purchasing the whole game is that the game could be fed to the player in parts. Each part of the world is only downloaded when they approach it, or when they have the password.

There are many factors involved in making a game, not least of which is individuality. It is not our intention to see thousands of clones of one game appearing on websites, so it is not the aim of this chapter to take you through the creation of one game. The purpose is to cover many of the technical principles concerning 3D game development, incorporating the game elements supplied with the CD. This game will also appear on the book's website in its finished form (www.3dfortheweb.info).

Planning

Planning is a most important aspect of game design. Indeed, this holds true for any project where money is being spent on production. Assuming someone is paying for your time, you will have to plan for the games development. You need to know whether you are capable of creating the whole game yourself, or whether you need a team of people to do it. You might need a separate graphic designer, programmer, 3D modeler and animator. In the game industry, it is often the case that the programmer does not do the modeling and set design, but works in a team of such people. The budgets for Web games are almost certainly going to be smaller, so you might not be able to afford to have a large team. This means that you need to be multi-skilled in order to complete the project.

If you have the skills to create a game completely by yourself, you will still need to plan your time. As a rough guide there are three stages to consider, the design, the development and the testing. The game design stage is important as it is here that you will work out all the elements needed for your game, the characters, genre, storyline, scenario, interaction, aims, etc. This

will enable you to confidently develop the game without unexpected hitches. Once developed you will need time for testing; in a short project this might easily be a quarter of the time required for the games development. Never underestimate the importance of testing, as it is the chance to iron out all the bugs that your game will have. If you have a complex game then there will be many areas, such as object interactions, where errors can occur. No amount of planning can stop errors occurring in the first place, so you just need to allow time to fix them.

Only experience will help you plan properly, a game could take a few days to make, or many months. You will always improve your development time with the more games you make, speed and quality being the benefits of experience. Often with commercial projects there might be a time limit for delivery. This will influence you as to how complicated your game can be and how detailed the arena or world is. As long as you are aware of all the elements in your game and the experience of your team, then you will be in a good position to estimate the time needed, and hence the cost.

Game design

Thorough game design will help you develop the game without encountering unexpected issues. You should be able to give your game design document to another team and for them to create the game without needing to ask any more questions. The likelihood is that the team will be involved from the outset and this is good that you want to get other people's opinions involved. It is the blueprint and it contains every little detail needed for production. Team members with different skills will pick up in different points.

There are various theories on what should go into a game design document. We will include some of them during the course of explaining all the technical elements needed to create your 3D game.

Genre

There are many genres relating to 3D games like shooter, simulation, adventure, sport, role-playing, flying, racing, strategy, puzzle, etc. They often cross with each other, e.g. a role-playing shooter. Most of these genres will have similarities like having to control a character. That character might not be human, it might be a car, a duck or a plastic toy, and may not be controlled by the player, but by the computer. Computer controlled characters (CCCs) are also known as mobiles. They may have a degree of artificial intelligence, all of which has to be programmed, with behaviors such as how they deal with object collisions, whether they react to you, the game player, etc.

Pacing in a game is often genre specific. A racing game needs to be non-stop action, but a shooter will create tension by having periods of low action, interspersed with shooting mayhem as all the aliens or bad guys try to attack you. All this needs to be planned. Building up tension during a game might be as simple as increasing the number of enemies that come to attack, or shortening the time limit to complete a task or adding degrees of complication as you progress through the game.

Physical point of view

To see your game you need to have a virtual camera. By default, just having the 3D view creates a camera. For a game you need to control that view, otherwise your character might run off the screen! There are a few ways to describe physical points of view, namely first person and third person.

First person view is where you become the character, as if you see through his or her eyes. Turning and running around moves the camera as if it is head mounted. There is not much complication involved in using a first person view. There is no need to model a character in this situation, but you might show the arms, or the weapon, if it is a run around and shoot game.

Third person view is also known as over-the-shoulder. Here you are an observer of your character, as well as probably being the controller. You see the character in all its detail with all of its movements and animations. It is perhaps easier to identify with your character if you can see them and you can add many different movements to make them interesting (Figure 8.1).

Using a third person view creates the significant issue of where to position the camera. The following section describes different ways to position the camera for this kind of view.

Fixed camera view

When deciding your camera style you should make reference to the use of cameras in film making. Terms such as panning, zooming, wide-angle, close-up and tracking are just as relevant in games as they are in films. You might use a combination of camera movements and techniques to give your game a cinematic quality. It is possible to set up your camera to change position depending on where your character is. You can then make your camera follow an object as it moves across the scene. In film terms this would be panning (turning the camera from side to side) and tilting (point

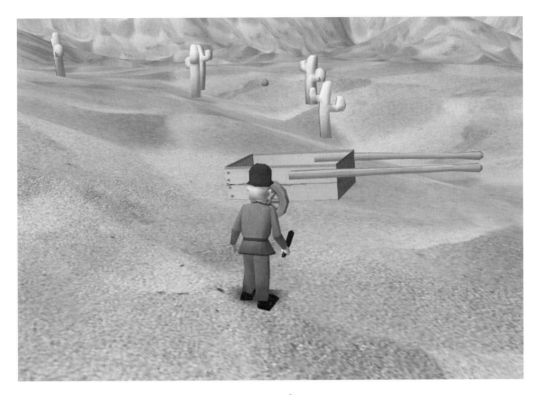

Figure 8.1 A third person point of view

the up and down). Following an object is easy in computer 3D. There are graphics commands to allow you to do this. In Director, the Lingo command is PointAt. You use this command by specifying which object you want the camera to follow.

Top Tip
Directly following an object with a camera is not very natural. No real cameraman can keep up exactly with a person or object's movement. There is always a slight delay, which we accept as being natural. Likewise, no self-respecting cameraman changes the direction of their camera with sharp movements, but they would use smooth motions. You can achieve this effect by using a dummy object. A dummy object is an invisible object. It is possible to make the dummy constantly travel towards your target object.

Using the Lingo command InterpolateTo, you can make an object move towards another object. It is calculated in percentages, i.e. every frame of movement the dummy object would move towards its target object by 10% or whatever percentage set. You then set the camera to follow the dummy object (Figure 8.2).

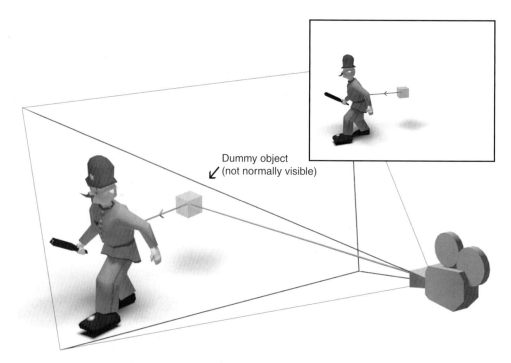

Dummy object
(not normally visible)

Figure 8.2 A camera tracking a dummy, which is following a game character. Inset with the camera view

Multiple cameras

When you use a fixed camera there is an obvious limitation that your character might move too far away for it to be seen. So you need to set up many cameras in positions that allow you to view the action in the best way. This does not mean that you have to actually create many cameras; all you need to do is make a list of the positions of all the cameras. Then as the character gets near to that position the camera jumps to that position and then continues to follow it.

You could achieve this camera swapping by measuring the comparative distances of camera to object and then always making sure that the camera moves to the nearest position. Calculations like these are quick to do, there is even a Lingo command, DistanceTo which does the measuring for you. Otherwise you would have to use trigonometric math to work out the distance from the world position coordinates of the cameras and object.

This method sounds fine in principle, and is if there are no objects in your scene that are blocking your view. Just because a camera happens to be nearest to your main character, does not necessarily mean that it has the best view. There is, however, another method you could use.

You could create a map of your environment that is color coded to show which camera you want to use when the character is over certain areas. It is then possible to test the color of the map depending on the position of the character. For example, if the character is over the blue area then this could relate to the first camera, and red might mean camera two. You can use a simple rule like this to create a complicated camera setup that appears to intelligently select which camera to use. The color-coded map should take into account the camera angle and the amount that the camera can pan (Figure 8.3). In the figure below black is used to indicate the objects in the

Figure 8.3 A camera position map, showing three cameras and their color codes, a character (marked by an x) and obstacles in black

scene. There need not be a rule to say what happens when the character walks over these areas. It should be impossible, as the character should bump into them. This is discussed in the collision section of the book.

Top Tip

In films there is a camerawork rule known as 'crossing the line'. You will notice in Figure 8.3 that the cameras are all positioned on one side of the stage. This is done purposely, so the viewer is not disoriented by camera's swapping sides and, in essence, changing around your left and right. It is a good idea to try and abide by film making concepts, unless you feel you need to break the rules, or that you have no choice due to the game circumstances.

Single camera

The most commonly used camera setup is just to have one camera that tracks your character. Computers allow us to have a much more complicated

system for a single camera than can be achieved in real life, so it is slightly ironic that this book is recommending following film camerawork methods. In a computer set a camera is not restricted by physics and can fly around, even passing through objects! Of course this is impossible in a real film set, but Directors have always tried to get as much flexibility out of a camera as possible, using cameras mounted on cranes, dollies and steadicams. In a computer game we do not need to set these up, but can make our camera follow our character, tracking through the environment.

There are a few particularly useful methods to achieve camera tracking in your 3D environment. When you use them in combination with each other a fairly sophisticated result can be achieved. The simplest method is to have the camera fixed to a position behind your target object and for it to be oriented towards that target. As the target object rotates, then the camera swings around with it. Likewise as the target object moves around the environment the camera follows it. However, this result is very dizzying. It does not take long to spin your character completely around which makes the camera swing around too. This method also means that you are always positioned exactly behind your character and hence cannot see what they are doing.

Note	*This amount of camera movement is basically uncomfortable. Comfort is important when playing a game and if it is any good, people will be playing it for hours, so there is no need to give them a headache! This comfort factor is not just about eyestrain though, it is about helping the player accept the reality of the game situation. The more they accept it, due to good camera work, then the more they will play.*

The way to overcome this swinging is to use more dummies. If you have a dummy immediately behind your character then you can make the camera travel toward (interpolate to) that dummy object. This way, the camera is not spinning around all the time, but smoothly tracking over your scene. This method can also be improved, as was the multiple cameras method, by orienting towards a dummy that is traveling towards the object you are controlling (Figure 8.4).

Note	*The dummy object in Lingo does not need to be a physical object. It can just be a transform. A transform is a list of the coordinates for position and orientation. This means that using dummy transforms does not negatively affect the performance of your game.*

It is possible to increase the subtlety of camera movement. You may not want the camera to always be moving towards the character. For example, if he or she is running towards you, it would be better to track the camera

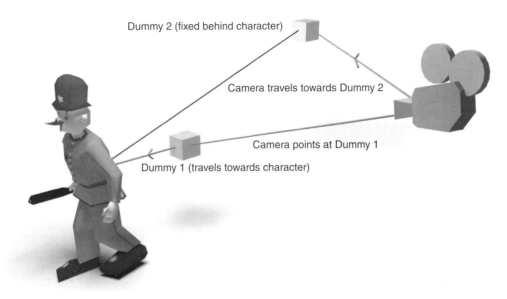

Figure 8.4 Tracking camera using dummies as targets

backwards. You use a dummy that is positioned between you and the target object but it is always a set distance away from the target. You then tell your camera to travel towards this object as well as the dummy that is behind the character (Figure 8.5).

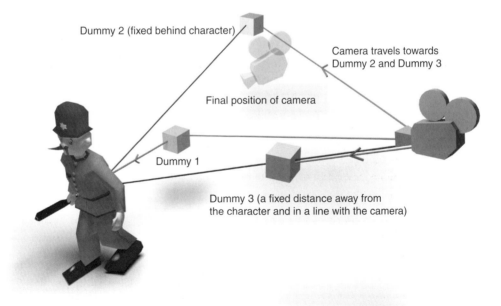

Figure 8.5 A tracking camera system that prevents the camera from getting too near the target

To get your dummy to be in line with you and the target you should start by giving it the same coordinates as the target (duplicating its transform). Then orientate it towards the camera (using the PointAt command in Lingo) and finally move it forward by the desired amount of units (using the Translate command).

Top Tip

You do not have to keep your camera moving all the time, particularly if you are only turning the character around. You could include a time delay, so the camera only tracks to a new position when the character has been stationary for a few seconds. Another idea is to only make the camera track towards the dummy object when the target is a certain distance away, or only when it is moving forward. Combining the above camera systems with the multiple camera concepts can lead to a great degree of sophistication. This adaptable and controlled system, if done well, can make the player feel that the game has a good standard cinematography. You could even create your game to be in wide-screen format for a cinematic feel.

Avoiding objects (collision detection)

Now we have made our cameras fly around our game world, we need to take into consideration the other objects in the scene, which are likely to get in our way. The two issues here are objects that obscure our view and objects that the camera might bash into. Using the multiple camera idea can get around the objects obscuring our view, but it is not an answer to moving cameras. We need to devise a system that can take into account the positions of objects and allow the camera to navigate around them; this is really collision avoidance.

Collision detection is a fundamental part of 3D game creation. Without it, your game will not feel solid, its plausibility will diminish and players will get bored far too quickly. Clearly you do not want your players to be able to make your character walk through walls, unless they have a magic power or they are a ghost! Collisions can take place between moving objects or between a moving and stationary object. It is possible for non-moving objects to 'collide' if one object is positioned in the same place as another. This might happen if you are creating a world with randomly positioned objects.

There is not really a difference between collision detection and avoidance. To make an object avoid a collision you need to know if it is going to collide with another object. This involves making a collision test which can be done either before the object has moved or afterwards. It is important to remember that your objects do not move smoothly, they move in steps. These steps are changes in position that occur every frame, every time the screen is updated. The steps appear to be a smooth motion when the frame rate is high enough at approximately 25 frames per second or more.

There are many ways to detect when collisions have taken place but first we will deal with the moving camera and collision avoidance. This will introduce principles that we can reuse for other collision situations.

Coordinate collisions

The simplest of scenarios is that you have a rectangular arena, perhaps a football pitch and you want your characters to avoid running off the pitch. As you can easily track their coordinates in world space you can provide constraints to their positions. An example would be to have a pitch that was 1000 units wide, 2000 units long and positioned in the center of your world. This means that one pitch 'wall' is located at the coordinate minus 500 in the X-axis and the opposite wall positioned at positive 500. So you can make a rule that states: If your object has moved to an X coordinate less than − 500 then changes its X position to − 500. This works for the opposite wall by making the X position change to 500 if it is already greater than 500 units. Likewise for the other two walls your rule would use the Z pos-itions − 1000 and 1000 as the walls are further away.

Casting a ray

A very common situation is where you want to have an object follow a terrain. In the case of our camera, we would want it to always be above the ground, and not to crash into it. This is not a problem if our ground is flat, but if it is a terrain, as in the previous chapter, then our camera could easily move into the side of a hill. We can stop this happening by firing an imaginary line from the camera's position vertically downwards (Figure 8.6).

In Director there is a Lingo command for this called 'ModelsUnderRay'. This command makes a list of the objects that are in the path of the ray. If no objects are in the path of the ray then the list is empty. But as we are assuming the ground will be beneath the camera, there should always be at least one object in the list. The ModelsUnderRay command does not just tell you that an object is in its path, it provides you with details such as the point on the model (in world coordinates) that the line intersected and the distance

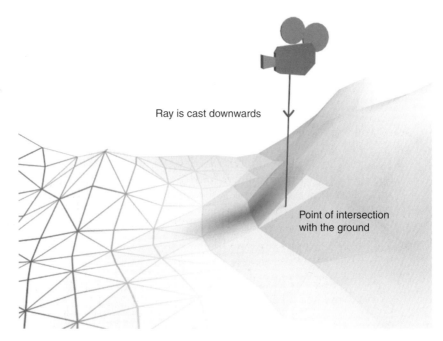

Ray is cast downwards

Point of intersection
with the ground

Figure 8.6 Casting a ray vertically down to keep a camera above ground

between that point and the ray's origin. It can also tell you the face number and the normal (the direction of the face is pointing). This can be used to provide a rebound direction if you want to bounce of the object.

In the case of our camera and the ground, we are only interested in the distance from the origin of the ray. If we decide that we want our camera to be 300 units above the ground then we can cast a ray downwards, to get the vertical position of the terrain at the point of contact, and then add 300 units in the vertical direction (Y-axis) to that position.

> **Top Tip**
>
> If you create objects in Director using Lingo, then it treats the Y-axis as being up. This is not the case for 3ds max which treats the Z direction as up. You need to be aware of this, otherwise your ray will not be pointing in the right direction. If you have a terrain that has been created in 3ds max then fire your ray with a direction vector of (0, 0, −1), this means negatively in the Z direction, as opposed to (0, −1, 0).

Other uses for ray casting

Ray casting is not just restricted to cameras and fixed distances. For a start you can use it to keep your character at a set distance above the ground.

The Director example files supplied on this book's accompanying CD use this method, at a slightly more complicated level. Instead of just keeping the Keystone Cop at a fixed distance above the ground, the character is kept at a height no less than that distance. The subtle difference is important as it allows the Keystone character to jump up in air and land, with his feet apparently on the ground, as if they have collided.

The idea of having a minimum height above ground is also useful for any flying simulation, where you can have the freedom to fly an airplane or spaceship in all directions, unless it is too near the ground. In a futuristic racing game, you could combine this idea with the traveling towards the point of contact plus a fixed distance. If your object is too low then, instead of jumping straight to the required height, you use the InterpolateTo command to make it move towards it, perhaps by 30% at a time. This would have the appearance of a soft bounce, or an anti-magnetic response. The further that you had gone past the distance limit then the more you would be propelled back towards it, the greater the repulsion force.

Understanding vectors

You can cast a ray in any direction you like. This is not done using angles, but using a normalized vector. A vector coordinate might look something like vector (60, 20, −80). This corresponds to the x, y and z positions in world space, where vector (0, 0, 0) is the center of the world, also known as the origin. If you drew a line from the origin to the vector coordinate then it would have a length, this is also known as the magnitude. The magnitude of vector (60, 20, −80) is 102 units.

Normalizing a vector means making its magnitude equal to 1. The resulting vector then describes its direction only. So the above vector normalized gives the result vector (0.59, 0.20, −0.78). Having a normalized vector allows you to do math on it, like finding the angles between two vectors, which is one reason it is useful.

So a position can be described in coordinates (x, y, z) or as a normalized vector (x, y, z) and a magnitude (any number). In the above case, the pos-ition vector (60, 20, −80) is equivalent to vector (0.59, 0.20, −0.78) with a magnitude of 102.

Horizontal rays for collisions

In simple terms, in a 3D scene, if your camera view is aligned with the world axes, then the vector (−1, 0, 0) is a direction pointing left and (1, 0, 0) is pointing right. Likewise (0, 0, 1) would be pointing away from

the camera and (0, 0, −1) would be pointing towards the camera. These are all vectors in horizontal directions and we can use them to detect whether our camera (or other object) is going to collide with other objects in our scene. In addition to firing a ray downwards, if you fire a ray in the four horizontal directions then they will possibly intersect with other objects. You should set the ray lengths to be a particular number of units, perhaps as long as our Keystone Cop's arm, then you will know whether it has hit an object or not. If it has then you can tell the character (or camera) to move in the opposite direction by the amount that it has overlapped (Figure 8.7).

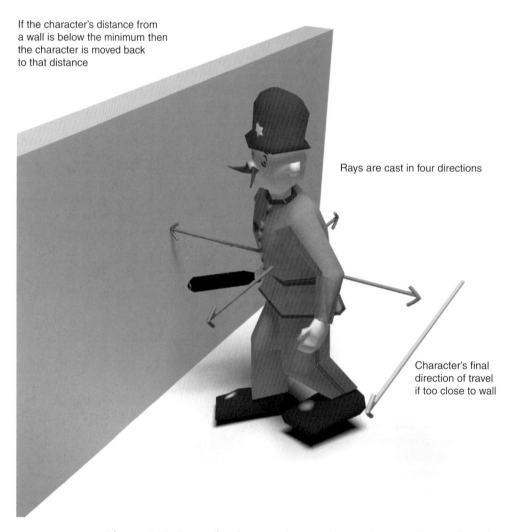

If the character's distance from a wall is below the minimum then the character is moved back to that distance

Rays are cast in four directions

Character's final direction of travel if too close to wall

Figure 8.7 Casting four horizontal rays to keep a character from walking through walls

Note *Setting the length of a ray with the ModelsUnderRay is not possible in versions of Macromedia Director previous to MX 2004. If you have an earlier version then you will have to use the distance measurement in the resulting list.*

You could actually just use one ray pointing in the direction that your character (or camera) is facing. When it hits a wall or object, you could use the direction of the intersected face to adjust your rotation. Firing another ray in the opposite direction to the wall's face would allow you to measure the nearest distance from the wall. If you are too close then you could make sure you are a fixed distance away from the wall, perhaps 20 units.

Simple detection

Ray casting, as described above, is a very useful method to detect whether your objects are going to collide. It works particularly well for games which feature straight sides, like games that are set inside buildings, as there are only likely to a few directions that the walls might be facing. This method can cause problems when you are trying to stop more complicated objects from colliding, e.g. spherical or irregularly shaped objects.

There is a method that works for collisions with cylindrical objects, like trees. Instead of casting a ray, you just need to measure the distance from your character to the cylindrical object. If that distance is less than your desired amount, you move your character away from the object by the difference in distance. This works particularly well when two spherical or cylindrical objects collide, e.g. pool balls.

To make this concept work you need to check the distances from your character (or camera) and all cylindrical objects. This is done best by making a list of these objects and cycling through that list, to see if any objects are too close.

The result of this collision detection method is that your moving object will smoothly move around the colliding object, whilst maintaining its previous trajectory (Figure 8.8).

Mesh collisions

Perhaps the most accurate collision detection system is that of a mesh collision. This is where the mesh of one object is compared to the mesh of another object and, if any parts of the mesh intersect, action is taken. In

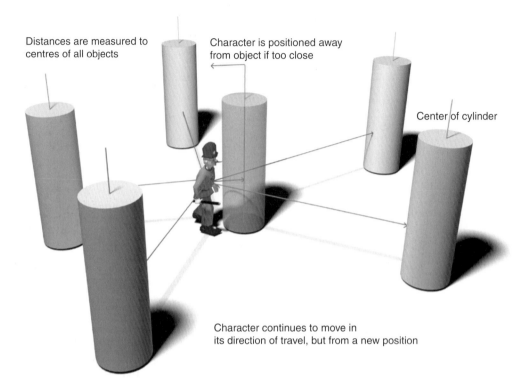

Distances are measured to
centres of all objects

Character is positioned away
from object if too close

Center of cylinder

Character continues to move in
its direction of travel, but from a new position

Figure 8.8 Measuring the distances to objects, for cylindrical shaped collision detection

Director the Collision modifier takes care of this, by being assigned to your objects that you want to be treated this way. A straightforward use of this modifier is to 'resolve' the collision. This means that if both objects are moving and they are set to be resolved, they are moved back to their last position before the collision took place. If only one of your objects is movable then you would only need to set this one to be resolved.

There are several properties that you can set with the Collision modifier. You do not have to resolve collisions via the shape of the mesh. It is possible to set it to detect collisions by a bounding sphere or bounding box. These are quicker methods than detecting proper mesh collisions, as there are fewer calculations to perform. If you are using the mesh mode for your collisions then detecting between two detailed meshes can significantly slow down your games frame rate performance. Using the bounding sphere is a bit like the simple detection method discussed in the previous section.

Usually, once a collision has taken place you will tell the object to perform an action. This could be based on the normal of the face of the object that it hit, e.g. moving the object in the direction of the normal.

Note *It is not really advisable to use the mesh method for collisions on animated complicated objects, such as moving characters. The performance of your game will slow down and you will have the added complication of not necessarily wanting to move your whole character if just his hand has hit an object. It would be better to use a bounding box in this case.*

Collision meshes

It is quite possible that you have a very complicated object in your scene that you want other objects to interact with it. As complicated meshes, with lots of vertices and faces slow down collision detection, one idea is to create a collision mesh. This is essentially a very low polygon version of your model that will be invisible (have a blend value of 0). This can be grouped with your complicated object or linked as a child of it.

Top Tip

Once you attach an object as the child of another (the parent), then it operates in local coordinates relative to that object and not in world coordinates. Moving child objects can be confusing if you have not realized this but you can force the object to move in world coordinates. In fact, the World is a parent of all objects so when you reposition an object you are in fact moving it in its parent's coordinates, i.e. the world coordinates.

If you have a lot of objects requiring collision meshes then it is advisable to try and reduce the number of objects needed. If these objects are stationary and positioned on the ground then you could create a mesh that covers all of them, as if they are shrink-wrapped. Remember that it is the number of objects in your world that has the biggest effect on the frame rate, so doubling the number by creating individual collision meshes may not be beneficial. Your computer actually runs through the whole list of objects every frame in order to detect collisions.

Collision maps

One method of collision does not involve 3D at all. You could create a 2D map of your scene, in a similar manner to the camera position map. This works particularly well for games with simple layouts, like rooms, corridors and buildings. In fact any object that is made from straight lines, e.g. parked cars in a street. The concept works by sampling the color of the

image map, in a position that relates to the horizontal position of the moving object.

There are two ways in which the map can be produced. The first would be to have a simple black and white map, with black representing objects and white representing space (Figure 8.9). The object can only move in white space, so if it hits black then the object is returned to its previous position.

Figure 8.9 A simple black and white map for collision detection

In Director, you use the Lingo command GetPixel to test the color of a bitmap image at a particular coordinate. If your world is large then your map would have to be detailed. The main advantage is that the testing for collision is simple no matter how many objects are in your scene.

One downside to using this technique is the possibility of getting stuck in your objects. If you bash into a wall at an angle then you do not want to stop still, you want to run along it. The previous method means you would stop still. The alternative to this is to have a more complicated color-coding system in your map. It has already been explained that this map idea works best for straight lines, in fact it works best of all for straight lines that align with the world axes, that is the X and Z directions. If you only have walls

that are at right angles to each other then we know that their Normals can only be facing one of four directions, analogous to north, south, east and west. You can color code your map so that a north-facing wall is blue, an east-facing wall, yellow, etc.

Having color-coded walls means that when your object collides with it, you need only move it back in one axis direction. For example, if east–west corresponds to the X-axis, hitting an east-facing wall would mean you return back to your X position, but your Z coordinate stays at its new one. If you walked into the wall at an angle then your object would start to move along it (Figure 8.10).

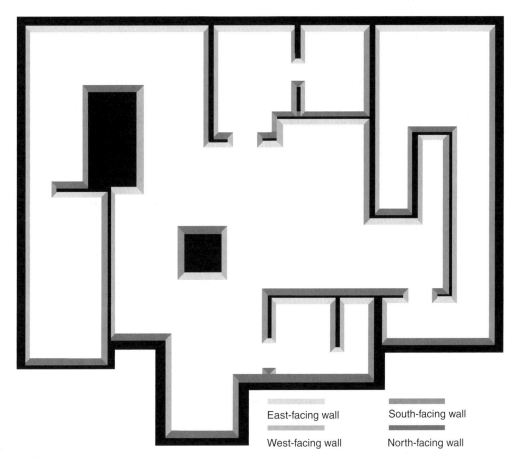

East-facing wall

West-facing wall

South-facing wall

North-facing wall

Figure 8.10 A grayscale-coded map for collision detection

Making a game world

After discussing the various ways in which you can detect collisions, you should have many different ideas as to how to navigate around physical

objects in your game. This means it is time to place these objects in our game. We need to design our world, devising what needs to be in it and where to put it. The previous chapter of this book covered many of the techniques needed to create an environment, but we did not cover accurate positioning of objects or some of the techniques required for buildings.

Naturally, what goes in your game world depends on what your game is about and where it is set. Perhaps you need some small village huts and stone walls for a fantasy adventure, or you might require many tall buildings combining to form a futuristic city. Either way we need to devise some efficient techniques in order to make our game suitable for the Web.

Do I need a world or an arena?

Answering this question is a crucial step in the approach we need to take for our game development. As you are probably aware, making games for the Web brings us certain limitations, mainly to do with file size. A full console or PC game will be delivered on CD, or now DVD, and will often be a huge game taking hundreds of hours to complete. As such it can measure hundreds of megabytes in amount of data. All this data includes the programming, the textures, sounds and music, 3D models, and video clips (cut-scenes).

A game of this size might take hours to download (even with a Broadband connection) and what you want is a game that loads in minutes or better still seconds. You cannot expect your site visitors to wait around for ages whilst a game loads, unless you already have a reputation that your games are worth the wait. This leaves us with a few options. Either we have a small game, set in an arena, or a larger game that loads gradually. A larger game might contain many small levels, as you complete one you wait for the next to load. Your players will hopefully be happy to wait, as they are lured deeper and deeper into your playing experience. Alternatively, you might have a large world that you will need to load up gradually as the game player explores it. This might involve pauses in the game play, or the game might actually load all the time, whilst it is being played.

If you decide to have a single level arena then you will need to decide what kind of arena it will be. If you have martial arts fighting game then it might only be a small area of land, or a boxing ring. You might need some surrounding buildings, and objects setting the scene, perhaps an alleyway with trashcans, and a burnt-out vehicle. In this situation you are not talking about hundreds of objects and there is unlikely to be any cloning needed. It makes sense to create this scene entirely in your 3D package, and then import it in to Director to create the interaction, setting up the collision detection.

Top Tip

Pitching your game to the right level of computer is a crucial issue. If you make it so that it can only run on the latest and greatest computer then you will be alienating a majority of your audience. You need to be efficient in your use of textures and number of objects, without compromising on quality. Be aware of the objects in your scene and decide a minimum specification of computer that you want the game to work well on and test it on that computer. Older graphics cards need a lot more consideration than the latest with tons of memory available and super-fast rendering capabilities. Minimum specification changes all the time, so if you are not sure what specifications to go for then look at the back of computer games packaging. That will give you the best guide to what the professionals currently think is acceptable.

Game object creation

In the chapter on building a character for a Shockwave; the Keystone Cop, you have covered probably the most complicated build for a game. A character is going to be scrutinized more than any other object in your scene. It is he (or she) that you will be looking at for the most time, so a careful balance between complexity of design and simplicity of building is needed.

Overall we need to make our objects as simple as possible, in order to maintain a decent frame rate, whilst making them believable. Maintaining a frame rate involves low-poly modeling, and making them believable means good quality textures. You will use textures to imply physical detail where there is only really a flat triangle. For example, in our Keystone Cop character, his eyes are not separate objects, but created with the texture that covers his whole head. If the textures are created well then your players will not even think about the illusion you have created.

A common object in a game would be a wall. Indeed, these form part of the set in classic shooting games like Doom, Quake, etc. It will be a useful exercise to create a simple walled building layout, a dungeon or castle perhaps.

Making a walled dungeon

The first stage of building a set for a game should be to draw some kind of diagram, a map or blueprint. This is best done on graph paper or in an illustration program with grids turned on. This can be done simply at first, by blocking out rooms and corridors, assuming that that is what you want in your game (Figure 8.11). You might find this easier to do in a program like Adobe Illustrator. You can import the vector shapes from Illustrator into 3ds max and

Figure 8.11 An Adobe Illustrator sketch for a dungeon blueprint

use them to create your building. Alternatively you can use your 3D packages Spline drawing options. This will enable us to use a simple structure for our building. Ideally, we create our building as one object, with relatively few polygons. This will be very useful from the frame rate efficiency aspect and we can always increase the complexity by adding details with other objects.

Top Tip

Although our map is rough, there are some points to note about it that are important. There is always a gap between each room; this is set to the size of the grid, as the rectangles are snapping to the grid. This gap is important, as the walls will only be visible on one side. This is a real time rendering issue as any plane can be rendered on both sides or just the front or back. Rendering on just the front means that half the amount of triangle needs to be rendered, hence it is twice as quick to complete the task.

Our map is at a sketch stage. You can manipulate the rooms until you have a desired layout. When you are satisfied it is time to make the actual walls. Remember that we want to create the whole building out of one object. You can do this by tracing two lines around the shapes of your rooms, this results in a shape that we can use as a template in 3ds max (Figure 8.12). It is recommended that you save your Illustrator file as a Version 8.0 file as this is more compatible with 3ds max. When you import it, make sure you select Single Object, and not Multiple. You should then scale it up until it fits a coordinate scale that you are happy with, perhaps equivalent to 40 meters across or 4000 units.

Figure 8.12 An Adobe Illustrator map made out of two vector shapes

Note *Getting your scale correct is essential at this stage, as everything in your world will relate to this. I recommended that you align your 'blueprint' to the grid in your 3D package. This should make it easier to place objects and make sure they align with the walls, without gaps. A staircase would be one such example.*

Now you have an outline of your building, all you need to do is import it into your 3D program and use the Extrude modifier to make the walls the height that you require. Of course this is a very simple structure, and you might want a more complicated design. Perhaps you want windows or different thicknesses of walls. It is at this stage that you should implement these design details.

Making windows

This is not a very difficult task to do, particularly when you should have already modeled a character earlier in the book. Essentially, all you need to do is mark off where you want the windows and then extrude them into your wall.

Select the Spline shape that you have imported and open up the Modifier Stack to select vertex editing. Then choose the Refine button. This will allow you plot extra vertices on your Spline shape. You need to place them on either side of where you want window to be or on both sides of the wall (Figure 8.13). Make sure that the outer wall vertices align with the inner wall vertices.

Once you have marked all the windows you need, you can add the Extrude modifier. When you do so, make sure you have at least three

Figure 8.13 Adding four vertices at the bottom of your Spline shape in preparation for creating a window

segments selected, but not many more as you do not need the extra poly-
gons. Now add an Edit Mesh modifier and select Polygon from its sub-
menu. Click on your window polygon and extrude it negatively, punching
a hole in the wall. Only extrude it as far back as the wall is thick
(Figure 8.14).

Figure 8.14 Extruding a window out of the mesh

To finish it off, you should delete the polygon that you have extruded and
the one on the outer wall. Then select Edit Mesh > Vertex and align the
loose vertices from the inner wall window with the four corners of the outer
wall window. When they are aligned you can choose Weld > Selected
from the Edit Geometry menu to join them together. This will fix any gaps in
the geometry of your wall.

Now we have made our simple dungeon, you can start to make it look more
interesting. Add a floor and a ceiling using planes that cover the entire area
of your building. You could start to add more details, such as more objects
in your rooms. Exactly what you need depends entirely on what kind of
building you have, perhaps a dungeon, a futuristic building, an office

block, etc. When building your objects keep them simple; it is in the textures that the details will show.

If you have more than one floor in your building then use a box for each floor as you will need the thickness. You will then have the issue of how to travel from floor to floor. Perhaps you will have a lift to travel up or perhaps a staircase on the outside of your building. Most likely, your stairs will be in one of the rooms, so you will have to punch a hole in the floor to let your characters go through. Make sure you allow for this by creating enough vertices in your floor mesh, so that you can extrude a hole.

Making a texture

Now you have made your building you need to give it a convincing material. It is always best to make up your own textures, (although it is possible to buy them or download them for free on the Internet). These might come from photographs, as discussed in the previous chapter. In the case of our dungeon, we require a stone wall. The chances of you finding a suitable dungeon style wall are slim, but you could use your 3D package to create the texture you require, e.g. stone bricks. One advantage to making up your own texture is that you can have accurate control over the lighting so that you get a decent depth to your texture; also you get to decide the size, shape and color of your bricks.

To make a wall you need some brick shapes, so you should start a new file, as you are only doing this exercise in order to create a texture. These can be as complicated as you like, but I recommend you to choose a chamfered box shape, as opposed to a normal box. This is important as you will get a highlight on the edges when the box is chamfered, this adds to the realism. In real life most edges are always rounded, just look around you to see what I mean. If you want your bricks to be irregular then add a Noise modifier or Mesh Edit to them. You may not want to do this though, as we are going to make up a repeating pattern for use on our walls and your irregular bricks might stand out as they become part of a pattern.

Assemble your wall to your desired brick or tile pattern. You might want to push some of the bricks slightly backward and forward, if you want an old style wall (Figure 8.15). Now attach them together as one object using the 'Connect' compound object. This will treat the object as one so that you can apply a texture to the whole set of bricks and not just to each individual brick. This way all of your bricks can appear slightly different, as if they have been weathered or had moss growing on them.

If you want your bricks to appear chiseled, use a Noise modifier as a Bump map and set the size of the Noise to a low value. If you want a more natural

Figure 8.15 An assembled brick wall, made from chamfered boxes

looking stone then use another Noise map for the Diffuse Channel, and choose some texture bitmaps for the Noise colors. In the Figure 8.15 two different photographs were used and blended together by using them as the Noise colors. Ideally you could find some stone and take a photograph; perhaps you could even go to your local carpet store and use some marble effect patterns. If you want your bricks to appear slightly damp then adjust the specular and glossiness curves to give them a slight shine.

When you are happy with your stone material, place a light that points down, to simulate the most common type of light that will appear on the building. Do not use an Omni or Point light, but use a directional light as this will give you an even spread of light. Make sure you turn the shadows on, as this will provide the depth you require.

Finally, render your picture in the front view and not the perspective. This will give you a flat image that you can use for tiling (Figure 8.16). You might want to add in another box to represent the mortar in between the bricks. The next stage would be to use a program like Adobe PhotoShop to cut out your rendered image and making it into an image that can be tiled.

Figure 8.16 An assembled brick wall, rendered for use as a texture

Applying the texture to your building

You can make the task of applying your brick texture simple by using a UVW map modifier, set to Box wrap and tiling it as many times as is necessary. This will place your new wall material over the entire building, and make it map correctly for box directions of walls. However, if your walls are not placed at right angles to each other, then this box wrapping method will give stretched results. In this case you should apply the Material to individual walls.

You can always use the Multi-Sub-Object Material to place different textures onto different walls. This way you can create a lot more variety, like making window surrounds, or details like door opening panels in a futuristic building.

Top Tip

Always remember when texturing to use the UVW map modifier, or the UVW unwrapper (as used earlier in the book when building the Keystone Cop). The UVW modifiers are responsible for the texture coordinates when you export your scene as a .w3D Shockwave file. If you have not applied the modifiers then your textures may not appear correctly wrapped. Do not use the tiling options within the Materials, but tile textures from the UVW map modifier.

Shadows

In a real time game environment shadows are very complex thing to calculate. This in turn will reduce your frame rate to unacceptably low levels. Real time shadows are possible in commercial games as they can take advantage of new technologies in graphics cards, but the Shockwave engine cannot do this, as yet.

Another issue with real time shadows is that they tend to be hard edged which is not always the desired effect. In real life, the shadow from a light bulb is not going to be hard edged, but will be softer the further the shadow is from the object. This effect can be achieved in a properly rendered scene using area shadows or shadow mapping, and it would be good to incorporate subtle lighting into our building. This will lend a greater sense of realism to our rooms.

Top Tip

It is still a good idea to have a shadow on your character in your game. This of course, is a moving shadow. A simple and effective technique is to have a Plane object that is set to follow the ground at the feet of your character. This plane can be oriented to match the direction of the face of the ground that it is on. If this plane has soft, round texture applied to it (with alpha transparency) then you get the appearance of a soft, round shadow. This is not perfect, but does help provide solidity to your character. Figure 8.1 shows a shadow under the Keystone character.

Texture baking

Texture baking is used to create materials that appear to have lighting effects like shadows on them. Essentially it involves rendering the scene in your 3D package, with all the lighting, shadows and material effects set. This rendering is only done on the objects that you want baked.

3ds max has a texture baking option under the Rendering > Render to Texture menu. This enables you to render complicated shapes and store the Texture Coordinates automatically. This can be a very useful feature as you can have effects like Raytraced reflections on objects that you would not be able to achieve in a real time situation.

In the case of our Dungeon, first of all make sure you have set up all the lighting that you want in your scene. This will be as many lights as you

would expect to have in all of your rooms. Then you just need to select your floor (or wall or ceiling) and choose the Render to Texture option. Next you add the maps that you want to render. For simplicity, choose to render the Complete Map. This will create a texture that you can use to replace the floor material that you previously had. This material will have all the shadows and lighting changes that you require. You can then repeat the concept for any other objects that you want to be shadow mapped. This works best on flat planes but applies to more modeled objects as well. You have to remember that you will lose some detail on your floor texture if it was made from a previously tiled material. Now your texture will cover the entire floor (Figure 8.17).

Figure 8.17 A texture baked floor with lighting and shadows

Rendering to a texture automatically generates UVW coordinates, so it is not necessary to apply a UVW map modifier.

Top Tip

When you render to texture, select Map Channel 1 before you actually render (in the Render to Texture palette). The problem with Render to Texture is that it creates a Shell material, which cannot be exported to Shockwave. To get your new baked texture to work, you should create a new material with the Diffuse map set to be the bitmap that the Render to Texture function has created. You will be able find this in the Material Editor list, when you set the Diffuse map. You have to select Map Channel 1 when rendering in order for this new material to work, when exported to Shockwave. The default value (map channel 3) does not work (bear in mind that this process was not designed just for Shockwave 3D). Also as your texture has lighting on it, you can set the Materials Self-Illumination value to 100. This will mean it will be properly visible and will not rely on lighting when you have exported it.

Exporting your world

When you export your building you might have some large textures created from texture baking. It is here that you will have to compromise between detail and overall file size. You can set the compression value of textures in the Export window. This uses JPEG compression and so it can significantly reduce the size but it is at the expense of quality, so a balance will have to be found through experimentation.

The finished building can be imported into Director and then used in conjunction with your collision routines to create a navigable experience (Figure 8.18).

Assembling a game

Games are not just about a virtual reality tour, they have to have a purpose, a reason for playing them. Obviously your game needs an aim, e.g. shoot as many monsters as you can, or collect all the parts of a golden talisman. Your game might have a scoring system, or it might be a race against time or a combination of both. There might be objects to collect that aid you on your way to completing the game, objects that restore your health or give you greater weapons. Either way we need to include other objects in the game, and we also want to keep in mind the fact that it is for Web publication, hence keeping an eye on download size.

Figure 8.18 The dungeon in Shockwave form with baked textures on the floor and ceiling

Using a map to generate objects

We have already used graphical maps to plan and create our worlds. We can also use them as a way to position objects in our world. This is useful in situations where you might have an object that is repeated a lot, e.g. the power pills in a 3D Pacman game. Ideally, when you create your environment in your 3D package, you only create one of each object. You can then clone them many times in Director, in runtime. This was done in the previous chapter to create trees, but in that case they were positioned randomly. We can use a map to mark the positions of objects using color coding.

All you need to do is have a scale map of your environment and mark on different colors to represent the positions of your objects. In the case of Figure 8.19, the map shows an Island with the dark pixels representing the positions of coconuts. In this case they are actually red pixels, or in Lingo terms, the colors red, green and blue (RGB) (255,0,0). When you set up the game, the program scans the map image row by row, using the Lingo GetPixel command. If it finds a red pixel it positions coconut in the world at

Figure 8.19 A 128 by 128 pixel map (enlarged), for positioning objects

a point relative to the map, scaled up. Each coconut is actually positioned well above the ground and a ModelsUnderRay command is used to check the height of the ground below it. Then each coconut is moved to the appropriate height position.

The coconuts are intended to be collected or drunk by being bashed by the Keystone Cop's truncheon. As well as positioning you can set these objects to be responsive to collisions.

Bashing

Shooting something is very common in games, but in this case, we bash with the truncheon instead of shooting. Usually shooting involves concepts of firing a ray from the position of the character and checking to see if it has hit another character. This is actually quite a straightforward task; it is the

same principle as keeping the camera and other objects above the ground, or as used in collision detection. However, the process is different in the case of the Keystone character. We require a very specific collision, that of his truncheon and a coconut.

In the case of our Keystone guy, his truncheon has been made to be part of the single mesh that makes him up. This is fine for him, but if you have a character that needs to change weapons or items then this is not appropriate. Another issue this leaves us with is that we cannot detect whether an object has hit just the truncheon, we can only detect collisions with the whole mesh. To overcome this you can attach objects to the bones of the character.

Attaching an object to the bones system is not like grouping it or adding the object as a child of the bone. The bone system is part of the Bonesplayer modifier in Director. As such you cannot add a child object to it, but you can find out the positions of the bones. Their positions are relative to the mesh object, so then it is just a case of taking into consideration the position of the mesh. If you do this test each frame, you can get an up-to-date transform (the transform being the position and direction) for a specific bone and then make your object's transform the same as the result.

In the case of our Keystone Cop, we have attached a box to his truncheon (Figure 8.20). This is what is used to collide with the coconuts. Although visible in the picture, this box's Shader Blend value will be set to zero in the game. That way, you cannot see it, but it is still doing its job.

Exploding

In most games, after you shoot or bash something you want to see a reaction, otherwise it is not satisfying. If you fire a laser at an oncoming spaceship then you want to see it explode. This can be achieved by playing a short animation of an explosion: a few dozen frames each with alpha transparent backgrounds, so that the flames and smoke merge into the background. Another, more versatile, concept is to use a particle system.

Particle systems in real time graphics are actually primitive objects (like the box, sphere, cylinder), but they do not operate in the same manner. They are made out of Planes (as many as you set up) which always face the camera. They are motion objects in that you set up how they move (e.g. direction and speed) and how forces affect them, like gravity and drag (friction). You can make the motions follow paths or cover an area, but the usual use for them is to have a stream of particles emanating from a point. The two options are a Stream motion or a Burst motion. The Stream option is used to

Figure 8.20 A box attached to the truncheon for collision detection with the coconuts

simulate flowing, like a waterfall, or smoke rising from a campfire and even the fire itself. The Burst option is what we want with our coconuts, an explosion of particles lasting for a short while and flying out from a single point.

To achieve the effect of an exploding coconut, we need to first detect the collision between the truncheon and coconut. Then create a particle system in the coconut's position and delete the coconut object. The particle system needs to have a texture set for it (with an alpha transparent background to hide the square shape of the particle) and the speed, size, gravity, angle of particle emission values set. To add a bit of variety, two particle systems have been created to give two different broken coconut shapes (Figure 8.21).

Figure 8.21 The particle system used for a coconut explosion

Scoring and overlays

Scoring is a very important part of any game as it is probably the main motivation for playing it more than once. You may want your game players to come back and improve their score; this creates more visits to your website, which will hopefully lead to more revenue. You might even offer an extra incentive to play, like a prize for the highest score by a certain date.

In programming, a score is stored in a variable, which is increased or reduced as time passes or events happen, such as collecting items. Displaying the score, or time, for your game can be achieved through several methods. You could just use a text field that is positioned above or below your 3D window. This method is fine but you probably want to make your 3D experience all encompassing, perhaps even filling up the whole screen.

Note *You cannot display anything over the top of your 3D window without substantially reducing the frame rate of your game. 3D graphics are displayed in a hardware mode that means normal graphics like pictures and text are handled separately. You would have to use a software mode if you wanted to overlay graphics in this manner, which means the dedicated 3D hardware in your graphics card would not be used.*

Another method would be to use 3D text. You can create 3D text using any font, and then display that in your 3D window. Position the text by using the camera screen coordinates, this will allow you to keep the score's characters' positions relative to the 3D window dimensions, positioning in 2D. You could texture 3D text to give it the look you want.

The last method would be to use camera overlays. This is the only way to incorporate bitmap images over the top of your 3D scene. You can use it for text by image copying from a set of characters to another bitmap, and then using that bitmap as an overlay texture. Using overlays does not have to be for text alone, you could use it to give your game an irregular border, or add other graphics such as maps to it (Figure 8.22).

Figure 8.22 Using overlays for the score and a map

Computer controlled characters

Computer controlled characters (CCCs) have only been mentioned briefly so far, but are an integral part of nearly all games. A CCC can be any kind of object or character that does something in your game but is not under your control. It could be argued that the coconuts are computer controlled. Indeed they are positioned by the program and then react to the Keystone Cop's truncheon, by way of exploding. However, this interaction is very simple and they do not move.

A more useful definition of a CCC would be a character that is trying to obstruct you in your game task. Ten years ago you could have used bitmaps to make these characters, as was successfully done in games like Doom, using the same techniques we have for trees. If you have hundreds of characters then you might still have to use this technique. One thing you could do to make your characters look better would be to animate the texture used for the plane. That way you could achieve the appearance of motion, e.g. flailing arms for zombies.

It would be fair to say that today's game player will not be impressed by 2D characters in your 3D world, unless it suited the game. Perhaps it has a cartoon style, as if the characters are paper cutouts. This would lend itself very well to bitmaps. Other than that, you will probably have to create 3D characters. Of course this will have an effect on your development time, but you could always use the same character in different clothes, or, more correctly, different textures. Indeed, once you have created one character, it does not mean you have to start from scratch to make more.

Using 3D CCCs in your game has a lot of similarities with your main game character. In fact, the only conceptual difference will be the decision making for where he or she moves. Other than that you will have the same issues to deal with inside your game, namely the collision and animation handling.

Controlling the characters

On of the simplest methods to control your CCCs would be to make them follow a repeating path, like the spaceships in the classic Space Invaders game, or a more complicated path. Perhaps your character is an enemy soldier guarding a gate; you could set up a list of positions for him to

follow. When it reached one position it turned towards the next one and walks towards it. This sounds quite simple, but you still would have to take into account the animation for that character. The main issue with it is that the movement will be predictable. This might be a good thing, as it allows you a chance to run past the character. There might only be a small window of opportunity, too late or too early and your character is killed.

Another simple method would be to control the direction the CCC is pointing, either slightly every frame, or by deliberate amounts at certain intervals. In essence, this is same as following a path. But you could add some unpredictability by having the direction changes occur at random times or amounts. This might work for an open arena type of game, but will probably only create an increase in the difficulty level, where you have so many characters that avoiding them takes great skill.

Using rules to control the characters

You can build up a sophisticated type of control through the combination of rules. We already have rules for our main character, he can walk and jump, depending on keystrokes. We make the decisions for that, but other rules have an effect on him, like gravity and collisions. These rules make the character come down to earth when he is jumping and stop him falling through the ground. If you give our CCCs these rules, then you are on the way to building a type of artificial intelligence. The next rule to make would be the motivation for moving. We have talked about paths, but you could make your CCCs home in on your main character, by pointing towards him and moving forward. You could make this happen only when they within a certain range of the main character.

Combining rules together, results in your computer controlled characters behaving in a seemingly natural manner, and possibly even giving the illusion of making decisions. If you increased the complexity of the rules then they actually could make decisions, although whether they are intelligent is debatable. You could add a rule that took into account where you are traveling and the CCC could get there first to block you from your goal, an anticipatory behavior.

Figure 8.23 shows the Keystone Cop in action, being chased by a computer controlled turtle. You can play the full game on the website www.3dfortheweb.info. Have fun!

Figure 8.23 The Keystone Cop being chased by a determined turtle

The future of 3D on the Web

By the time you get to this final stage of the book, you should be brimming with ideas and have the confidence to explore them, to create interactive elements, layouts and games for your websites. All this would be intended for today's audience on today's computers. But what of the future of 3D on the Web? The answer is linked inextricably to the future of the internet itself. The internet is still young with the World Wide Web starting in the early nineties. In the time since then it has developed in its sophistication, but is not much different in terms of what it shows in a browser – text, link buttons and graphics (and sometimes sound). So if the concept has not changed much, then what has? Well, for a start, the net is diversifying. No longer do you have to sit at a computer to view a web page. You can look at it on your mobile phone or PDA. The mobile use of the Web is a crucial subject, and one which brings its own design challenges. For a start, screen resolutions are much lower on

these devices than on a desktop monitor. 3D may not be very popular yet on mobiles, but bandwidth is more of an issue, so being able to display real-time 3D graphics could be a much better way to advertise a product.

The way people use the Web *is* changing our lives, after all, how many people booked holidays online ten years ago, compared to now? Today, you know you can find a bargain online, so it is the first place to visit. You can even buy a home through the Web. There are so many opportunities for 3D to enhance a Web situation. 3D could easily come to dominate the net market in the way that it has for television graphics.

As broadband becomes more standard and machines more powerful we should see 3D for the Web follow the way of 3D in commercials and features. When this happens, my hope is that designers and clients will not be tempted to pursue the holy grail of realistic rendering, but will instead keep searching for creative solutions to the interactive format. Tomas Landgreen, co-founder of Titoonic, tells how he was instantly attracted to interactive 3D, rather than the high-end world of the big 3D houses. He wanted to 'do the fun parts: the concept, the character designs, the animation and the storytelling.' He is pointing out a crucial difference the current restrictions make on the designer: They actually force designers to be more creative.

I have a reputation amongst my students for wearily dumping on their realistic renders by saying, 'Yeah, yeah. It's great, but why bother to *animate* it?' As I said before: Animation is hard work, it is also magic. Why throw away the fun stuff? With animation and design there are well established principles drawn from centuries of other art forms. If a theatre designer needs to evoke a wood for Midsummer Night's Dream he or she will happily suggest the lover's forest with some lights and a gobo. The audience does not expect or want an Athenian Wood to be shipped in and put on stage. It is more fun to solve problems creatively than to throw money at a poor imitation of life. David Hockney said that 'A painting gives you so much more than a photograph'. He is right. Just because interactive 3D is an immersive media, does not mean we have to try and recreate the world Matrix-style. I truly believe that for 3D on the Web, less is more.

One of the questions we asked several of the companies in this book was which technology do they think is best for 3D. Although they all gave answers, perhaps the question should not be which is best, but which is the most popular. Take the old Betamax versus VHS situation in the early days of home video. Betamax was considered to be a better format, a better picture, but VHS was the best distributed, had the most rental movies. It won the contest due to better marketing. This is probably the case for Macromedia and Shockwave. Whether it is the best for 3D, or not, is perhaps irrelevant. The point is that it is the most popular and best marketing platform for displaying 3D, whether through its Flash player or the Shockwave player. Macromedia's dominance has left other companies struggling to get a foot hold on the Web

market. Whichever software dominates, you need to be flexible enough to adapt with the times. Which software you use is not important; it is the ideas you have that will help you gain work and recognition as a 3D Web master.

So don't just run through the exercises in this book, make up your own. Add your own ideas and explore the possibility of 3D. It is with you that the future of 3D on the Web lies, so go and create it.

Appendix

Software

To use this book successfully you'll need software. You might already have this, but if not you can download free trial versions from the following websites.

www.discreet.com for the latest version of 3ds max (including Character Studio)

Be sure to get the free Shockwave exporter (it will say it's for version 4) from the following link.

http://www.discreet.com/products/3dsmax/exporter/register/

You can also download free trial versions of Director, Flash, DreamWeaver and other Macromedia Software from www.macromedia.com

Information on Adobe products, such as PhotoShop is available from www.adobe.com.

Books

Two excellent books on traditional animation.

Frank Thomas and Ollie Johnston. *Illusion of Life: Disney Animation*. Disney Editions 1995

Richard Williams. *The Animator's Survival Kit*, Faber and Faber 2002

I recommend these two books for digital animators.

George Maestri *Digital Character Animation 2, Volume 1: Essential Techniques*. New Riders 1999

Steve Roberts, *Character Animation in 3D*. Focal Press 2004

For further reading on Flash and Director, I recommend these books. The Director one, in particular goes into great depth on programming 3D in Lingo.

Leon Cych, Benjamin J Mace and Glen Rhodes. *Macromedia Flash MX Express.* Wrox Press 2002

Paul Catanese. *Director's Third Dimension: Fundamentals of 3D Programming in Director 8.5.* Que 2001

Useful websites

A highly useful discussion list for Shockwave 3D is the Dir3D Mailing List. It has help and advice for beginners and experts alike.

http://nuttybar.drama.uga.edu/mailman/listinfo/dir3d-l

Flask Kit contains hundreds of resources for Flash, including tutorials, sounds and loops, graphics.

http://www.flashkit.com/

To make texture files for your games and 3D models try Texture Maker, a commercial texture making software.

http://www.i-tex.de/

A great resource for articles, tutorials, reviews on game design and development can be found at Gamasutra.

www.gamasutra.com

For animation news and discussion go to the Animation World Network at www.awn.com/

For links and animation help then I would visit Angie Jones' Spicy Cricket site at www.spicycricket.com

The Designers Network is an international forum of designers, including web designers.

http://designers-network.com

Our website

For many other links, tips and advice on 3D animation, you must visit www.3dfortheweb.info

Index

Focal Press　　　　www.focalpress.com

Join Focal Press online
As a member you will enjoy the following benefits:

- browse our full list of books available
- view sample chapters
- order securely online

Focal eNews
Register for eNews, the regular email service from Focal Press, to receive:

- advance news of our latest publications
- exclusive articles written by our authors
- related event information
- free sample chapters
- information about special offers

Go to www.focalpress.com to register and the eNews bulletin will soon be arriving on your desktop!

USA
Tricia Geswell
Email: t.geswell@elsevier.com
Tel: +1 781 313 4739

Europe and rest of world
Lucy Lomas-Walker
Email: l.lomas@elsevier.com
Tel: +44 (0) 1865 314438

Catalogue
For information on all Focal Press titles, our full catalogue is available online at www.focalpress.com, alternatively you can contact us for a free printed version:

USA
Email: c.degon@elsevier.com
Tel: +1 781 313 4721

Europe and rest of world
Email: j.blackford@elsevier.com
Tel: +44 (0) 1865 314220

Potential authors
If you have an idea for a book, please get in touch:

USA
editors@focalpress.com

Europe and rest of world
ge.kennedy@elsevier.com